FICTIONS OF
EMANCIPATION

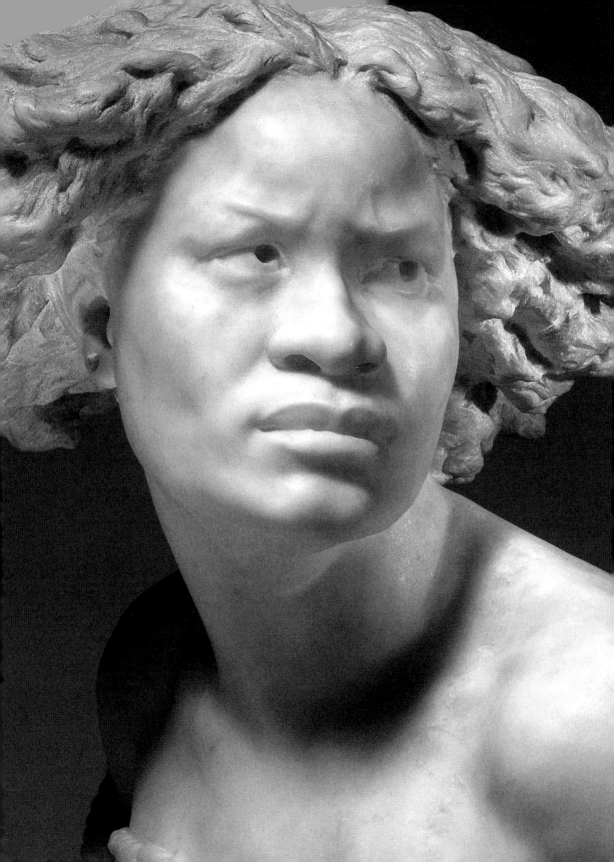

EDITED BY ELYSE NELSON AND WENDY S. WALTERS

FICTIONS OF EMANCIPATION

CARPEAUX'S *WHY BORN ENSLAVED!* RECONSIDERED

The Metropolitan Museum of Art, New York

Distributed by Yale University Press, New Haven and London

This catalogue is published in conjunction with
Fictions of Emancipation: Carpeaux Recast,
on view at The Metropolitan Museum of Art,
New York, from March 10, 2022, through
March 5, 2023.

The exhibition is made possible by the
Iris & B. Gerald Cantor Foundation.

Additional support is provided by
Allen R. Adler and Frances F. L. Beatty.

This publication is made possible by
The Met's Fund for Diverse Art Histories,
Mary J. Wallach, Robert E. Holmes, the Ford
Foundation, and the Henry Moore Foundation.

**Published by The Metropolitan Museum
of Art, New York**
Mark Polizzotti, Publisher and Editor in Chief
Peter Antony, Associate Publisher for
 Production
Michael Sittenfeld, Associate Publisher
 for Editorial

Edited by Elizabeth Benjamin and
 Eleanor Hughes
Production and color separations by
 Christopher Zichello
Designed by Rodrigo Corral and Alex Merto
Bibliographic editing by Eleanor Hughes
Image acquisitions and permissions by
 Shannon Cannizzaro

Photographs of works in The Met collection
are by Paul H. Lachenauer, Richard Lee, and
Bruce J. Schwarz, Imaging Department,
The Metropolitan Museum of Art, unless
otherwise noted.

Additional photography credits appear on
page 140.

Typeset in Bradford and Yellix by
 Tina Henderson
Printed on 120 gsm Munken Lynx and
 130 gsm Arctic Matt
Printed and bound by Ofset Yapımevi, Istanbul

Cover illustrations: front, detail of Jean-Baptiste
Carpeaux, *Why Born Enslaved!*, modeled 1868,
carved 1873 (pl. 1); back, Kara Walker, *Negress*,
2017 (pl. 3)
Page 2: detail of Jean-Baptiste Carpeaux, *Why
Born Enslaved!*, modeled 1868, carved 1873
(pl. 1)

The Metropolitan Museum of Art
1000 Fifth Avenue
New York, New York 10028
metmuseum.org

Distributed by
Yale University Press, New Haven and London
yalebooks.com/art
yalebooks.co.uk

Cataloguing-in-Publication Data is available
from the Library of Congress.
ISBN 978-1-58839-744-7

Contents

Plates

Note to the Reader

Some of the artworks discussed in this publication bear titles that reflect pejorative historical naming conventions. Where this is the case, the plate captions show the relationship between our suggested titles and their historic referents. Across the book, authors have used various titles for the works discussed, depending on the political and historical context of their discussions. Likewise, some authors have chosen to avoid usage of the word "slave" in referring to enslaved individuals, while others have employed the term as it suits their arguments. Except where noted, all translations are by authors.

Director's Foreword

While Jean-Baptiste Carpeaux is widely recognized as one of the great French sculptors of the nineteenth century, his evocative bust *Why Born Enslaved!* has never before received as nuanced an examination as you will find in these pages. For the first time, an exhibition has been devoted to this work, and a group of scholars has been gathered to probe its representation.

From our present-day perspective we can recognize that, underlying the empathy of Carpeaux's portrayal, the sculpture reinforced the colonial and imperial power dynamics of French society and its lack of freedom for its Black population. How, this book's authors ask, does Carpeaux's work fit into a continuum of Western portrayals of vanquished, ethnographic, and emancipated subjects? What do the contradictory themes of this single work tell us about the representation of abolition in nineteenth-century sculpture? And what role can this complicated object play in the stories that The Met tells about art and history?

Fictions of Emancipation is one of a number of important projects at The Met that are engaged in redressing institutional narratives by bringing race to the forefront of our discussion of 5,000 years of art. The roots of the current project lie in a productive collaboration between Elyse Nelson, Assistant Curator of Eighteenth- and Nineteenth-Century European Sculpture in the Department of European Sculpture and Decorative Arts at The Met, and

Wendy S. Walters, Concentration Head in Nonfiction and Associate Professor in the Writing Program in the School of the Arts at Columbia University. Their creative engagement with the sculpture began when *Why Born Enslaved!* was acquired by the Museum in 2019 through the initiative of Sarah E. Lawrence, Iris and B. Gerald Cantor Curator in Charge of the Department of European Sculpture and Decorative Arts. Together they have created an exhibition that beautifully realizes the potential of cross-disciplinary engagement and is exemplary in combining meticulous scholarship and original insight. Likewise, this accompanying publication grew out of a desire to engage the voices of distinguished scholars from varied fields of study to contribute further to this chorus of interdisciplinary interrogation. The sensitivity and intelligence displayed by Nelson and Walters in the curation of their exhibition are no less apparent in their editorial collaboration on these collected essays. The aspiration for any exhibition catalogue is that the scholarly contribution will be felt past the closing date of the exhibition. *Fictions of Emancipation* will significantly and permanently reframe the discourse on abolition in nineteenth-century sculpture.

The works of art gathered in this exhibition include spectacular loans from private collections and from museums across Europe and the United States; a complete list of lenders is at the back of the book. I owe my gratitude to the Iris & B. Gerald Cantor Foundation for its lead support of this exhibition. The gift from Allen R. Adler and Frances F. L. Beatty is also instrumental to its success, as is a grant from the Wallace Foundation and from Mr. and Mrs. Richard L. Chilton, Jr. The support of The Met's Fund for Diverse Art Histories, Mary J. Wallach, Robert E. Holmes, the Ford Foundation, and the Henry Moore Foundation allowed us to realize this publication. For making possible the convening that helped to shape the curatorial vision of this project, I thank the Robert Lehman Foundation. Juxtaposing these works of art challenges our assumptions about them. I am deeply grateful for the generosity of our lenders and to all who have contributed to this extraordinary project.

Max Hollein
Marina Kellen French Director
The Metropolitan Museum of Art

Preface

Sarah E. Lawrence

I became aware of the opportunity to acquire Jean-Baptiste Carpeaux's *Why Born Enslaved!* (pl. 1) shortly following my arrival at The Metropolitan Museum of Art in 2019 as the Iris and B. Gerald Cantor Curator in Charge of the Department of European Sculpture and Decorative Arts. The addition of this sculpture to an already significant collection of works by Carpeaux was motivated by a commitment to broaden the narratives told in our galleries. Visitors are surrounded there by sculptures of figures from history and classical mythology, all of whom are presumed to be white. Carpeaux's affecting depiction of a woman of African descent interrupts this racial uniformity and elicits powerful, conflicting responses from the viewer. This artwork is a prompt to acknowledge issues of race and empire; it complicates the motivations of empathetic sentiment; and it disturbs the viewer's comfort with the display of the female nude. These complex and intertwined subjects are densely contained, and they unspool for the viewer with sustained contemplation of the sculpture.

The marble bust was initially put on display in the Carroll and Milton Petrie European Sculpture Court with other masterworks of eighteenth- and nineteenth-century European sculpture. The picturesque display, flooded with natural light, was designed to evoke a French outdoor courtyard. In keeping with this ambience, its seating—for decades—had been green

slatted chairs identical to those at the Luxembourg and Tuileries Gardens in Paris. In 2020 these were replaced by Skeleton Chairs designed by the Ghanian British architect David Adjaye. According to Adjaye, the chairs' latticework design draws on African textile patterns and pays homage to the history of enslaved blacksmiths. The introduction of Adjaye's chairs was an intentional disruption of the cultural homogeneity of the gallery, contrasting classical with contemporary design, and European with African influences. Having installed Carpeaux's sculpture in Petrie Court, there was an urgency to acknowledge both the history of enslavement and also the beauty of creative practice brought from Africa into Europe and the United States.

Carpeaux's bust *Why Born Enslaved!* took form while the artist was designing the bronze Fountain of the Observatory (see fig. 1) for the Luxembourg Gardens. On the fountain, the allegorical personification of Africa is a full-length figure of a formerly enslaved woman, shown with a broken shackle around her ankle to signal her newly emancipated status. In reenvisioning the subject of an enslaved African woman for a new purpose, Carpeaux shifted his sculptural treatment from allegory to a different sort of pictorial mode. The bust bears the attributes of narrative reference, specifically the woman's disheveled clothing and the rope binding her arms. The animated torsion of her upper body and the focused attention of her gaze suggest an interrupted moment. But this mode of pictorial rendering brings action to a standstill. The figure's distress is given an intolerable duration.

When it was acquired, *Why Born Enslaved!* was placed adjacent to The Met's earlier work by Carpeaux, *Ugolino and His Sons*, both sculptures that depict moments of unimaginable psychological anguish rendered with an intensity that discomforts the viewer.[1] Indeed, many of the surrounding sculptures are themselves depictions of humiliation, decapitation, suicide, and rape. These abhorrent subjects are rendered tolerable—even beautiful to look at—because of their conceptualization by the artist and an acceptance by his audience that these are, above all, works of art. The unintended consequence is to obscure the disturbing subject and provide an aesthetic experience for the viewer. It would be particularly pernicious, at this moment in history, to allow the display of Carpeaux's bust similarly to dilute the content of the image. Having acquired this sculpture, we have assumed responsibility for the ethical display of Carpeaux's *Why Born Enslaved!*. Can we be other than

complicit in the aestheticization of slavery, what the literary scholar Christina Sharpe names the "colonial project of violence"?[2]

The significance of this acquisition has a different inflection now and an even more powerful resonance today than it did in 2019. The civil upheaval and demands for racial justice that intensified in the summer of 2020 following the murder of George Floyd compelled The Met to confront its own institutional racism. There has been a demand for the recognition of the imperialist origins of the Museum's encyclopedic collections, of the location of its buildings on stolen lands, and of the pervasive narratives of white supremacy told in its galleries. In response, The Met has made a broad-reaching institutional commitment to promote racial equity and has begun a process of critical self-scrutiny that is long overdue. The Department of European Sculpture and Decorative Arts (ESDA) has a particular responsibility in this: the objects in ESDA's collection are themselves compelling material manifestations of a contested past, embedded within a pernicious history of colonialization. ESDA embraces the opportunity to give voice to these divergent stories, to offer a narration that speaks to the current resonance of our collection at a moment when the Eurocentric reality of our collecting and displays requires redress. The questions posed by the acquisition and display of Carpeaux's *Why Born Enslaved!* have been a prompt to reflect on our intention, our responsibility, and our voice, in conversation with our visitors.

When Carpeaux's sculpture first entered The Met collection, the artwork was the subject of the November 2019 episode of MetCollects, an online series that features new acquisitions.[3] The series pairs a curatorial voice with an alternate creative mode of critical response. In this instance, the poet and essayist Wendy S. Walters was invited to read a poem that she wrote in response to the work of art. In her introductory remarks to the MetCollects episode, she seeks to retrieve the humanity of the woman who served as the model for the sculpture. Considering the unknown identity of the woman, Walters wonders aloud if the model chose to sit for the artist or if she was forced to find work as an artist's model under economic duress. Walters comments, "In the world of the poem, I like to think of her being much more vivid and present in life than her bound by rope." Walters's poem offers us a way of imagining this woman other than how she is shown to us in this sculpture. The poet gives the woman a voice that the sculptor did not.

IN THE GALLERY

Wendy S. Walters

1.
The woman I've been mistaken for
Is not myself, and yet I've developed
An expression of agony to share
Despite being so long lonely.

My name, for now, is my body
Soft in flesh but louder in stone.
I find my way through years of silences
After a life surrounded by enemies.

The crowd comes to calibrate beauty
Their eyes on me, and I am Black.
By this I mean I own myself
In marble or other measures cast
To be displayed in passages eternal.

Take care with those who think they're free,
Who claim the rope belongs to someone else,
Who took all they could gather in arms,
Who built machines to steal the rest.

There is a language for this loss.
None have learned to speak it
Though I practice with eyes closed,
As if to learn from memory.

2.
I am one unlikely to be here.
And so is she who comes after me.
So is the one after her who owns herself
Despite a world of superstitions.

The hall is not quite a cathedral
Though the crowd's singing overpowers
The sleepwalkers who seek shadows
Despite the light's devotion.

Imagine waking in the midst of a festival
Looking in all directions
For evidence of the soul's journey,
Call it liberty—

See how the room grows
To accommodate my view
This is what walls can do.

Introduction

Wendy S. Walters and Elyse Nelson

Why dedicate an entire volume to Jean-Baptiste Carpeaux's sculpture *Why Born Enslaved!* (pl. 1)? Known by its numerous versions in collections throughout Europe and the United States, the bust is one of many accomplished compositions that Carpeaux made in multiples. Developed from studies for the allegorical figure of Africa in his last major commission, the central sculpture for the Fountain of the Observatory (fig. 1), the work exemplifies the artist's late-career practice of extracting narrative elements from his public monuments for use in independent sculptures reproduced for commercial sale.[1] *Why Born Enslaved!* stands apart from Carpeaux's standard commercial repertoire, however, as his only documented depiction of a woman of African descent.

While this fact alone would warrant our engagement, the impetus for this project stems from an acknowledgment of the magnitude of the misperceptions that surround this sculpture. As their titles suggest, *Fictions of Emancipation: Carpeaux's "Why Born Enslaved!" Reconsidered* and the exhibition it accompanies frame a new conversation around a work that is often extolled as a token of inclusivity in displays of nineteenth-century French sculpture and cited as evidence of Carpeaux's assumed humanitarianism. "Fictions" refers to statements or beliefs that are imagined or false, while "emancipation" denotes the process of being set free from enslavement.

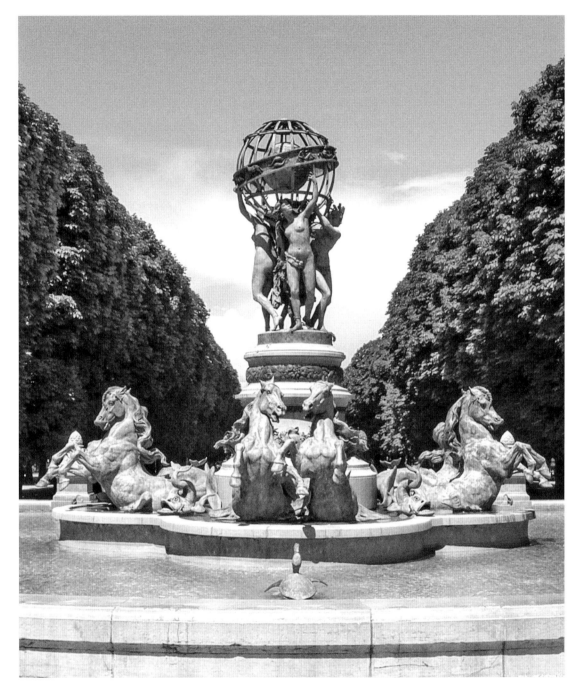

FIG. 1. FOUNTAIN OF THE OBSERVATORY, 1867–74
Jean-Baptiste Carpeaux (French, 1827-1875) and Emmanuel Frémiet (French, 1824-1910).
Bronze. Avenue de l'Observatoire, Paris

Together these terms suggest that Carpeaux's work represents certain false-hoods about freedom. Probably the most notable fiction in this framework is the idea, reinforced by the exercise of power manifested in the enduring visual culture of abolition and emancipation, that Black persons must first have been enslaved in order to be free. Another fiction is the predominant discourse of racial typologies articulated through the popular scientific field of ethnography, present here in the bust's depiction of a "type." Finally, the term "fiction" points to the contradictions that arise when abolition is represented through the body of the enslaved.[2] These fictions, we suggest, were sufficient to interfere with broader cultural understandings of Black identity and personhood within imperial and colonial contexts.

Why Born Enslaved! is at once an invitation to sympathy, a reminder of colonial conquest, and an object of exquisite beauty that equates Blackness with exoticism, novelty, and desire. It embodies the power dynamics that characterized the relationship between European artists and the aesthetic possibilities of the Black figure in the nineteenth century. In an effort to address these complexities, the essays in this book offer multiple perspectives on a single artwork rather than a comprehensive history of abolitionist art during this period. They also trace a network of artists in countries across the Atlantic—in France, Britain, and the United States—whose work intersected in theme, influence, and audience. As such, this book contributes to a growing body of recent scholarship that seeks to examine the relationship between art and the histories of race, slavery, colonialism, and empire. *Fictions of Emancipation* builds on the foundations laid by Hugh Honour, David Bindman, and Henry Louis Gates Jr. with their influential anthology *The Image of the Black in Western Art*; Charmaine A. Nelson's studies of the representation of the Black female subject in Western painting and sculpture in *The Color of Stone: Sculpting the Black Female Subject in Nineteenth-Century America* and *Representing the Black Female Subject in Western Art*; Anne Lafont's treatment of the Black figure in the visual culture of the French Enlightenment in *L'art et la race: L'Africain (tout) contre l'oeil des Lumières*; and James Smalls's analysis of the colonialist implications of ethnographic sculpture.[3] The exhibition that this book accompanies also follows a precedent set by a number of significant shows dedicated to reevaluating the place and treatment of the Black figure in Western art. These have included, to name a few, *Figures of Empire: Slavery*

and Portraiture in Eighteenth-Century Atlantic Britain (Yale Center for British Art, 2014), which focused on previously overlooked representations of enslaved individuals, and *The Black Figure in the European Imaginary* (The Cornell Fine Arts Museum, Rollins College, 2017), which explored the currents of objectification that underlie even the most compelling and individualistically rendered portrayals of Black figures in European art. Most recently, *Posing Modernity: The Black Model from Manet to Matisse to Today* (Miriam and Ira D. Wallach Art Gallery, Columbia University, 2018) and *Le modèle noir de Géricault à Matisse* (Musée d'Orsay, 2019) offered timely interventions in the conversation about naming Black figures in European art and posed new questions about the obligations that institutions face when displaying works that represent the anonymous Black figure.[4]

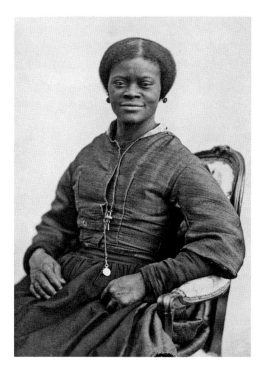

FIG. 2. LOUISE KULING, 1864
Jacques-Philippe Potteau (French, 1807–1876).
Albumen print from wet collodion negative mounted in an album from the series Collection Anthropologique du Muséum de Paris, photograph: 7⅛ × 5⅛ in. (18 × 13 cm). Muséum National d'Histoire Naturelle, Paris (SAP 155 [7] / 63)

As was the case with most Black models working in Paris at the time, the identity of Carpeaux's model is unknown. She may have been a free woman from Norfolk, Virginia, named Louise Kuling, who came to France with a Frenchman called Captain (or Commander) Louvet. Photographed at the age of thirty-five by Jacques-Philippe Potteau as part of an ethnographic portrait series, Collection Anthropologique du Muséum de Paris, for the National Museum of Natural History in Paris, Kuling bears a resemblance to Carpeaux's sitter (fig. 2; see fig. 29).[5] Without further documentation, however, this identification remains a speculation. A remarkable clay sketch provides the most direct surviving visual record of the woman who posed for the sculptor (pl. 6). Fingerprints and toolmarks from Carpeaux's vigorous modeling make palpable the hand of the artist at work as he encountered his subject.[6] As this sketch makes evident, the model for *Why Born*

Enslaved! was a present and particularly affective contributor in Carpeaux's studio. But this is not a book about the woman portrayed. Rather, it sheds light on Carpeaux's investment in fashioning her likeness into a symbol of abolition and underscores the ways her image supported the sculptor's ambitions to secure commercial success and contribute to the ascendance of the Second Empire.

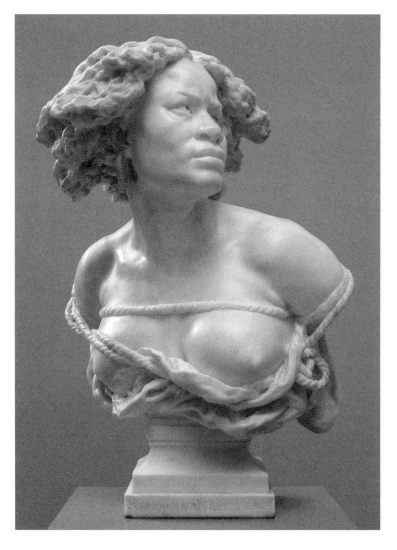

FIG. 3. WHY BORN ENSLAVED!, 1868
Jean-Baptiste Carpeaux (French, 1827–1875). Marble, H. 26⅜ in. (67 cm), W. 18⅞ in. (48 cm), D. 15¾ in. (40 cm). Ny Carlsberg Glyptotek, Copenhagen (MIN 1671)

Carpeaux studies have a long history at The Met, home to the sculptor's monumental *Ugolino and His Sons* and singular marble portrait, *Napoléon III*.[7] In 2014, the Department of European Sculpture and Decorative Arts mounted a Carpeaux retrospective curated by the late James David Draper and accompanied by an ambitious volume of essays covering major aspects of the artist's biography and oeuvre, including a history of *The Four Parts of the World Supporting the Celestial Sphere* (pl. 9, see fig. 21), the central sculpture group for the Fountain of the Observatory, and *Why Born Enslaved!* by Laure de Margerie.[8] Despite the breadth of that exhibition and the inclusion of *Why Born Enslaved!*, the sculpture remains an object worthy of further consideration given the ways it contributed to the construction of racial ideologies in the nineteenth century. At the time of the 2014 exhibition, only one marble version of *Why Born Enslaved!* had been located: the original marble displayed at the annual Salon in Paris in 1869, which was subsequently acquired by Napoléon III for Empress Eugénie and is now at the Ny Carlsberg Glyptotek, Copenhagen (fig. 3). Many of that work's superlative details—from its intact earrings, carved of a piece with the bust, to the fully undercut knot and interlacing ropes—are eye-catching performances in marble. The rediscovery of a second documented marble version of *Why Born Enslaved!* in 2018 led to its acquisition by The Met. This version, completed in 1873 and later recorded in the collection of Mme Demonts in Paris, eschews bravura detail in the carving.[9] Instead it hews closely to the simplicity and expressive tenor of the original plaster model to evoke the formal grandeur of classical and High Renaissance sculpture, deliberately recalling the agonistic intensity of *Laocoön and His Sons* and Michelangelo's *Rebellious Slave* (see fig. 18).[10]

Until recently, scholars have called Carpeaux's bust by the title under which it appeared at the Paris Salon, *Négresse*. This is the feminine equivalent of the pejorative term "nègre," used to designate a Black man as "Negro." The terms "nègre" and "négresse" entered into the French language in the sixteenth century but were rarely used before the eighteenth, when their usage became common alongside the development of the transatlantic slave trade and with the emergence of theorizations of racial categories. Unsurprisingly, the word "nègre" also came to mean "esclave" (slave) in eighteenth-century French dictionaries and in Jean-Baptiste Colbert's Code Noir (1685)—a decree that officially established the practice of slavery across the French colonies. The

two words were used interchangeably to support the fiction of racial difference that formed the link between Black personhood and slavery.[11]

At The Met, the bust is known by its inscription, but titling the sculpture by the words on its socle brings other complications, given that not all versions of the bust are inscribed. The bases of many but not all early examples of the bust bear the inscription "Pourquoi naître esclave".[12] The Met marble's inscription, like that of the Copenhagen version, ends with an exclamation point, and, curiously, the terracotta in The Met collection bears two (pl. 2). Others lack punctuation. These variations attest to the participation of workshop assistants in adding inscriptions to versions by hand. Despite its grammatical ambiguity, the phrase "Pourquoi naître esclave!" is acceptable as a form of idiomatic French, posing a question as a declaration in a rhetorical manner.[13]

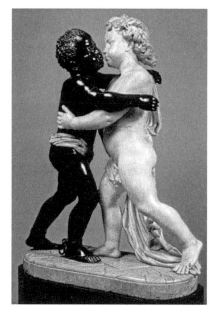

FIG. 4. LOVE ONE ANOTHER, 1867
Charles-Henri-Joseph Cordier
(French, 1827-1905).
White, black, and antique yellow marble.
Present location unknown

Employing language to align his sculpture with the tradition of abolitionist imagery, Carpeaux undoubtedly intended for the bust to profit from the popularity of antislavery works and representations of Black figures during the post-emancipation period, particularly those inspired by the 1787 Wedgwood antislavery medallion (pl. 10). Its slogan "Am I not a man and a brother?" likewise conveyed both an emotional emphasis and a question with which to reckon in the midst of volatile debates about morality and property. In France slavery was abolished twice: first in 1794 and—following its reinstatement by Napoleon Bonaparte in 1802—again in 1848.[14] The tensions surrounding abolition amid the sweeping dramas of nineteenth-century revolutionary history gave it great aesthetic appeal, as artists endeavored to find ways to express France's advancing moral stance and burgeoning vision of a capitalist empire through the formation of a new visual vocabulary rooted in traditional allegorical tropes (pl. 15). Marianne, the embodiment of the French Republic and female personification of liberty, who is often depicted bare-chested, served as a point of departure for Carpeaux's *Why Born Enslaved!*. It is widely assumed that the end of the Civil

War and abolition of slavery in the United States in 1865 inspired Carpeaux to take up the subject. Indeed, he may have been encouraged to do so by the broader antislavery discourse that took place at the 1867 Universal Exhibition, where John Quincy Adams Ward's sculpture *The Freedman* (pl. 22) and Charles-Henri-Joseph Cordier's *Love One Another* were both on display (fig. 4). With members of Carpeaux's own family seeking their fortunes in the United States, the artist may have been kept apprised of the civil strife unfolding there around the question of slavery, the critique of which proved immensely popular in France following abolition in the French colonies.[15]

Each essay in this collection rethinks *Why Born Enslaved!* in the context of late nineteenth-century imperialist and capitalist endeavors. Adrienne L. Childs connects Carpeaux's work to the tradition of the vanquished, in particular as it manifests in depictions of slavery and liberation. Iris Moon explores the production of abolitionist porcelain during the Revolution, revealing the specific tensions inherent to such representations in the French context. Elyse Nelson considers the bust in light of the racial politics under-girding Carpeaux's imperial patronage and commissions. James Smalls asks us to reconsider the function of Carpeaux's work, as well as those of some of his predecessors, in a creative economy built on the colonialist desire to define Black identity through the ethnographic idiom. Wendy S. Walters looks at how presumptions about Carpeaux's intentions may have occluded the understanding of *Why Born Enslaved!*. Caitlin Meehye Beach draws a connection between the economies of art and slavery, and examines the ways that reproduction serves narratives of power in the long and grinding arc of commodity production and consumption. Finally, Rachel Hunter Himes's brief chronology knits together key moments from Carpeaux's career and the vast history of slavery in the Atlantic world.

As these essays touch on many of the complexities surrounding the bust, they also inspire questions for collectors, museum audiences, and scholars of the history of art of the long nineteenth century. Despite their focus, the texts represented in this collection do not exhaust the range of perspectives that could be brought to bear on the work of art at hand. Another book, for example, could be dedicated to explaining the differences between ethnographic and Romantic gestures in Carpeaux's bust and other depictions of the Black figure. We hope these provocations inspire further reconsiderations of the influence and implications of nineteenth-century art that represents enslavement.

Adrienne L. Childs

THE VANQUISHED UNCHAINED

ABOLITION AND EMANCIPATION IN SCULPTURE OF THE ATLANTIC WORLD

Embedded in the complexities of a post-emancipation Black Atlantic world, Jean-Baptiste Carpeaux's *Why Born Enslaved!* (pl. 1) is a pivot point for the wide-reaching discussion about slavery, abolition, emancipation, and art explored in this book. While grounded in French sculptural practice of the 1860s, *Why Born Enslaved!* has aesthetic and conceptual roots in a centuries-old European visual tradition of representing the vanquished, the captive, and the enslaved. These restrained figures were a testament to the power and triumph of their captors. By the end of the eighteenth century, in the wake of the brutality and violence of the race-based Atlantic slave trade and its colonial dynamics, a new visual language of captivity and enslavement had emerged in the growing discourse around abolition and the emancipation of the Black enslaved. As the objectified, commodified, and abject did not lend themselves easily to representation, the various strategies used to unfetter the Black slave body in sculpture proved to be fraught with opaque intentions, contradictory messages, and open-ended narratives.

The tradition of depicting prisoners in art dates back to antiquity. In the wake of wars and conflicts in the late fifth century B.C., the Greeks bound prisoners to columns in order to display their vanquished enemies. This kind of spectacle of victory led to the development of architectural pillars that feature the vanquished or enslaved bearing the burden. These and similar

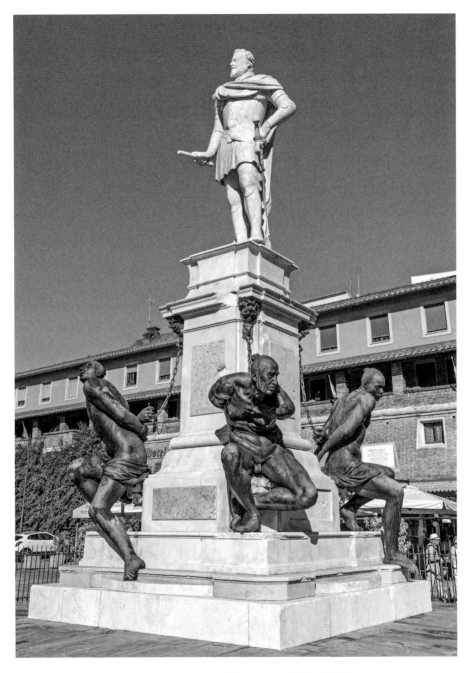

FIG. 5. I QUATTRO MORI (THE FOUR MOORS), 1621–26
Pietro Tacca (Italian, 1577-1640). Bronze. Installed around the
base of the marble monument to the Grand Duke of Tuscany,
Ferdinando I de' Medici (1599), by Giovanni Bandini (Italian, 1540-1599),
in Livorno, Italy

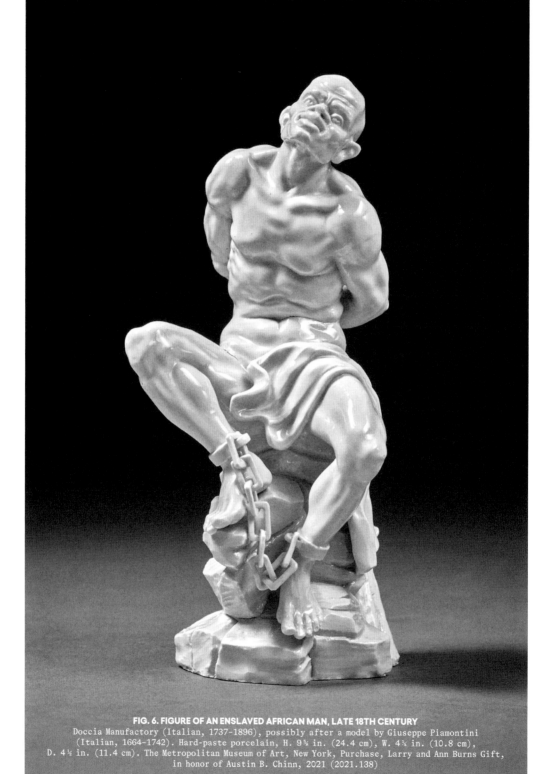

FIG. 6. FIGURE OF AN ENSLAVED AFRICAN MAN, LATE 18TH CENTURY
Doccia Manufactory (Italian, 1737–1896), possibly after a model by Giuseppe Piamontini
(Italian, 1664–1742). Hard-paste porcelain, H. 9⅝ in. (24.4 cm), W. 4¼ in. (10.8 cm),
D. 4½ in. (11.4 cm). The Metropolitan Museum of Art, New York, Purchase, Larry and Ann Burns Gift,
in honor of Austin B. Chinn, 2021 (2021.138)

antique architectural conventions were born of a punitive expression and retained that connotation through the centuries.[1] As civilizations and cultures collided, the imagery changed, but the tone and tenor remained the same. By the seventeenth century Black slaves had begun to appear as vanquished prisoners in European visual culture. One of the most important and influential seventeenth-century monuments depicting captives was Pietro Tacca's *I Quattro Mori* (*The Four Moors*) of 1621–26 (fig. 5). Tacca's slaves were chained to the pedestal of the 1599 monument by Giovanni Bandini to Grand Duke Ferdinando I de' Medici in Livorno, Italy. The Black and Turkish figures represented were referred to indeterminately as "Moors" and reflect the Christian conquest of the Ottomans in the sixteenth century.[2] Their hands behind their backs, these colossal bronze galley slaves crouch, twist, and turn under the restraint of heavy chains. They were executed with great naturalism and with individualized treatments of both physiognomy and expression. *I Quattro Mori* has been called the first major work of monumental sculpture to depict modern slavery and one of the most influential depictions of the slave body.[3]

Into the nineteenth century Tacca's captives inspired replication and influenced reduced-scale bronzes as well as copies in porcelain and majolica.[4] A singularly dramatic late eighteenth-century porcelain figure by the Italian manufactory Doccia demonstrates the currency of the Tacca forms as they were adapted through the centuries (fig. 6).[5] The tension between the captive's anguished expression and emaciated face, and his assertively muscular body acknowledges anxieties about the slave experience that were bold and unusual for the time. Although the Tacca source material depicts Ottoman captives, by the middle of the eighteenth century Doccia's bound Black slave would have reflected the plight of Africans in the Black Atlantic world. Fashioning slaves in porcelain tended to popularize, ornamentalize, and domesticate this epic human drama into diminutive decorative appointments.[6] Yet, although it is unlikely that the Doccia porcelain captive was intended as an antislavery statement, its emotional pull anticipates abolitionist attempts to elicit empathy for the slave through representations of bondage.

By the eighteenth century, as the culture of slavery in the Black Atlantic world expanded, the vanquished captive body had become associated with the New World persona of the Black slave. The historian Robin Blackburn

describes the shifts in the nature of slavery during this period: "Slavery in the New World was not based on an Old World prototype. Its bonds were woven from a variety of materials—ethnic identities, legal codifications, technical resources, economic impulses, and so forth—and all these together comprised something quite new."[7] In the age of race-based Atlantic slavery, Black figures that appeared in European art and material culture were framed by this experience. Black slaves and servants who populated eighteenth-century art were not pictured in chains or restrained, although many wore slave collars that alluded to their bondage. In portraiture, they were fashioned as appointments of luxury and domination playing foil to the white aristocracy. Even though they are pictured in the act of serving, the accoutrements of colonial chattel slavery were distanced or erased in favor of exotic costumes and luxurious settings. Interestingly, shackled Black figures did appear in decorative arts, adorning "blackamoor" stands, candlesticks, and more.[8] However, explicit depictions of the abject slave body were not prevalent in eighteenth-century European painting and sculpture until the development of the visual rhetoric of the abolitionist movement.

IMAGINING ABOLITION

In the introduction to the exhibition catalogue *Art and Emancipation in Jamaica: Isaac Mendes Belisario and His Worlds*, the curators Tim Barringer and Gillian Forrester argue that images played a significant role in the campaign against slavery. They point to icons such as Josiah Wedgwood's antislavery medallion (pl. 10) and James Phillips's *Description of a Slave Ship* (1788), caricatures of decadent planter life, and images of cruelty to the enslaved as all having played a role in dismantling the broad-reaching system of Atlantic slavery.[9] As European sensibilities regarding the moral and religious dilemmas around slavery grew, an alternative framework for the vanquished Black slave body emerged in visual culture—one that drew upon the chained captive but operated to elicit sympathy for the enslaved and called for the abolition of the practice.

Perhaps the most noted image of the slave body in the service of abolition is Wedgwood's medallion, known by its inscription, "Am I not a man and a brother?" The design was originally created as a seal for the Society for Effecting the Abolition of the Slave Trade, of which Wedgwood was a member.[10] Wedgwood, the entrepreneurial potter, fashioned the image of

the kneeling Black slave into a jasperware porcelain medallion or cameo that enjoyed widespread circulation in multiple forms. On a stark white background, the kneeling figure is bound with chains. His hands, rather than restrained behind his back like the captives in Tacca's *I Quattro Mori*, are clasped together in front of his body in a prayerlike gesture. Further diverting from the Tacca precedent, the slave does not resist or contort. Rather, he submissively entreats his captor or his God for freedom.

The figure's kneeling pose provides full exposure of the chain from both wrists to both ankles. This chain is the unmistakable symbol of captivity, the troubling garniture of slavery that links the Old World and New World embodiments of the defeated. Not just a symbol, it is the tool of restraint without which the institution of slavery could not have flourished as it did. The historian James Walvin describes the importance of the chain:

> But above all else, chains were ubiquitous. From the loading of the slave ships at the European and American dockside, to the African coast, in mid-Atlantic, and finally on the plantations of the Americas, chains were inescapable in the world of Atlantic slavery. Yard upon jangling yard of chains were loaded onto every slave ship bound for the African coast, alongside a vicious array of other metal items: handcuffs, leg irons, speculums for forced feeding—right down to the simple, excruciating thumb-screws, used to force confession from potentially rebellious Africans.

Walvin goes on to make a fascinating claim that the necessity of the physical restraints was evidence of the power that Africans could wield collectively.[11] As opposed to the collars that mark the status of enslaved youths in European painting and sculpture, the chains that restrict enslaved adults in European painting, sculpture, and decorative arts import the vicious garniture of slavery into the spaces of luxury aesthetics in order to restrain the perceived menace of the Black body.[12]

Perhaps the frank evocation of the chain had an impact on the response to the Wedgwood image, as the medallion became highly influential in the visual rhetoric of abolition on an international scale. It was adopted by other sculptors and repeated and rehearsed in both quotidian and luxury decorative arts and in print (pls. 11–13). The widespread circulation of the image achieved the goal of evangelizing on behalf of the cause of abolition and undoubtedly contributed to the 1807 abolition of the trade in slaves in the British Empire

and the subsequent abolition of the practice of slavery in 1833. Although the anonymity and passivity of the image have been widely discussed, it is worth repeating that the supplicant Black male is rendered prominently shackled in an atrophied state of servility, completely dependent on white largesse.[13]

HOUDON'S FRAGMENT

The abolition of slavery in the Atlantic world was a rolling phenomenon. The French Republic decreed the slaves in its colonies free in 1794 after the successful slave revolt that had begun in 1791 in Saint-Domingue. That period of abolition was short-lived, as Napoleon Bonaparte reintroduced colonial slavery and the slave trade in 1802.[14] In this era, representing newly freed slave bodies proved to be an ambivalent enterprise, perhaps anticipating the instability of that very freedom. In a pragmatic, if shallow, acknowledgment of this first iteration of abolition in the French colonies, Jean Antoine Houdon, the premier French sculptor of the Enlightenment, repurposed a sculpture fragment of a Black servant woman to represent the liberated.

Houdon's painted plaster head of a Black woman (pl. 19), modeled in about 1781, was refashioned into an emblem of freedom when thirteen years later, in 1794, the artist inscribed the sculpture's base with "Restored to Freedom and Equality by the National Convention 16 Pluviôse, year two of the French Republic, One and Indivisible." In its original state the bust was a study or model for the Black servant woman

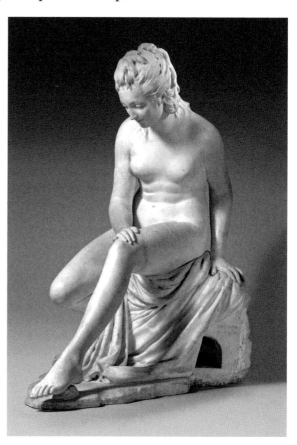

FIG. 7. BATHER (FROM A FOUNTAIN GROUP), MODELED CA. 1781, CARVED 1782
Jean Antoine Houdon (French, 1741–1828). Marble, H. 47 in. (119.4 cm), W. 43 in. (109.2 cm), D. 28 in. (71.1 cm). The Metropolitan Museum of Art, New York, Bequest of Benjamin Altman, 1913 (14.40.673)

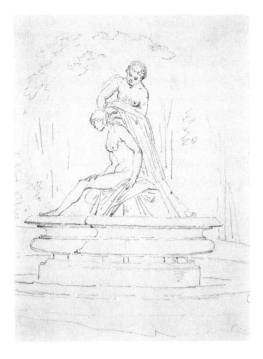

**FIG. 8. STUDY OF A FOUNTAIN
WITH BATHER AND ATTENDANT, 1782–95**
Pierre Antoine Mongin (French, 1761/62-1827).
Graphite on cream laid paper, 5¾ × 4⅜ in.
(14.6 × 11.1 cm). Philbrook Museum of Art, Tulsa,
Gift of Richard P. Townsend in memory of his
grandparents Harry and Joan R. Renek (2011.2)

in Houdon's 1781–82 polychrome fountain *The Bather*, a work destined for Louis Philippe Joseph d'Orléans's English garden at Monceau. The fountain group featured a seated nude in white marble and her Black attendant, made out of lead, who showered water over the back of her mistress from a gilded ewer.[15] The scene reflected the fashion for the white nude and Black servant, a titillating pair that had become a conventional signifier of slavery, sexuality, and exoticism in the eighteenth century. The combination of Black and white, servant and served, often pointed to a Turkish or Moorish bath, or to the interior of a harem. This exemplifies the eighteenth-century propensity to reroute images of slavery through an imagined, often Orientalized space. Houdon's original fountain was partially destroyed in the Revolution. The damaged white marble female was restored and is in the collection of The Metropolitan Museum of Art (fig. 7). Yet the only remaining references for the lead sculpture of the Black woman are the plaster study, a painted terracotta reduction with the commemorative inscription (pl. 20), and a drawing by Pierre Antoine Mongin (fig. 8).[16] They are fragments of a servant freed by Houdon's tepid gesture recognizing the abolition of slavery in France.

The art historian James Smalls has pointed out that Houdon's decision to repurpose the head of the Black servant from *The Bather* and transform her into a symbol of freedom was a political response to the fact that the sculptor had not exhibited sufficient loyalty to the revolutionary cause.[17] This kind of expression of Black freedom, rooted in alterity and the subjugation of Blackness, was emblematic of the larger discourse of antislavery imagery that promoted French abolitionists as the upholders of liberty for a victimized population.[18] Indeed, in aligning with the cause, one could boost one's political profile and moral standing. Even as European artists ostensibly

celebrated freedom and the possibility of equality, the imagery did not adequately represent the radical act of abolition but continued to further tropes of benign servitude, the anonymity of the enslaved, and their dependency on the enslavers to bestow freedom and equality.

AMERICAN EXPRESSIONS

As abolitionism spread across Europe and America, and artists attempted to commemorate emancipation and represent Black liberty, the chained figure that was essential to the aesthetic of the vanquished and to abolitionist tropes remained central to visualizing freedom. As the historian and literary scholar Saidiya Hartman has eloquently stated, "The texture of freedom is laden with the vestiges of slavery. . . ."[19] I see chains as the symbolic vestige of slavery that literally linked Black people to an essentialized state of servitude and that would anticipate their subjugation into an uncertain future. The initiation of American abolition did not occur until two years into the devastation of the Civil War. On January 1, 1863, the Emancipation Proclamation freeing America's enslaved population came into effect. That same year, the American sculptor John Quincy Adams Ward exhibited the plaster statuette *The Freedman* at the National Academy of Design in New York.[20] Remarkably, the bronze version of *The Freedman* was the first representation of a fully realized Black man in that medium in American art (pl. 22).[21] The powerful statuette depicts a Black man seated on a tree stump, nude save for a loincloth. Looking upward, he places one hand on the stump, readying himself to stand. The man's chains are broken: he holds several links in his right hand while his left hand remains shackled. The moniker "freedman" and the broken chains are the ultimate indicators of his emancipation yet keep him tethered to enslavement. In 1916 the Black historian Freeman Murray described the paradox of Ward's sculpture with clarity: "The freeman's shackles are broken it is true, but still he is partially fettered; still un-clothed with the rights and prerogatives which freedom is supposed to connote—a 'freedman' but not a free-man."[22]

The chained nude male in a loincloth was a leitmotif of the enslaved in European art that was notoriously articulated in the Tacca monument and its progeny. He was also the central character in the "Am I not a man and a brother?" iconography that enjoyed international circulation in the currents of nineteenth-century abolitionist campaigns. Here, Ward moves beyond

the flat, schematized symbol of the Wedgwood design in favor of the three-dimensional, individualized rendering that recalls the spirit of the Tacca slaves. The art historian Steven F. Ostrow has asserted that Ward's *Freedman* is the most eloquent successor and counterpart to Tacca's *Moors* and claims that both sculptors subverted stereotypical imagery and cultural attitudes toward Black people.[23] Although Ward's rendering of the figure's body language does not reflect the passion and struggle of Tacca's *Moors*, the artist does reveal human emotion in his upward gaze. The warm brown hues of Ward's bronze version approximate natural tones of Black skin in ways that the undifferentiated, nonnaturalistic black of Houdon's head of a Black woman and the Wedgwood medallion do not. Ward's sensitive rendering of the emergence of the enslaved Black man met with acclaim. The art historian Kirk Savage notes that the sculpture's classicism, combined with the contemporary subject of Black emancipation, seemed to promise a new sculptural order that could accommodate a classicized Black subject.[24] Yet the liminality of the work—falling between slavery and freedom—ultimately renders it inconclusive. In fact, the 1863 Emancipation Proclamation that this work commemorates was not the ultimate act of abolition, as it was limited in its scope and dependent on an uncertain Union victory. Meanwhile, the Civil War still raged on, and slavery would not be abolished until the ratification, two years later, of the Thirteenth Amendment to the US Constitution. This uncertainty permeates Ward's *Freedman*. As Savage states, "*The Freedman* remains somewhere between the two sculptural poles of abjection and triumph."[25]

The entry of Edmonia Lewis, a mixed-race African American and Native American woman, into the visual discourse surrounding emancipation in Western art was a seismic shift indeed.[26] In nineteenth-century America, professional Black artists were few and far between. Enslavement and lack of training and opportunity had created an environment that largely denied Black participation in the so-called fine arts. The costs and training associated with sculpture in particular left little room for the socially marginalized to engage in it. In spite of such obstacles, Lewis proved an exception and forged a successful career as a sculptor. She even moved to Rome in 1865 to study and live in an American expatriate colony of white male and female sculptors.

Lewis was supported by a network of abolitionist patrons and gravitated toward subjects that demonstrated her solidarity with antislavery causes and individuals. *Forever Free*, Lewis's tribute to the emancipated in America,

was completed in Rome in 1867 (pl. 21). The title, a quotation from the Emancipation Proclamation, was inscribed on the base. The circumstances surrounding the sculpture vary greatly from those of the other works considered in this book. Created by a woman of color to commemorate emancipation and executed after the Thirteenth Amendment unequivocally eradicated slavery in the United States, it was dedicated in a public ceremony to the Reverend Leonard A. Grimes, a prominent Black abolitionist minister. *Forever Free* is an early and important case of Black self-representation and was fueled by a network of Black activist stakeholders including Lewis, Grimes, and others who were vested in the struggle for freedom in profound ways.[27]

The art historian Kirsten Pai Buick observes that *Forever Free* represents a "reconstructed image of the African American family after slavery and becomes a subtle commentary on the hopes for the newly liberated population."[28] Indeed, it features a standing male and a kneeling woman, a family unit, giving thanks for their liberation. The man holds up broken chains in a gesture of strength and empowerment, implying that *he* broke them. His agency is even more apparent when compared to that of Ward's *Freedman*, who remains seated. Like that of Ward's bronze, his muscular body suggests the labor and supposed brute physicality of the Black male. Ward assuages any suggestion of aggression, however, with his seated, contemplative figure whose liminal status remains nonthreatening. However, Lewis's standing man with head held high repudiates the submissive male slave of abolitionist visual culture. Yet the classicizing style and white marble medium drain Lewis's figure of his skin color, equivocating and mediating the potentially transgressive subject of the muscular, assertive, free, and chromatically Black male.[29]

The female figure in Lewis's *Forever Free* has garnered much attention due to her subjugated echo of the "Am I not a man and a brother?" genuflection as well as to her racial indeterminacy.[30] Yet as Buick points out, the group adheres to typical Victorian gender ideals, and the woman's posture of submission and piety show her to be virtuous.[31] Still, questions do linger as to why Lewis made her freedwoman racially mixed, potentially alluding to the taboo subject of the sexual domination of enslaved women by white men. Why did Lewis choose not to depict an identifiably Black woman? In fact, the sculptural vocabulary for making Black women visible in nineteenth-century neoclassical sculpture was limited at best. The art historian

Charmaine A. Nelson points out that the difficulties that sculptors had in racing the Black female body related to the belief that women of African descent were sexually degenerate, compounded by the irreconcilability of Blackness and beauty.[32] Lewis opted for European standards of beauty and a traditional family unit to characterize her freedman and freedwoman. In light of the impossibilities of reanimating slavery and freedom, Lewis's insistence on beauty and family in *Forever Free* might respond to Hartman's question, "Can beauty provide an antidote to dishonor, and love a way to 'exhume buried cries' and reanimate the dead?"[33]

In spite of their different trajectories, Ward, Lewis, and Jean-Baptiste Carpeaux came to a fascinating crossroads in 1867 at the Universal Exhibition in Paris. Just two years after the United States ratified the Thirteenth Amendment, both Lewis and Carpeaux visited the Universal Exhibition and subsequently completed their sculptures dedicated to the question of slavery and abolition—inarguably one of the most important social issues of the nineteenth century.[34] Ward's *Freedman* was displayed at the Universal Exhibition, where it was almost certainly encountered by Lewis and Carpeaux.[35] Could Ward's moving depiction of *The Freedman* have influenced Lewis or Carpeaux? As the first sculpture of a Black man in American art, it was likely to have made an impression. In addition to Ward's meditation on the possibilities of freedom were other works by American artists, such as Eastman Johnson's *Negro Life at the South* (1859) and Edwin White's *Thoughts of the Future (Thoughts of Liberia, Emancipation)* (1861), that spoke to sentimental notions of Black lives under enslavement and to the dream of freedom.[36] Although these works would have been received very differently by Lewis and Carpeaux, they expand an international dialogue about slavery and freedom at work in the aftermath of the American Civil War and abolition.

The triumphs as well as the inadequacies and shortcomings that plague these international conceptions of emancipation are all the more apparent under our twenty-first-century scrutiny. Euro-American standards of beauty as well as the processes, themes, styles, and technologies of art-making left little room for accurately representing the abjection of slavery and its aftermath. Yet in their time, the works discussed above revealed bold and moving attempts to depict the fraught transition of enslaved Black people into the social fabric of freedom.

POSTSCRIPT

In 1867, while Edmonia Lewis celebrated emancipation by sculpting *Forever Free* with her own hands in her Rome studio, another Black woman was *being* sculpted while performing slavery in Carpeaux's Paris studio. The as yet unidentified Black model posed for numerous studies for Carpeaux's Fountain of the Observatory, a major commission for the city of Paris featuring allegories of the four continents (see fig. 1). In addition to representing Africa in the fountain, she modeled for a new composition depicting a bound captive. A terracotta sketch by Carpeaux from about 1867 of this model, shown kneeling (pl. 8), recalls the dramatic contortions characteristic of the sculptural tradition of the vanquished discussed above. In the end, Carpeaux did not realize the crouching figure but settled on the striking and disturbing bust in which the rope-bound model portrays a struggling, enslaved Black woman. Modeled in 1868, the work known initially as *Négresse* is now commonly referred to as *Why Born Enslaved!* after the inscription he added to its socle.

While questioning the state of slavery, Carpeaux's bust problematically eroticizes the bound woman, who is in fact not liberated but remains captive. However, her naturalistic features and evocatively pained expression speak to conditions of slavery in ways that Lewis's racially indeterminate, grateful freedwoman elide. Carpeaux's figure is the embodiment of contradictions. Born vanquished, she has been patently and gratuitously sexualized, yet her emerging agency through resistance is palpable. Ironically, Carpeaux captured both the physiognomy and the defiance of the Black model, while Lewis could not, or dared not. Taking on the fragile theme of Black freedom at this moment would lead to divergent ends for both women. Lewis went on to become the most important Black American sculptor of the nineteenth century; *Forever Free* would be her most significant work. Carpeaux's Black model remained anonymous but served as the face for a problematic sculpture that has become one of the most important and influential images of an enslaved person in Western art. Both Lewis and the anonymous model were Black women dispersed in the currents of the Black Atlantic world and in this moment came to embody the complexities of slavery, abolition, and representation in nineteenth-century art.

Iris Moon

WHITE FRAGILITY

ABOLITIONIST PORCELAIN IN REVOLUTIONARY FRANCE

This essay explores three abolitionist works made at the Sèvres porcelain manufactory in revolutionary France in order to draw attention to the complicated geopolitical realities that shaped the purportedly universalizing, humanitarian message of abolition across the Atlantic. Scholarly attention has tended to focus on the ceramic antislavery medallion (pl. 10) made by Josiah Wedgwood for the London-based abolitionist movement without taking into consideration the ways in which the medium of porcelain was briefly mobilized in France in the name of racial equality. The three works made in biscuit, an unglazed porcelain, under the supervision of the sculptor Louis Simon Boizot at Sèvres that are explored here show how the revolutionary tradition that began in 1789 redeployed an ancien régime material associated with sweetness and pleasure to new ideological ends. Intended as abstract allegories advocating or celebrating racial equality and freedom, they nonetheless called to mind the violence through which the enslaved freed themselves from their oppressors in the French colony of Saint-Domingue between 1791 and 1804. This earlier history of revolutionary violence haunts all later figurations of Black emancipation, including Jean-Baptiste Carpeaux's sculpture *Why Born Enslaved!* (pl. 1).

In the spring of 1789, the Sèvres manufactory made a biscuit medallion with the image of a kneeling enslaved African man in chains (fig. 9). Executed under the direction of Boizot, then head of the Sèvres sculpture workshop, the figure is turned to the right in a three-quarter profile bas-relief and accompanied by the words, "Ne suis-je pas un homme? Un frère?" (Am I not a man? A brother?). The inscription and the pose of the figure imitate the

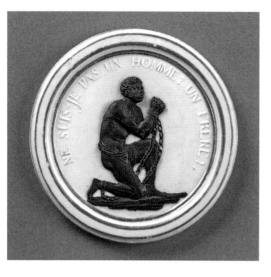

FIG. 9. ANTISLAVERY MEDALLION, 1789
Sèvres Manufactory (French, 1756–present).
Hard-paste porcelain biscuit with gilding, 3⅜ × ¼ in.
(8.6 × 0.6 cm). Princeton University Art Museum,
Trumbull-Prime Collection (y931)

medallion that the English entrepreneur Wedgwood had produced two years earlier on behalf of the Society for Effecting the Abolition of the Slave Trade.[1] However, the Sèvres medallion is not a direct copy: it has a round format and is larger in scale, and its figure has been reworked. In a curious form of punctuation, a period has been added after the final question mark. It is the only known example of porcelain made at the royal manufactory that incorporated an unglazed black ceramic body set against biscuit, the durable, white clay with a matte appearance and texture that Sèvres had perfected first in imitation of sugar and later as a sculptural medium in its own right.

Neither widely circulated nor celebrated, the Sèvres medallion's aesthetic and commercial failure directly contrasted with the success of the British version, which was enthusiastically donned by fashionable women and admired by abolitionist sympathizers such as Benjamin Franklin.[2] The French government immediately recognized its insurrectionary potential. In April 1789, after eighteen examples had already been fired, Charles Claude de Flahaut, comte d'Angiviller, the last director of the Bâtiments du Roi, who oversaw Sèvres, abruptly halted its production.[3] A letter of April 8, 1789, addressed to Antoine Régnier, the director of the manufactory, expressed d'Angiviller's surprise that

> someone had executed at the Manufactory medallions in a white ground representing an enchained and kneeling black man, with the words, "Am I not a man and a brother?" Without a doubt, the motif is good, it is dictated by humanity, but such medallions taken to the colonies could, seen by the blacks, stir them to action. Monsieur le Comte has tasked me with underscoring to you that it is expressly forbidden to go further with this object and if the medallion is already made, to absolutely not deliver it to anyone.[4]

D'Angiviller sought to maintain strict surveillance over the royal manufac-tories, viewing porcelain as a vital instrument in bolstering the fragile image of monarchy. What is most surprising is the missive's expression of fear: d'Angiviller imagines the biscuit medallion not in the hands of paternalistic white Christian abolitionists, often assumed to be the sole audience for the Wedgwood medallion, but instead cupped in the palms of the enslaved Black viewers who had made France's profits and tropical luxuries in the colonies possible. The emphatic contrast that d'Angiviller establishes between the "white ground" of the unglazed porcelain that uncharacteristically supports a "black man" suggests that he saw the object in starkly racialized terms. What made white biscuit seen by the enslaved appear so incendiary, with the potential to ignite Black action? These anxieties certainly lend credence to the historian Julius S. Scott's description of a "masterless Caribbean," an archipelago of opposition where "local rulers were no more able to control the rapid spread of information than they were able to control the ships or the masterless people with which this information traveled."[5] For d'Angiviller, the Black figure on the fragile white biscuit called forth the disquieting image of the colonies in revolt.

The imagined Black audience of the Sèvres medallion, as suggested by d'Angiviller's letter, allows us to contemplate the ways that the specter of colonial violence haunted and "stained" the innocuous sweetness of biscuit. D'Angiviller undoubtedly had Saint-Domingue, France's largest and most important colonial territory in the Americas, in mind. In August 1791, slave revolts would spread across Saint-Domingue as the French fought to combat Spanish and British troops who were working with armies of the formerly enslaved led by General Toussaint Louverture. As the situation escalated, France fought to regain control by offering emancipation to the enslaved through the passage of the Law of 16 Pluviôse, Year II (February 4, 1794), which abolished slavery in France and the colonies. It was in this charged context that Boizot created two biscuit sculptures commemorating the abolition of slavery, the only depictions of Black figures other than the medallion to be rendered in biscuit by Sèvres. Boizot's biscuits did not find a wide audience.[6] Their aesthetic and commercial failures as works could be tied to a fundamental problem of the Revolution: the ephemeral nature of racial equality. Less than a decade after Boizot's sculptures commemorated the Law of 16 Pluviôse, Napoleon Bonaparte sought to reinstate slavery, which he achieved on May 20, 1802.[7]

"The slave-trade and slavery were the economic basis of the French Revolution."[8] So wrote the historian C. L. R. James in *The Black Jacobins*, the riveting story of how the revolution in the French colony of Saint-Domingue, not the one in France, was "the first revolution in the third world" that gave birth to a myriad of postcolonial futures.[9] For politicians in the Paris of 1789, economic interests in the island's lucrative plantations played a determining role in bourgeois politics, fomenting the internecine racial violence that ultimately led the formerly enslaved to declare Haiti's independence from France in 1804.[10] A century earlier, France had established plantations dependent on enslaved African labor in Guadeloupe, Martinique, Saint-Domingue, and Guiana that supplied the metropole with tobacco, cocoa, coffee, indigo, cochineal, and, most importantly, sugar. By the late eighteenth century, Saint-Domingue supplied nearly half of all the sugar consumed by Europe and the Americas.[11]

The lofty moral claims adopted by the transatlantic abolitionist movement tend to mask the stark differences between the French and British historical contexts. In France, abolitionist art was deeply mired in the trenchant politics of a country on the verge of a revolution. The commercial interests of powerful merchants and planters, along with a lack of the support found in England from dissenting religious groups, made the abolitionist activities of the Société des Amis des Noirs (Society of the Friends of the Blacks) particularly challenging in the French context. Established on February 19, 1788, by Jacques Pierre Brissot de Warville, the group maintained an active connection with abolitionists in London; Honoré Gabriel Riqueti, comte de Mirabeau, and Thomas Clarkson, founder of the Society for Effecting the Abolition of the Slave Trade, were particularly active correspondents. Due to censorship laws, the Société was forced to publish translations of English pamphlets rather than issue their own reports as the London-based abolitionists did. Moreover, the Société was reformist in nature, hoping only for a more gradual "softening" and humane treatment of the enslaved, rather than for a complete end to the institution of slavery and total emancipation, goals that would only be achieved in France in 1848.[12] Few of the members of the Société could have imagined the chain of events that would occur in France during the summer of 1789, which quickly escalated from the extraordinary calling of the Estates-General in May to the storming of the Bastille on July 14. The Revolution, in any case, turned in the abolitionists' favor after the Declaration of the Rights of Man on

August 26, 1789, which famously proclaimed that "all men are born free and remain free in equal rights." Nonetheless, powerful vested interests continued to oppose abolition. When Brissot gained power in the Legislative Assembly, he and members of the Société became silent on the colonial question, for the Assembly's bourgeois leaders would "not touch property, and the slaves were property."[13] Neither Mirabeau nor Brissot in fact lived to see the passage of the law abolishing slavery under the Jacobin faction in 1794.[14]

The Société des Amis des Noirs' adoption on its political pamphlets of the antislavery medallion used by London organizers undoubtedly spurred Sèvres to manufacture its own version, though we do not know for sure if Boizot directly oversaw its production. Although the level of Boizot's involvement in the radical politics that made abolition possible is unclear, at the very least we know that his work at Sèvres responded to the new aesthetic ideals of the Revolution. In spite of his training in sculpture at the royal academy during the ancien régime and his employment at Sèvres since 1773, Boizot eagerly participated in newly formed patriotic arts clubs. He briefly left the manufactory in the fall of 1792 due to difficulties over pay but returned at the height of the Terror in 1793 when Dominique Garat, the interior minister, reinstated him to his old post, where he remained until 1800.[15] Failing to win any of the major sculptural prizes in the public competitions of Year II, Boizot nonetheless proved a prolific supplier of designs for revolutionary prints, including profile portraits of the figures who would appear in his biscuit sculpture *Les noirs libres / La liberté des nègres* (*The Free Blacks / The Negroes' Freedom*; pls. 17, 18).[16] His blunt renderings led the print historian Jules Renouvier to declare him "the most fecund and crudest inventor and designer of allegorical figures relating to the new spirit."[17] Evidently the sculptor had no issues with turning from modeling biscuits of Louis XVI and Marie Antoinette to allegorical figures of Reason and Force.[18] As chief sculptor at Sèvres, he provided models and oversaw the production of medallions, sculptural groups, and busts that catered to the radical political ideology espoused by the revolutionary government, which had assumed control over the former royal porcelain manufactory. Revolutionary heroes such as Jean Paul Marat; Louis Michel le Peletier, marquis de Saint-Fargeau; and Mirabeau appeared in the kilns of Sèvres, replacing the Great Men (Grands Hommes) biscuit sculptures that had been fired as part of d'Angiviller's last project before he went into exile in 1791, never to return to France.[19]

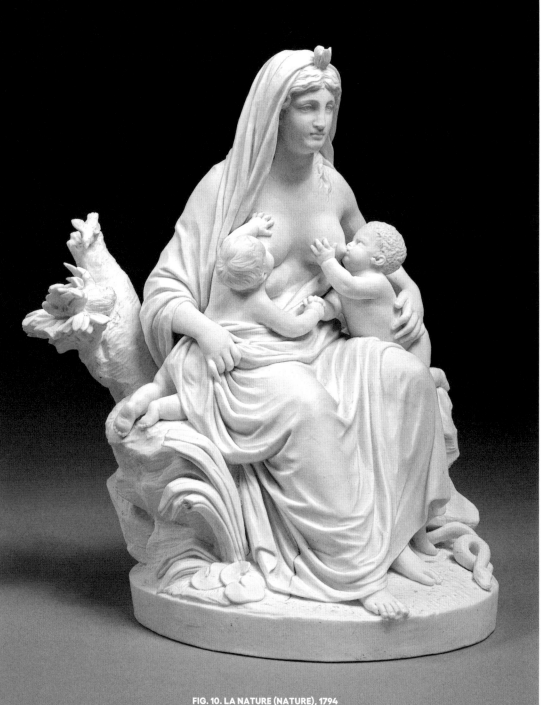

FIG. 10. LA NATURE (NATURE), 1794
Sèvres Manufactory (French, 1756-present), modeled by Louis Simon Boizot (French, 1743-1809).
Hard-paste porcelain, H. 9⅝ in. (24.5 cm), W. 8¼ in. (21 cm), D. 7⅛ in. (18 cm).
Victoria and Albert Museum, London (C.361-2009)

Far from starting out as a heroic sculptural medium, biscuit had rather modest origins in the ancien régime as a form of decorative sculpture for the tables of wealthy French consumers, whose enjoyment of global pleasures depended upon the transatlantic slave trade. The unglazed ceramic was produced as early as 1752, when the manufactory began selling models based on works of the painter François Boucher that mimicked molded sugar sculptures for the table.[20] The appearance of these porcelain sculptures, imitating sugar, coincided with the rise of sugar as a readily available commodity for French consumers, produced on colonial plantations in Saint-Domingue and Martinique that fed the voracious demand through the labor of enslaved Africans whose own lives were considered as nothing more than "fungible commodities."[21] European porcelain manufactories that catered to the courtly elite used Black figures to ornament objects meant to hold sugar and sweets. Prior to the creation of Wedgwood's medallion, gestures of Black servitude, far from being troubling, were merely accompaniments to the pleasures of luxury consumption.[22]

Although revolutionaries otherwise castigated the French court and aristocracy for their love of luxury, viewed as a sign of political corruption, the consumption of colonial commodities, especially sugar, continued unabated. Sugar and coffee had become such necessary staples of the French diet that Maximilien Robespierre (who was addicted to both) excluded them from the list of price-regulated foodstuffs issued in accordance with the Law of the General Maximum, arguing that the French were simply too dependent on both to survive without their unregulated consumption.[23] Notwithstanding Robespierre's and the Jacobins' principled support for abolition, metropolitan Paris's addiction to coffee and sugar depended upon the continuation of the slave trade.

Even as the colonies supplied the material sustenance of coffee and sugar to radicals burning the midnight oil in order to write laws and publish pamphlets, Sèvres replaced the busts of the king and the queen, who were guillotined in 1793, with allegories of Mother Nature replenishing and regenerating the nation. She appears in Boizot's *La nature* (*Nature*), recorded in the kiln registers in June 1794, four months after the passage of the law abolishing slavery. A female allegory of nature seated upon rocks stares into the distance as a European and an African child nurse at each breast (fig. 10). At her bare feet is a coiled serpent, a symbol of the aristocracy. Boizot probably based the

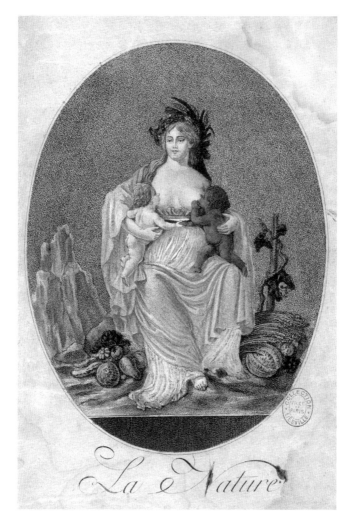

FIG. 11. LA NATURE (NATURE), 1794
Probably after Louis Simon Boizot (French, 1743-1809), engraved by
Duchemin (French, active 18th century). Stipple engraving, 6⅜ × 5 in.
(16.2 × 12.7 cm). Musée Carnavalet-Histoire de Paris (G.23472)

model on his earlier color print, which articulates the difference in skin tones
of the two infants who are nursed by Mother Nature on an equal footing
(fig. 11). Boizot's porcelain exploited the gleaming whiteness of biscuit to
heighten its associations with both the nourishment of Mother Nature and
the notion of purity that was espoused by radical Jacobins as a crucial part of
the ideology of the Terror. About ten examples of the sculpture were issued
between June 20 and September 7, 1794. A single example was documented

as being sold, on June 27, 1795, to citoyen Jean Barthélémy Le Couteulx de Canteleu, an aristocratic politician and banker from Rouen, less than a year after he had been released from prison during the Terror.[24] This suggests that there were indeed few buyers for this unusual subject, in contrast to Boizot's more "trivial" genre scenes made by the manufactory such as *Insomnia, or the Flea Hunter*.[25]

La nature was produced during the same month that the Festival of the Supreme Being marked Robespierre's consolidation of power, shortly before he was denounced and guillotined. The abolition of slavery had directly depended upon the rise of the radical faction in Paris and its policies.[26] Thus, soon after the fall of Robespierre and the denunciation of terrorists during the Thermidorian Reaction, attempts were already being made to overturn the antislavery law. Given the strong ties of the allegory with radical Jacobin politics, one pauses to consider why the banker and aristocrat Canteleu, who would later enjoy considerable success as a financial administrator under Napoleon, purchased such a work. After all, a similar allegorical figure had earlier featured at the Festival of Unity and Indivisibility, an event orchestrated by Jacques Louis David in 1793 to mark the first anniversary of the founding of the Republic. Revolutionary men quenched their thirst for fraternity before the Fountain of Regeneration, a plaster statue of the Egyptian goddess Hathor, whose breasts provided equal nourishment for all (fig. 12). Boizot had earlier participated in what the historian Madelyn Gutwirth has described as the "politics of the breast," famously designing a cup in the shape of a breast for Marie Antoinette's dairy at Rambouillet in 1787, at a time when breastfeeding had become a popular topic of public debate following Rousseau's calls for natural forms of child-rearing (fig. 13). Although the cup may

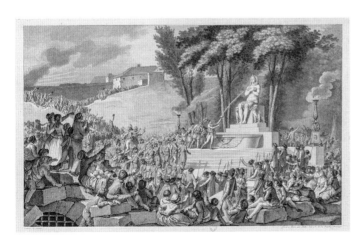

FIG. 12. FOUNTAIN OF REGENERATION, 1796
Isidore Stanislas Helman (French, 1743-1806/09). Engraving and etching, 12½ × 17¾ in. (31.6 × 45 cm). Bibliothèque Nationale de France, Paris, Département des Estampes et Photographie (RESERVE FOL-QB-201 [132])

have contained cow's milk, the form and naturalistic glazing of the vessel would make it appear as if its contents came directly from the human breast. In many ways, the earlier Sèvres Breast Bowl forms a direct contrast with the sculpture made by Boizot. Whereas his print had pictured Mother Nature in human form, the biscuit sculpture transformed her into the ancient, monstrous, multiple-breasted figure of Diana of Ephesus.[27] Maternal figures remained unsettling within the masculine discourse of revolutionary politics. As Gutwirth explains, "Overthrow of the French monarch called up a more sentient icon as substitute for the inadequate father: the body of a kindly mother, ultimately too disbelieved in to be viable, was nevertheless proposed, for a time, as a figure capable of conveying ideas of clemency and unity."[28]

Paternalism, rather than a maternal nurturing, seems implicitly to structure the reading of *Les noirs libres*, recorded in the Sèvres firing books on September 7, 1794 (pl. 16). By the time the sculpture was issued later that month, the political atmosphere had changed considerably from just a few months earlier, when *La nature* had appeared. Boizot chose to depict the children of equality as "grown-up": a seated adolescent African boy and girl wearing revolutionary attributes are accompanied by the phrase, allegedly written in Petit-Nègre (putatively a simplified form of French), "Moi libre aussi" (Me also free).[29] The girl wears a headwrap reminiscent of the tignon worn by African and Creole women in the colonies and a large necklace in the shape of a level, a revolutionary symbol of equality. The boy is shown in classicizing drapery and points to his Phrygian bonnet as the symbol of his liberty. We do not know if Boizot based the figures on real individuals, but a child was among the deputation of citizens of color from Saint-Domingue who had visited the Jacobin club in June 1793 to plead for equality.[30] Fired between September 7, 1794, and February 17, 1796, examples were delivered to the government on February 20,

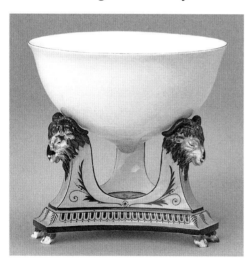

FIG. 13. BREAST BOWL, 1787
Sèvres Manufactory (French, 1756-present),
designed by Louis Simon Boizot (French, 1743-1809)
and Jean Jacques Lagrenée (French, 1739-1821).
Soft- and hard-paste porcelain with enamel,
H. 4⅞ in. (12.5 cm), W. 4¾ (12.2 cm), D. 5¼ in.
(13.3 cm). Cité de la Céramique, Sèvres and
Limoges (MNC 23399)

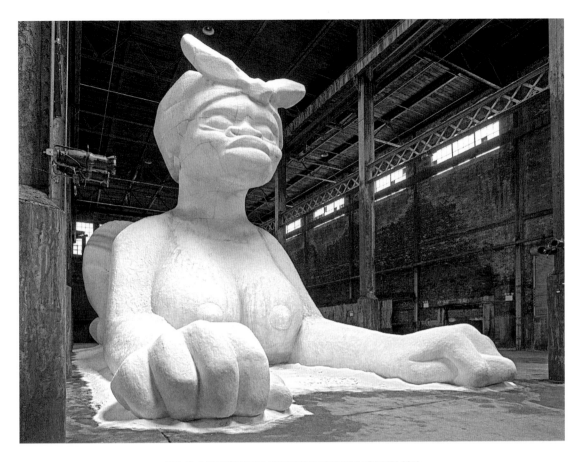

FIG. 14. A SUBTLETY, OR THE MARVELOUS SUGAR BABY, 2014

an Homage to the unpaid and overworked Artisans who have refined our Sweet tastes from the cane fields to the Kitchens of the New World on the Occasion of the demolition of the Domino Sugar Refining Plant.
Kara Walker (American, b. 1969). Polystyrene foam, sugar, H. 35½ ft. (10.8 m), W. 26 ft. (79 m), D. 75½ ft. (23 m). Domino Sugar Refinery, A project of Creative Time, Brooklyn, NY, 2014

1796. The famed abolitionist Victor Schoelcher, whose father had headed a successful porcelain manufactory in Paris, later purchased an example to commemorate the definitive end of slavery in France and its colonies on April 27, 1848, during the Second Republic.[31]

Infantilized, bleached, and turned into petrified imitations of sugar, these two figures of "liberty" feel small. The political dimensions of their diminutive scale become more obvious when one reads these figures against the monumental sugar sphinx constructed by Kara Walker in *A Subtlety, or the Marvelous Sugar Baby*, a figure of revenge come to remind us that we still live paralyzed in the time of slavery's racial terror (fig. 14). The biscuit

figures can be seen to rehearse the same paternalist rhetoric of the Wedgwood medallion, which spawned an indelible repertoire of kneeling, captive figures in an array of media that made it impossible to picture the liberation of Blackness without seeing simultaneous scenes of subjection.[32] It haunts, for example, in hallucinogenic form a drawing by Nicolas André Monsiaux (fig. 15). Ostensibly a heroic composition mimicking David's *Tennis Court Oath, June 20, 1789*, the drawing, possibly a preparatory sketch for a painting, fantasizes the colonized and the enslaved on bended knee imploring the Convention to abolish slavery.[33] Rather than picturing equality, the image is, as the art historian Anne Lafont has pointed out, "decidedly emblematic of the paternalist option, charitable, deferential to the abolitionist cause, of which the project was compassion for infantile and victimized populations, more so than equality (imperceptible in the entire image), leaving no place for the unleashing of rage [*déchaînement*] in the proper sense."[34]

In revolutionary France, fragile emancipation proved impossible to commemorate without the accompanying images of dissent, revolt, and decolonization. Although the figures of *Les noirs libres* are seated rather than kneeling, there is something deeply perverse in the decision to use biscuit, virtually synonymous with the aesthetic tyranny of whiteness in the eighteenth century, to figure the freedom of Black people in sculptural form. Nonetheless, beyond the common tropes of paternalist white subjugation that shaped the abolitionist discourse of the past, might it be possible to see the whiteness of Boizot's biscuits in another way: as embodying the double-sided potential for violence, used by the colonizers to subjugate enslaved Africans with racial terror but also wielded by the leaders of the Haitian Revolution to claim independence?[35] Indeed, to return to d'Angiviller's letter, biscuit figurations of Blackness, already haunted by the specter

FIG. 15. 16 PLUVIÔSE YEAR II: THE ABOLITION OF SLAVERY PROCLAIMED AT THE CONVENTION, AFTER 1795
Nicolas André Monsiaux (French, 1754/55–1837). Graphite, wash, and gouache, 10¼ × 13⅛ in. (26.1 × 33.2 cm). Musée Carnavalet-Histoire de Paris (D.6008)

FIG. 16. DESSALINES RIPPING THE WHITE FROM THE FLAG, 1995
Madsen Mompremier (Haitian, b. 1952).
Oil on canvas, 30⅜ × 36 in. (77.2 × 91.4 cm).
Fowler Museum at UCLA, Los Angeles, Purchase (X95.22.5)

of violence, had the potential to provoke action. We can imagine how this medium of white fragility, no longer about an untouched innocence, became inextricably bound not only to the language of colonial violence and the realities of enslavement, but also to the powers of negation. For after all, Jean Jacques Dessalines, leader of the Haitian Revolution, slashed the white stripe out of the blue, white, and red of the French Republican flag, as he anticipated establishing a newly independent nation, on May 18, 1803. In the contemporary artist Madsen Mompremier's reimagining of this moment (fig. 16), not only has the white been torn from Haiti's new identity, but the breasts formerly representing the fecundity of Mother Nature have been dismembered and grafted onto a tree with exposed roots that bears fruit.

Elyse Nelson

SCULPTING ABOUT SLAVERY IN THE SECOND EMPIRE

Jean-Baptiste Carpeaux's *Why Born Enslaved!* holds a prominent place in the canon of European art. As perhaps the best-known nineteenth-century representation of an enslaved woman of African descent sculpted fully in the round, the bust has been discussed in terms of the artist's virtuosic portrayal of his marginalized subject; his straddling of classical ideals, Romantic exuberance, and ethnographic realism; and the presumed antislavery sentiments that seemingly inspired the work's conception. Until recently, however, what has remained missing from its interpretation is a socially engaged art history—one that accounts for issues of race, gender, and empire, and the power dynamics that play out when a white male sculptor produces a bust of a woman of African descent denuded and bound by rope for a European audience's viewing pleasure.[1] The art historians James Smalls, Hugh Honour, and Denise Murrell have begun to address this lacuna by considering the implications of *Why Born Enslaved!*'s creation and popular success in the context of broader studies of the post-emancipation period.[2] In this essay, I consider especially the politics of race and imperial patronage in order to reframe an understanding of the work.

Unlike Charles-Henri-Joseph Cordier, who left behind memoirs with carefully crafted statements linking his ethnographic busts to antislavery discourse, Carpeaux during his brief but meteoric career professed no personal sentiments regarding slavery's abolition in the French Atlantic; nor did

he position his creative practice in line with the progressive social causes espoused by the short-lived revolutionary government of the Second Republic (1848–52).[3] On the contrary, the facts of Carpeaux's career underscore his clear investments in, on the one hand, catering to the mainstream values and tastes of the Second Empire (1852–70) bourgeoisie and, on the other, securing his reputation as the favorite sculptor of Emperor Napoléon III and Empress Eugénie. Carpeaux's *Why Born Enslaved!* was first and foremost a product of these investments.

FIG. 17. AMERICAN SLAVE (A DAUGHTER OF EVE—A SCENE ON THE SHORE OF THE ATLANTIC), AFTER CA. 1862
Cast by Elkington and Company (British, 1861-1963), after original plaster model of ca. 1853 by John Bell (British, 1811-1895). Bronze patinated copper electrotype, H. 62 in. (157.5 cm). Present location unknown

Soon after *Why Born Enslaved!* debuted before the viewing public at the 1869 Paris Salon, a version of the bust was purchased for Empress Eugénie's apartments at the Château de Saint-Cloud (fig. 3). While it is thought that the sculpture was acquired using the emperor's personal allowances, by all accounts Napoléon III did not have a particular affinity for the arts and left most decisions regarding imperial commissions and the acquisition of paintings and sculptures to his trusted advisors.[4] Eugénie, on the other hand, was known to have a keen interest in the fine and decorative arts.[5] She chose *Why Born Enslaved!* from the vast array of artworks on view at the Salon during a visit on June 12, and was sufficiently invested in its appearance to have the marble that was delivered to Saint-Cloud exchanged for the bronze version she had seen.[6] The precise motivations behind the acquisition are undocumented; however, the empress probably understood the sculpture as contemporary critics did, as a work that depicts and condemns the conditions of slavery. One such critic, Théophile Gautier, vividly described the bust as a "grim protest" and "piece of rare vigor, where ethnographic exactitude is dramatized through a profound sense of suffering."[7] In laying emphasis on the immediacy and emotional tenor of the piece, Gautier underlines how Carpeaux departed from the conventions of neoclassical statuary to depict a sentient subject in a dramatic state of active resistance.

Indeed, its evocation of a Black woman's defiant struggle made Carpeaux's bust unusual for its time.[8] *Why Born*

Enslaved! found precedent to some degree in John Bell's *American Slave,* a full-length bronze statue of a Black woman bearing the burden of her chains with a downcast gaze and weary expression (fig. 17).[9] However, in nineteenth-century France, where three-dimensional representations of enslaved and captive figures were largely confined to decorative caryatids or ornamental tableware, independent sculptures depicting the expressive likenesses of either enslaved or free Black figures were rare. What predominated instead were fashionable ethnographic portrayals of subjects of African descent, figured as racialized types and notably devoid of feeling. Cordier's naturalistic busts, for instance, featured ennobled Black figures, often draped in elaborate costumes, wearing tranquil half-smiles (pls. 29, 30, 32). Frédéric-Auguste Bartholdi likewise conceived of a personification of Africa for the base of a fountain in Colmar, France, as a muscular male figure, reclined and dispassionate, in the manner of a classical river god (pl. 25, see fig. 22). Conversely, the woman depicted in *Why Born Enslaved!* grimaces, her brow furrowed and her gaze defiant. Her twisting pose, recalling that of Michelangelo's *Rebellious Slave* (fig. 18), a famous Renaissance marble, registers a painful struggle as she endeavors to escape the ropes pulled taut around her flesh. The words on the socle beneath the figure give voice to her anguish: "Pourquoi naître esclave!"

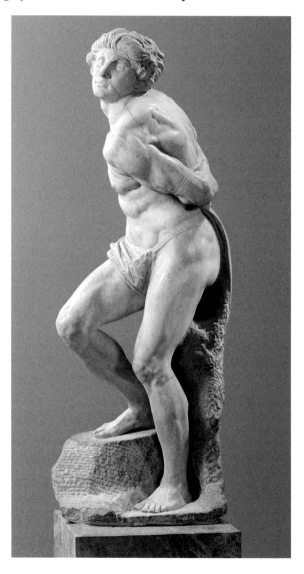

FIG. 18. REBELLIOUS SLAVE, 1513–15
Michelangelo Buonarroti (Italian, 1475-1564).
Marble, H. 84⅝ in. (215 cm), W. 19¼ in. (49 cm),
D. 29¾ in. (75.5 cm). Musée du Louvre, Paris (MR 1589)

Had *Why Born Enslaved!* been created in the period leading up to the French abolition of slavery in 1848, it would have been considered a timely antislavery appeal. By the time Carpeaux conceived of the bust in 1868, however, slavery had been outlawed in the French Atlantic for twenty years. *Why Born Enslaved!* thus did not contribute to the urgent political issue of abolition. Rather, it profited from the resurgence of antislavery sentiment in abolition's wake, three years after emancipation had finally been achieved in the United States.[10] The sculpture therefore functioned, on one level, as a token of humanitarianism for those who wished to promote their association with the moral cause of abolition after it had been achieved.

Eugénie stood to benefit from the political posturing that *Why Born Enslaved!* enabled. For the empress, art collecting transcended aesthetic concerns: it provided a crucial medium through which to establish her public identity and assert her social values.[11] As we shall see, the contingency of those values made such an acquisition a critical tool. For the duration of the American Civil War (1861–65), Napoléon III and Empress Eugénie maintained economic interests in the slaveholding South. But for fear of Union trade embargoes and a loss of support among large pro-abolition segments of the French population, France would have foregone its official position of neutrality in the conflict and sided with the Confederacy.[12] The Union victory came as a major blow to Napoléon III, whose grand ambitions for further imperial expansion into Latin America—a term he coined to unite the French, Spanish, and Portuguese-speaking countries against the English-speaking United States—were subsequently thwarted by the US government's refusal to sanction his project, leading to the total withdrawal of French troops from Mexico in 1866. At the same time, support for the emperor's conservative government was waning at home. In France, he introduced a series of limited social reforms in an effort to curb political discontent, but it proved insufficient to stem the rising tide of republican sentiment. In the face of diminishing public approval, Eugénie may have purchased *Why Born Enslaved!* in a bid to distance herself from the unpopular position of moral ambivalence she had previously assumed with respect to slavery and to protect her reputation as a virtuous empress devoted to charitable causes. The display of Carpeaux's bust was almost certainly intended to impart an image of the sovereign's enlightened compassion and morality in one of the primary imperial residences where she received visitors, including foreign diplomats and members of the court, within her private apartments.[13]

Yet *Why Born Enslaved!* was both a sympathetic representation of an enslaved woman's anguish and an eroticized object for visual consumption. As James Smalls has argued, the sculpture gives form to colonialist fantasies about the physical possession and containment of Black women's bodies.[14] The belated popularity of images of enslaved women in European art during the post-emancipation period strongly suggests that abolition functioned as a pretext for artists and their audiences to indulge in a long-popular subject in Western art: the theme of female captivity.[15] *Why Born Enslaved!* was conceived of by Carpeaux as part of this continuum of captive beauties. A drawing on the back of a letter dated to 1868 shows a cursory sketch for the sculpture positioned next to a standing nude—seemingly drawn from the same model—that recalls the image of a mythological Andromeda, with arms bound before the body (pl. 7).[16] The repetition of the figure in different formats (bust and full-length) and demarcated by various methods of constraint (binding of the torso and the arms) indicates a certain pleasure taken by the artist in his exploration of the creative possibilities provided by his subject.

This sense of pleasure is no less apparent in the final composition, where the representation of the moral issue of bondage also becomes a point of departure for the sensuous play between rope and body. Carpeaux's subject is, in Smalls's words, a "focus of simultaneous indignation against slavery and titillation for it."[17] This oscillation between outrage and arousal brings to mind what Saidiya Hartman has described as the spectacularization of Black pain. She asks, "Can the moral embrace of pain extricate itself from the pleasures borne by subjection? . . . Is the act of 'witnessing' a kind of looking no less entangled with the wielding of power and the extraction of enjoyment?"[18]

The fact that *Why Born Enslaved!* was designed to meet consumer desire further complicates this matter. At the time the sculpture was created, Carpeaux was on the brink of financial ruin. The enormous sums invested by the sculptor in the production of *The Dance* (1869), his monumental group for the Paris Opera facade, had left him nearly penniless.[19] As a result, he expanded the commercial arm of his creative practice by producing reduced-scale editions of figures extracted and altered from his public sculptures. Exemplifying this commercial endeavor, *Why Born Enslaved!* was developed out of preparatory studies for the allegorical figure of Africa on the sculptor's bronze fountain group *The Four Parts of the World Supporting the Celestial Sphere* (see fig. 1). With the transposition of the figure from monument to bust, Carpeaux

capitalized on the consumer demand for ethnographic likenesses of Black figures first popularized by Cordier (pls. 27, 29, 30, 32). Hardly impartially conceived paeans to Black beauty or portraits of individuals accompanied by their distinctive cultural attributes, ethnographic sculptures were rendered meaningful to their European audience through their distillation of the perceived essences of foreign cultures into generalized symbols of the nations and people subjugated by the French empire. With *Why Born Enslaved!*, Carpeaux catered to bourgeois French art buyers who enjoyed gazing at and possessing Orientalizing depictions of people they viewed as "other."

The bust thus spoke the humanitarian language of empathy while simultaneously giving powerful visual form to the desire for domination over non-Europeans. And yet its creation twenty years after emancipation undoubtedly said more about the sculptor's investments in empire than it did about his abolitionist sympathies. From early in his career, Carpeaux had endeavored to profit from the creation of propaganda that would support the image and interests of the new ruling family, whose coup d'état in 1851 he had witnessed in Paris. In the following year, Carpeaux began a relief commemorating Napoléon III's reception of the Algerian military leader Emir Abdelkader, whom the emperor had freed after years of confinement for his

FIG. 19. THE EMPEROR RECEIVING ABDELKADER AT THE CHATEAU DE SAINT-CLOUD, 1852–96
Jean-Baptiste Carpeaux (French, 1827-1875). Marble, 5 × 9 ft. ¾ in. (155 × 298 cm).
Musée des Beaux-Arts, Valenciennes (S.92.1)

role in leading the resistance against French colonial infiltration in Algeria (fig. 19). The relief shows the North African hero kneeling before his liberator in a pose that echoes that of the beseeching Black man depicted on the Wedgwood medallion (pl. 10), preparing to kiss the emperor's hand in deferential gratitude. Carpeaux's European audiences would have understood the patronizing gesture of the emperor's extended arm as an indication of the benevolent qualities they were meant to assign to him.[20] Not long afterward, Carpeaux began another sculpture, *The Empress Eugénie as Protectress of Orphans and the Arts* (fig. 20), meant to capitalize on the public image of the young empress as a pious and protective benefactress of the poor.[21] This work did not result in the desired patronage of the empress, and Carpeaux would spend the next years of his career pining for an imperial commission. He would finally receive one in 1864, when Carpeaux was invited to take up residence at the court of Compiègne. There he lived in privi-

FIG. 20. THE EMPRESS EUGENIE AS PROTECTRESS OF ORPHANS AND THE ARTS, CA. 1855
Jean-Baptiste Carpeaux (French, 1827–1875). Original terracotta, H. 7⅞ in. (19.5 cm), W. 4⅜ in. (11 cm), D. 5⅞ in. (15 cm). Musée des Arts Décoratifs, Paris (5252)

leged lodgings just above the apartments of the prince impérial and his mother, the empress, whose portraits he produced in 1865 and 1866, respectively.[22]

A year later, in 1867, Carpeaux began preparations for a bronze sculpture to top a fountain that would be situated along the Paris meridian line on the southernmost tip of the Luxembourg Gardens. The commission came from Gabriel Davioud, the city architect responsible for implementing Napoléon III's plans to reconstruct the gardens as part of the sovereign's vast renovations of the city of Paris. After months of sketching in clay in search of a composition and theme suitable for its symbolic location between the Luxembourg Palace and the Paris Observatory, Carpeaux arrived at his chosen subject and began the work that would result in *The Four Parts of the World Supporting the Celestial Sphere* (pl. 9, fig. 21) and also in the creation of *Why Born Enslaved!*.[23] The fountain sculpture, completed in 1872 and unveiled in situ two years later,

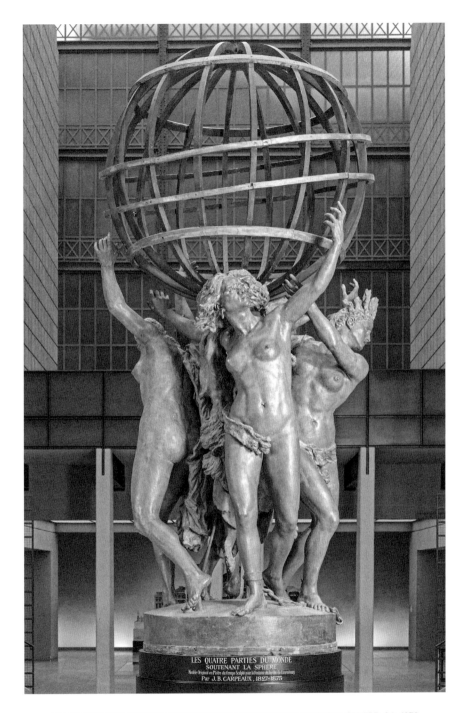

FIG. 21. THE FOUR PARTS OF THE WORLD SUPPORTING THE CELESTIAL SPHERE, CA. 1872
Jean-Baptiste Carpeaux (French, 1827-1875).
Varnished plaster, H. 9 ft. 2¼ in. (2.8 m), W. 69⅜ in. (1.77 m), D. 57⅜ in. (1.45 m).
Musée d'Orsay, Paris (RF 817)

depicts the allegorical figures of Europe, Asia, America, and Africa holding up the sky as they move in harmony to the rhythms of eternal time (see fig. 1).

Carpeaux's choice of allegory was grounded in a visual tradition that from the sixteenth century onward was used by Europeans to impart the global reach and supremacy of Christian-dominant Europe over people and places that they deemed less civilized.[24] Eighteenth-century engravings and porcelain figurines demonstrate the continuity of this imagery, which was first broadly circulated in graphic media and later translated into ornamental trappings for genteel interiors (pls. 23, 24). The iconography was standardized following Cesare Ripa's 1603 *Iconologia*: a chaste Europe wearing a crown and flowing robes reminiscent of an ancient deity and accompanied by a domesticated horse appears as the putative embodiment of civilization (pl. 23A). In stark contrast, Africa's attributes—her bare chest, an elephant headdress, jewelry, and a lion—distinguish her as "exotic" to European audiences who coveted the precious goods and natural resources indicated by her cornucopia (pl. 23B).[25]

In the nineteenth century, allegorizations of the continents became an increasingly advantageous and visible expression of dominion on a monumental scale as European nations sought to expand their imperial authority through exploitative trade agreements and the violent annexation of new territories. In 1864, the sculptor Bartholdi completed a fountain (fig. 22, pl. 25) commemorating Admiral Armand Joseph Bruat, who had commanded a naval warship during the French conquest of Algeria in 1830 and later oversaw plantation labor regimes as the governor-general of the French Antilles (1852–55). The fountain depicts Bruat as the personification of an all-powerful Europe standing atop the reclining figures representing each part of the world—Asia, Africa, Oceania, and America—in which the admiral had advanced French colonialism.[26] Carpeaux's fountain group, *The Four Parts of the World*, also functioned as

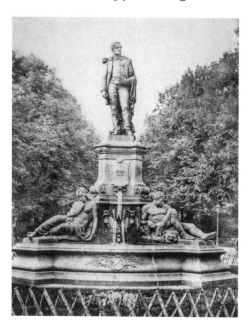

FIG. 22. THE BRUAT MONUMENT, 1856–64
Frédéric-Auguste Bartholdi (French, 1834–1904). Bronze and sandstone. Formerly Colmar, France (destroyed 1940)

a celebration of France's global supremacy. Placed along the axis connecting one of the most significant seats of imperial governance to the symbolic site of scientific discovery (by sea, land, and sky), it situates Paris as the capital of a vast colonial empire that stretched from territories in the Antilles and Algeria to Vietnam and New Caledonia, with footholds in India and China. Yet, going against earlier allegorical traditions, Carpeaux chose to represent the four parts of the world standing on equal footing, with no one figure presiding over the other. He minimized the presence of props and costumes used to connote cultural difference. Each of the continents is instead represented largely unclothed and as racially distinct; at one point Carpeaux even submitted a request to the fountain's commissioners for permission to apply different patinas to the figures in order to legibly index the "coloring of the races."[27]

Charmaine A. Nelson has argued that by rejecting a visual hierarchy of the races and instead highlighting the physiognomic differences between the figures, Carpeaux transgressed colonialist expectations for the representation of European supremacy over Africa and the other continents.[28] By 1867, when Carpeaux conceived of the fountain, however, racial differencing was established as the very means of imposing a social order. Europeans had since the eighteenth century constructed the fiction that people could be organized by their appearances into a racial taxonomy.[29] According to this new invention—which later comprised the field of ethnography—physiognomy, skin color, and other physical attributes formed the criteria by which a person's internal character and placement within a hierarchy of humankind could be determined. Undergirding this system of observation and categorization was a pernicious attitude of prejudice in which Black Africans were viewed as pathologically opposite and inferior to Europeans who, in the words of Ta-Nehisi Coates, "believed that they were white."[30] The development of such racial hierarchies in the long eighteenth century overlaid the accelerating enslavement of sub-Saharan Africans in the French Antilles. While it is difficult to determine the direction of causality between the two, by the middle of the eighteenth century, Blackness was indistinguishable from enslavement.[31]

In his fountain sculpture, Carpeaux makes this connection explicit. According to the logic of ethnography, the allegorical symbols previously located outside the body that had been used to signal Africa's perceived inferi-

ority and primitivism were no longer needed: the racialized body itself made these internal traits visible. Nonetheless, Carpeaux took pains to introduce a novel attribute to the figure of Africa—chains. By removing the conventional array of exoticizing symbols (but for the lion's pelt that nominally conceals her nakedness), Carpeaux defines the figure of Africa primarily by the racialized representation of her physiognomy and by the presence around her ankle of a broken shackle, the universal signifier of slavery and subjection.

The sculptor undoubtedly drew inspiration for the work from the Universal Exhibition, staged in Paris from April to November 1867.[32] One of a series of world's fairs held in the nineteenth century, the exhibition hosted exhibitors from forty-nine countries, mainly France, Great Britain and Ireland, the United States, and Canada, but also other European nations, China, Japan, Egypt, and Turkey, all displaying their products in a positivist demonstration of industrial and capitalist achievement. One correspondent wrote:

> The Paris Exhibition will hold up for a little while a mirror to mankind. . . . Men and women from all quarters of the globe will look into each other's faces, see at a glance each other's peculiarities, and meet with frequent opportunities of showing courtesy to each other. . . . There is room for the correction of narrow ideas and national prejudices in every people under heaven.[33]

The promise of an edifying experience through the intimate encounter and sympathetic observation of foreigners was central to the exhibition's appeal for its eleven million visitors. Yet far from an egalitarian exercise in cross-cultural contact, the Universal Exhibition aimed to justify colonial domination, as a robust display of Algerian products within the section dedicated to the French Empire made evident.

Staging the event was an occasion for Napoléon III—whose interest in its planning was "known to be intense"—to engage in intra-European competition and flaunt his imperial and colonial authority in public.[34] Such opportunities extended to state occasions that similarly demonstrated the nexus of art and empire. On June 11, the imperial couple hosted a luncheon for ninety guests—including the emperor of Russia and the king of Prussia—at the Château de Fontainebleau, where visitors encountered Cordier's *Arab Woman*, a lifesize polychrome lamp stand in the form of a female figure who evokes the exoticized likeness of a subject of French-occupied Algeria, and

Eugénie's so-called musée chinois, or Chinese museum, a vast collection of Asian art whose nucleus consisted of a group of extraordinary Chinese objects that had been seized during a recent expedition.[35] Mitigating Napoléon's triumph (and undercutting his authority) was the news, received in Paris soon after the opening of the Universal Exhibition, of Emperor Maximilian's execution at the hands of Mexican republican forces, putting a sober end to France's ambitions in the Americas.

Indeed, the exhibition and the pomp surrounding it laid bare the emperor's ideological vision of France as the epicenter of the civilized world and an expanding empire into which all non-Western "others" might be subsumed—a worldview contiguous with that expressed in Carpeaux's *Four Parts of the World. Why Born Enslaved!*, created in tandem with the fountain's figure of Africa, its shackles transformed into rope, must be seen as stemming from the same impulses and bearing the same accreted and conflicting meanings: the iconographic and racialized implications of the fountain; the imperial ambitions of its commissioners; and Carpeaux's desires, professional and otherwise. As we view this work and its iterations in the spaces of the museum, how does our bearing witness to Black pain also implicate us in the dynamics of pleasure and power intrinsic to its creation?

Plates

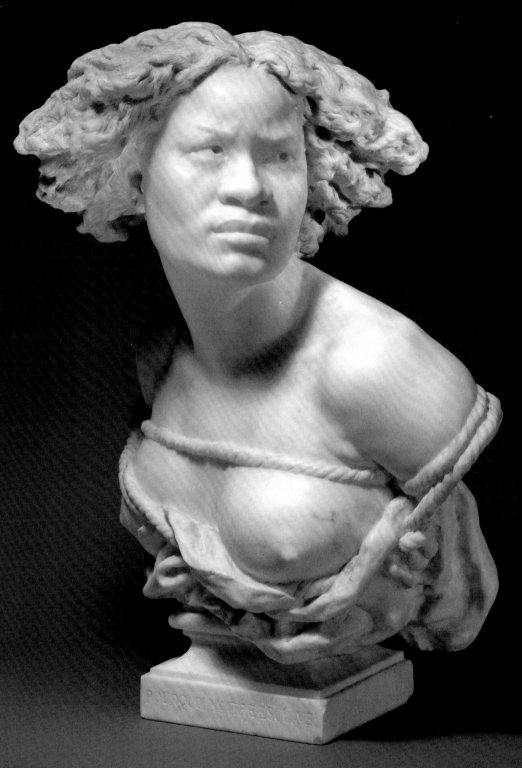

PL. 1A. WHY BORN ENSLAVED! (NEGRESSE), MODELED 1868, CARVED 1873
Jean-Baptiste Carpeaux (French, 1827-1875)
Marble

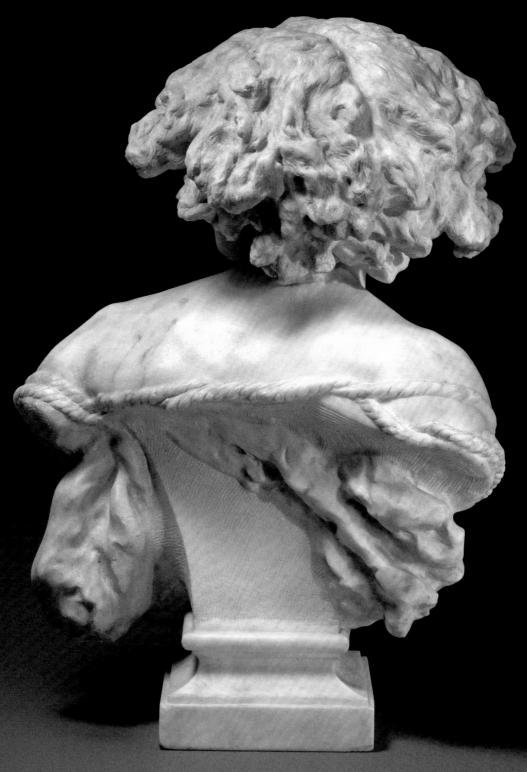

PL. 1B. WHY BORN ENSLAVED! (NEGRESSE), MODELED 1868, CARVED 1873
Jean-Baptiste Carpeaux (French, 1827-1875)
Marble

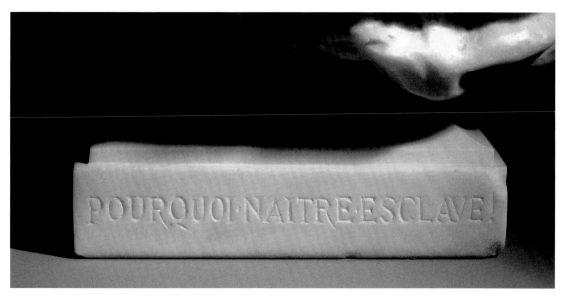

PLS. 1C, 1D. WHY BORN ENSLAVED! (NEGRESSE), MODELED 1868, CARVED 1873
Jean-Baptiste Carpeaux (French, 1827–1875)
Marble

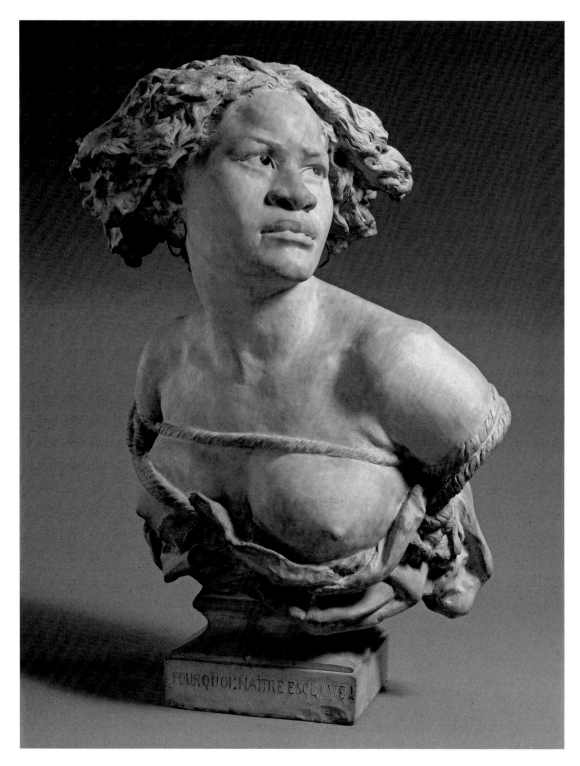

PL. 2. WHY BORN ENSLAVED! (NEGRESSE), MODELED 1868, CAST 1872
Jean-Baptiste Carpeaux (French, 1827–1875)
Terracotta

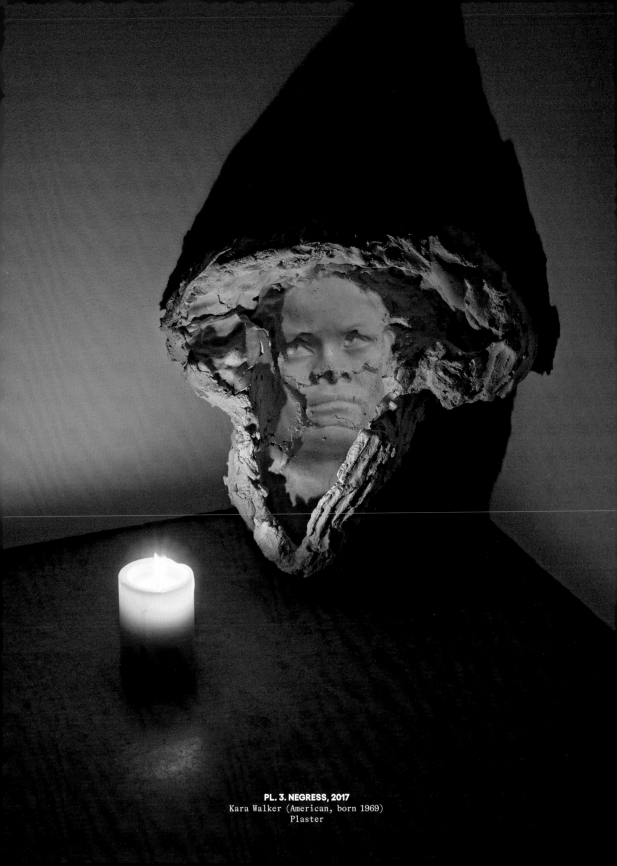

PL. 3. NEGRESS, 2017
Kara Walker (American, born 1969)
Plaster

PL. 4. AFTER LA NEGRESSE, 1872, 2006
Kehinde Wiley (American, born 1977)
Cast marble dust and resin, edition 170/250

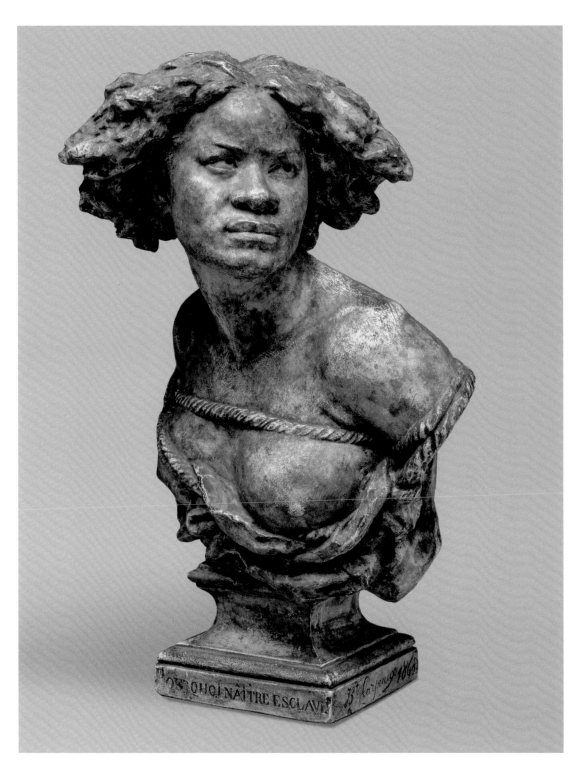

PL. 5. WHY BORN ENSLAVED! (NEGRESSE), MODELED 1868
Jean-Baptiste Carpeaux (French, 1827-1875)
Plaster and paint

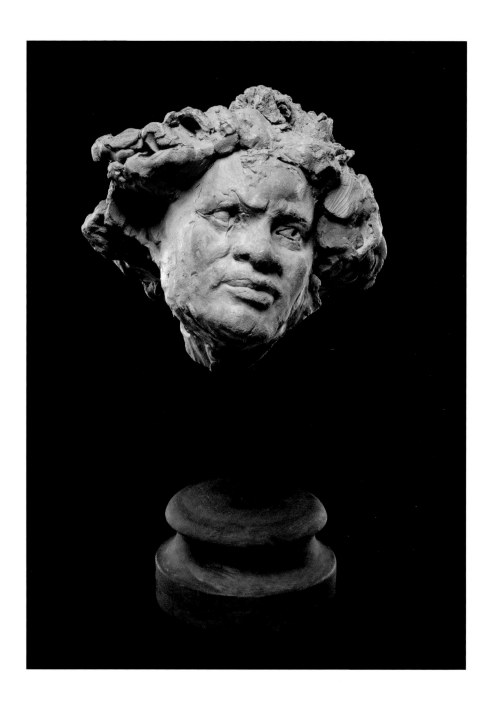

PL. 6. STUDY OF A WOMAN FOR "WHY BORN ENSLAVED!," 1868
Jean-Baptiste Carpeaux (French, 1827-1875)
Unbaked clay

PL. 7. SKETCH RELATING TO "WHY BORN ENSLAVED!" (RECTO), 1868
Jean-Baptiste Carpeaux (French, 1827-1875)
Black crayon on blue grid paper

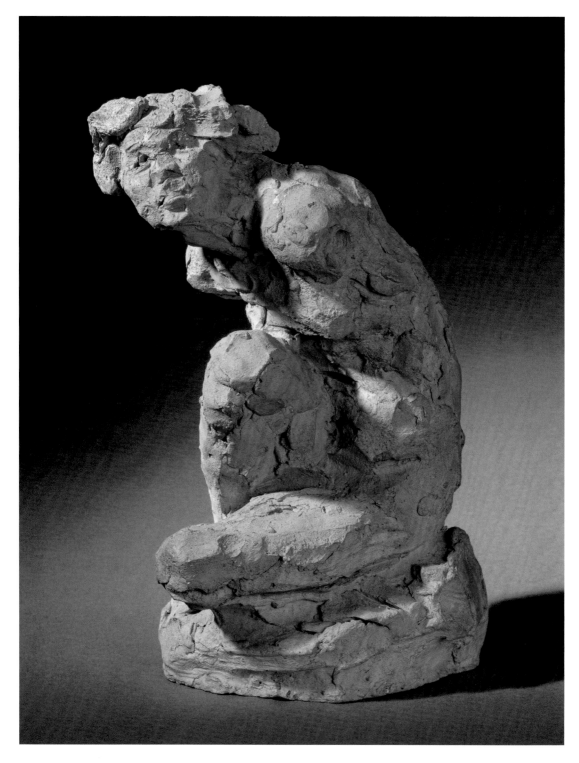

PL. 8. STUDY OF A WOMAN KNEELING, CA. 1867–68
Jean-Baptiste Carpeaux (French, 1827-1875)
Terracotta

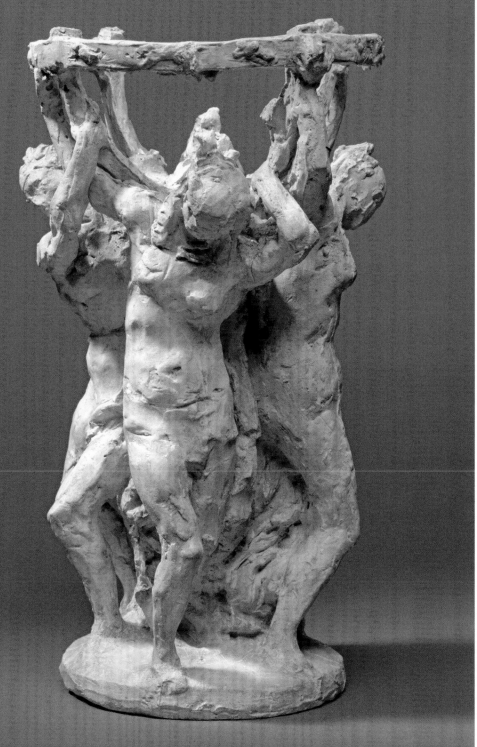

PL. 9. STUDY FOR THE FOUR PARTS OF THE WORLD SUPPORTING THE CELESTIAL SPHERE, 1867–68
Jean-Baptiste Carpeaux (French, 1827-1875)
Plaster

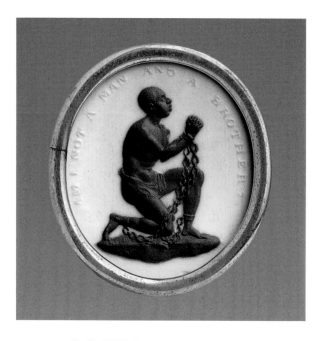

PL. 10. ANTISLAVERY MEDALLION, CA. 1787
Manufactured by Josiah Wedgwood (British, 1730-1795),
after a design by William Hackwood (British, ca. 1753-1836)
Jasperware

**PL. 12. DOUBLE-SIDED ANTISLAVERY SEAL
SET INTO A FOB, CA. 1830S**
After Josiah Wedgwood (British, 1730-1795)
Engraved gems; gilded metal setting

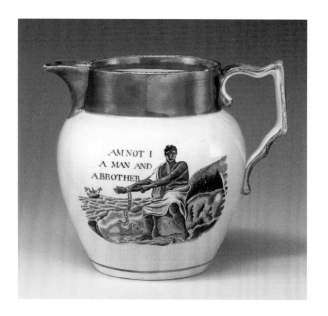

PL. 11. ABOLITIONIST JUG, CA. 1820
Unknown manufacturer (British,
probably Staffordshire or Sunderland)
Pearlware (glazed earthenware) with
transfer-printed and luster decoration

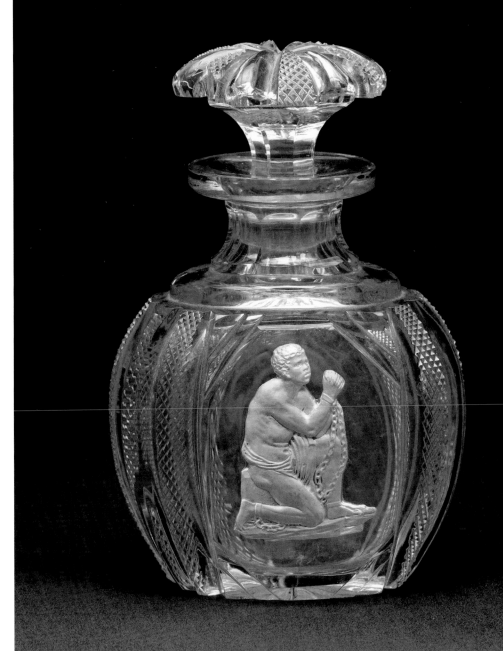

PL. 13. COLOGNE BOTTLE WITH ENCRUSTED ANTISLAVERY IMAGE, CA. 1830
Attributed to Falcon Glassworks of Apsley Pellatt & Co. (British, 1791–1890)
Blown and cut glass

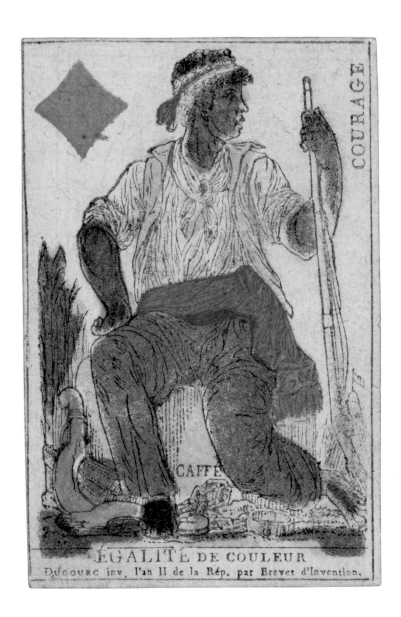

PL. 14. REVOLUTIONARY PLAYING CARD, 1793–94
Designed by Jean Démosthène Dugourc (French, 1749-1825), published by Michel Hennin (French, 1777-1863)
Woodcut engraving

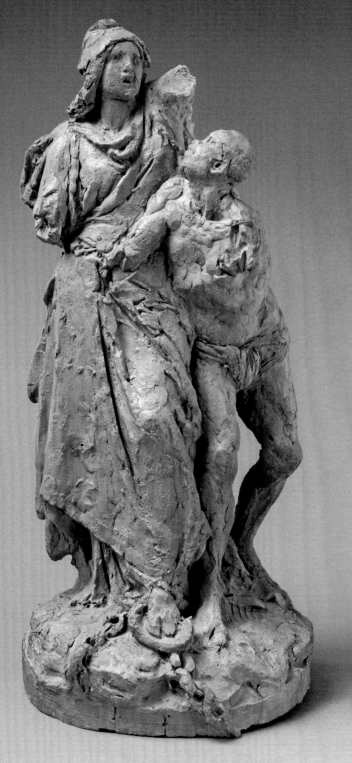

PL. 15. SKETCH OF AN ALLEGORY OF THE ABOLITION OF SLAVERY, CA. 1848
Unknown French artist
Terracotta

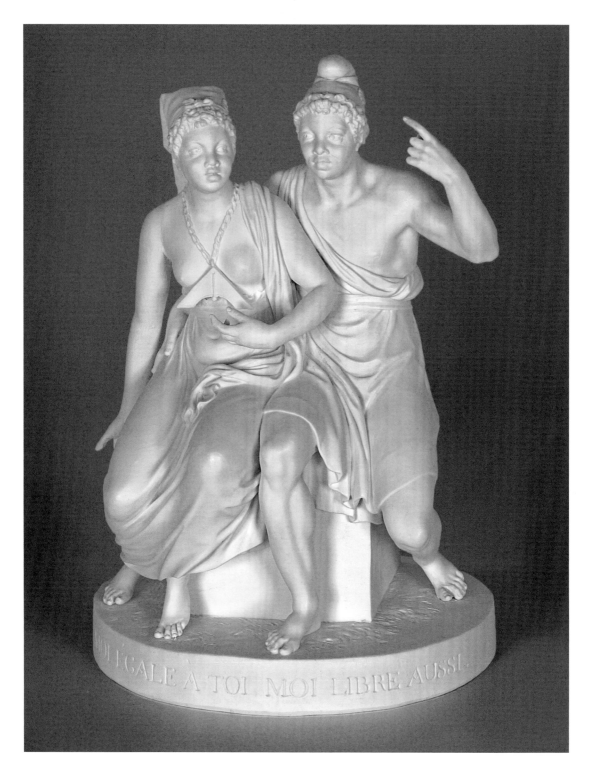

PL. 16. PORCELAIN GROUP OF A FREE MAN AND WOMAN (LES NOIRS LIBRES), 1794
Louis Simon Boizot (French, 1743–1809)
Hard-paste biscuit porcelain

PL. 17. PRINT OF A FREE MAN (MOI LIBRE AUSSI), 1794
Louis Darcis (French, 1760-1801),
after Louis Simon Boizot (French, 1743-1809)
Engraving

PL. 18. PRINT OF A FREE WOMAN (MOI LIBRE AUSSI), 1794
Louis Darcis (French, 1760-1801),
after Louis Simon Boizot (French, 1743-1809)
Engraving

PL. 19. HEAD OF A WOMAN (BUSTE DE NEGRESSE), CA. 1781
Jean Antoine Houdon (French, 1741-1828)
Plaster and paint

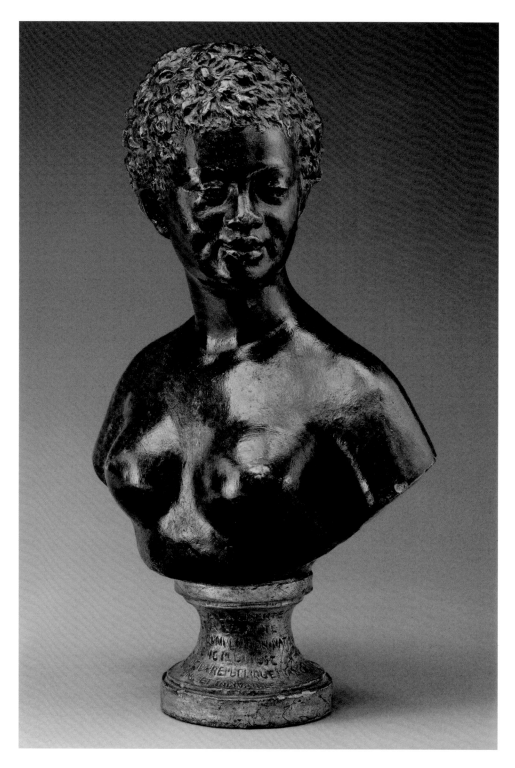

PL. 20. BUST OF A WOMAN (BUSTE DE NEGRESSE), 1794 OR LATER
Jean Antoine Houdon (French, 1741–1828)
Terracotta and paint

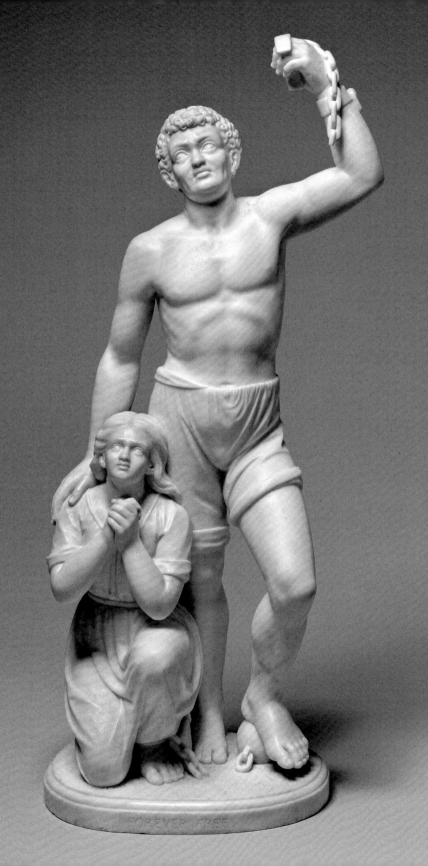

FOREVER FREE

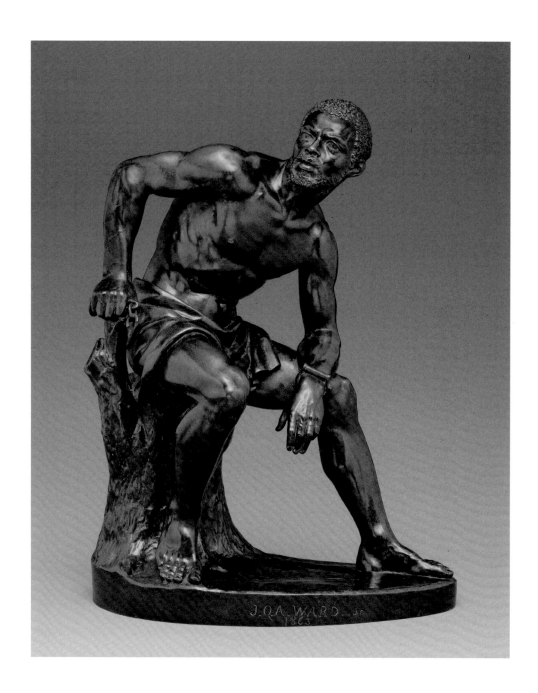

PL. 21. FOREVER FREE, 1867
Edmonia Lewis (American, 1844-1907)
Marble

PL. 22. THE FREEDMAN, MODELED 1863, CAST 1891
John Quincy Adams Ward (American, 1830-1910)
Bronze

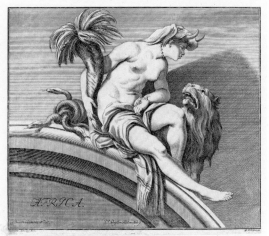

PLS. 23A–D. ALLEGORIES OF THE FOUR PARTS OF THE WORLD, 1730–32
Johann Justin Preissler (German, 1698-1771), after Edme Bouchardon (French, 1698-1762)
Engraving

PLS. 24A–D. ALLEGORIES OF THE FOUR PARTS OF THE WORLD, 1781–88

Fulda Manufactory (German, 1764-89), after a design by Johann Andreas Herrlein (German, 1720-1796)

Hard-paste porcelain

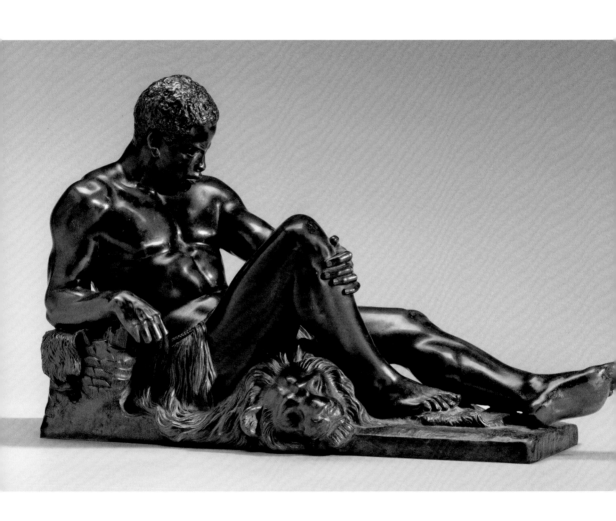

PL. 25. ALLEGORY OF AFRICA, MODELED CA. 1863–64
Frédéric-Auguste Bartholdi (French, 1834-1904)
Reduced cast after a figure for a fountain commemorating Admiral Armand Joseph Bruat
Bronze

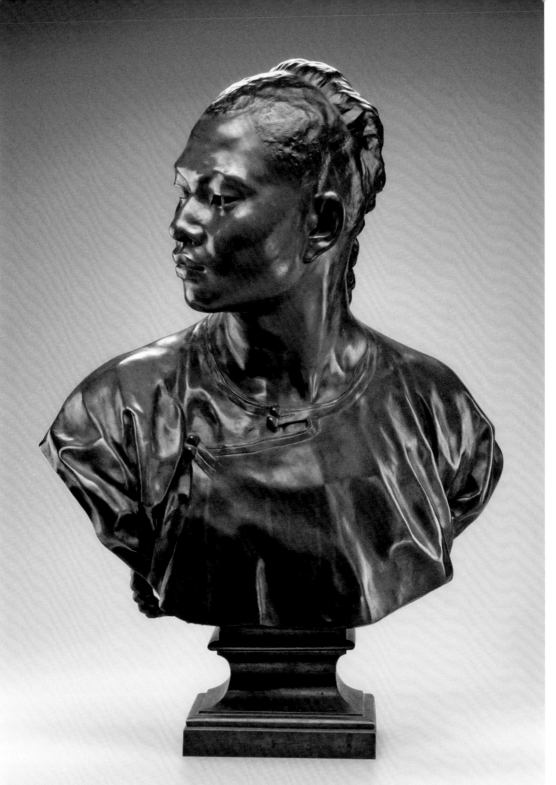

PL. 26. BUST OF A MAN (LE CHINOIS), MODELED 1868, CAST 1872
Jean-Baptiste Carpeaux (French, 1827–1875)
Bronze

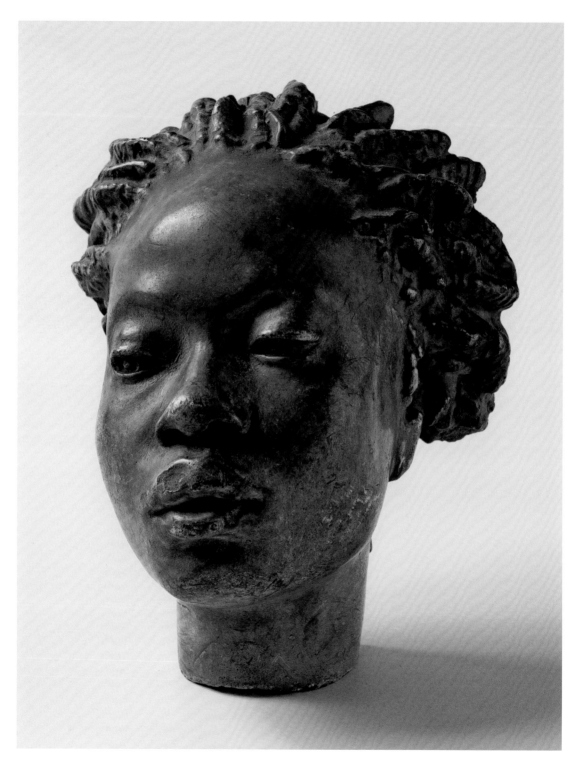

PL. 27. HEAD OF A WOMAN (VENUS AFRICAINE), MODELED 1851, CAST 1851 OR AFTER
Charles-Henri-Joseph Cordier (French, 1827–1905)
Plaster and paint

PL. 28. BUST OF HORA, 1848
Jean-Pierre Dantan, called Dantan-Jeune (French, 1800-1869)
Plaster and paint

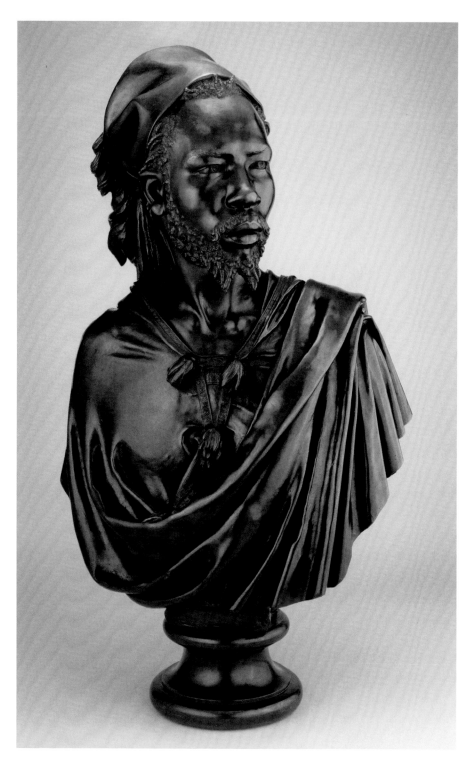

PL. 29. BUST OF SEID ENKESS (SAID ABDALLAH, DE LA TRIBU DE MAYAC, ROYAUME DE DARFOUR; AFTER 1850, NEGRE DE TIMBOUCTOU), 1848
Charles-Henri-Joseph Cordier (French, 1827-1905)
Bronze

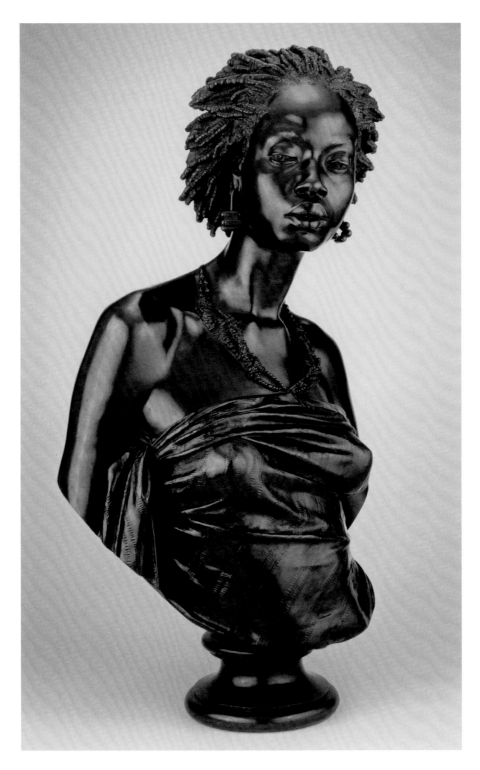

PL. 30. BUST OF A WOMAN (NEGRESSE DES COLONIES; AFTER 1857, VENUS AFRICAINE), 1851
Charles-Henri-Joseph Cordier (French, 1827–1905)
Bronze

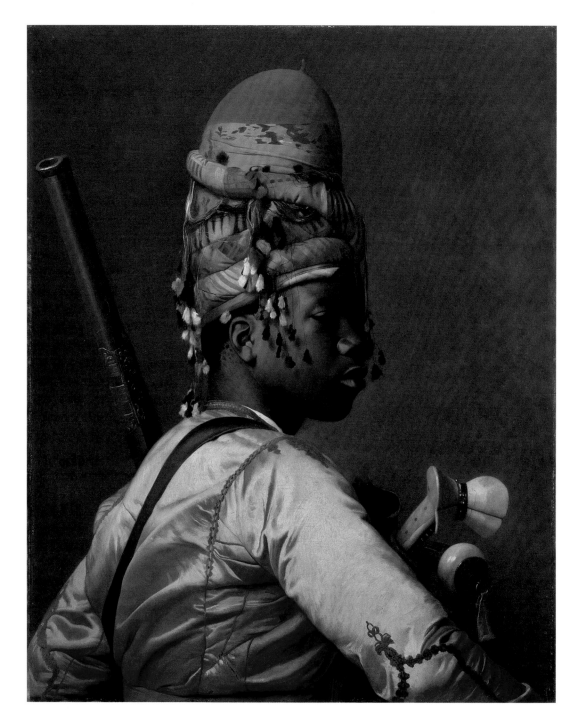

PL. 31. BASHI-BAZOUK, 1868–69
Jean-Léon Gérôme (French, 1824-1904)
Oil on canvas

PL. 32. WOMAN FROM THE FRENCH COLONIES (LA CAPRESSE DES COLONIES), 1861
Charles-Henri-Joseph Cordier (French, 1827-1905)
Algerian onyx-marble, bronze, enamel, amethyst; white marble socle

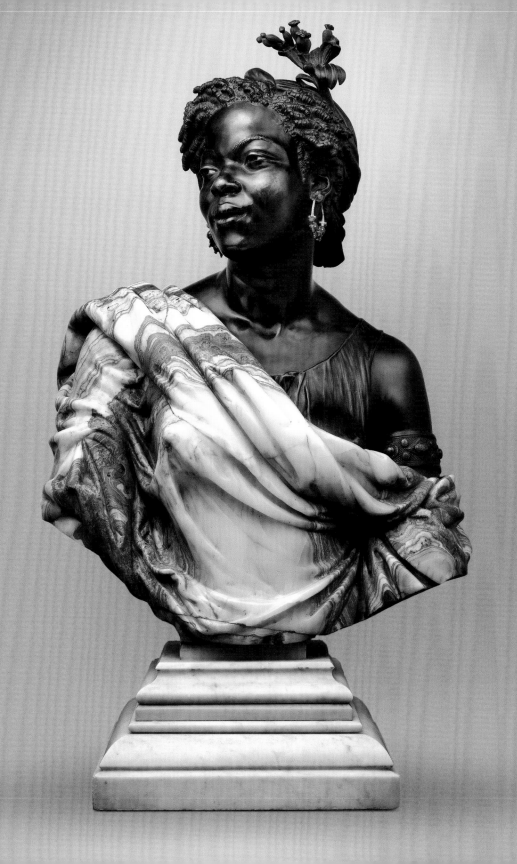

James Smalls

DRESSING UP/ STRIPPING DOWN

ETHNOGRAPHIC SCULPTURE AS COLONIZING ACT

Why Born Enslaved! (pl. 1) is the title now given to a bust by the French sculptor Jean-Baptiste Carpeaux, modeled in 1868 and produced in plaster, terracotta, bronze, and marble versions from 1869 onward. The work depicts a woman whose partially denuded upper torso is tightly bound with a rope that crisscrosses one of her exposed breasts, secures her arms behind her back, and bites into her pliant flesh. Potent in its facial expression of defiance, animated bodily movement signaling resistance, and detailing of physiognomic features, the bust drew attention from critics and other observers when it was exhibited in the Salon of 1869 under the title *Négresse* (*Negress*). The art and literary critic Théophile Gautier wrote that "the Negress, with the rope that binds her arms behind her back and creases her breast, raises to heaven the only free thing the slave has, her gaze [*le regard*], the look of despair and mute reproach, a useless appeal for justification, a grim protest against the crushing weight of destiny. It is a piece of rare vigor, where ethnographic exactitude is dramatized through a profound sense of suffering."[1] Gautier's commentary identifies topics of concern applied to ethnographic sculpture that are considered in this essay: race and racialization, ethnography, slavery, abolition, and the role these all played in French colonial expansion and the implicit declaration of French national identity in the nineteenth century.

Gautier was neither the first nor the last to link ethnography and sculpture in his reviews. The term "ethnographic" as applied specifically to sculpture

first appeared at the 1863 Paris Salon.[2] As a category, *la sculpture éthnographique*, as it came to be known, was first proposed by the diplomat and anthropologist Julien Girard de Rialle, who pointed out sculpture's connection to science when he wrote that ethnographic sculpture "begins to move away from academic bad habits . . . and this endeavor should have excellent results. In the first place it takes art into a new field, into the domain of science and, consequently, into that of the idea."[3] His remarks sparked a debate between admirers of traditional idealized classical sculpture and advocates of a modernist renewal that favored documentary realism while yielding to the "seductiveness of colorful exoticism resulting from contact with the overseas French colonies."[4] *Why Born Enslaved!* exemplifies the endeavor described by Girard de Rialle in that it simultaneously embraces the ethnographic while referencing the moral concern over slavery and abolition, the ideology of race, and classicism and Western dictates of beauty.

Produced during an active period of French colonial expansion in the Second Empire (1852–70) under Napoléon III, the bust is a prime example of sculpting as a colonizing act, as ethnography and colonialism embodied, a "spectacular humanitarian pronouncement" packaged and promoted as a self-congratulatory cultural exercise proclaiming the "universalization of enlightenment."[5] Ethnographic sculpture in France from 1848 into the 1870s and 1880s constituted a literal and figurative act of colonialism—part and parcel of France's enterprise of colonial expansion and its attempts at cultural and national definition and influence.[6] The French colonial endeavor depended on tapping into the domains of science (ethnography and anthropology), aesthetics (classicizing visual language), and racial politics in the debate over slavery and abolition in order to promote and legitimize the nation's undertaking of civilizing non-Europeans (*la mission civilisatrice*)—by the latter part of the nineteenth century "a 'mission' at the heart of liberal French colonial and foreign policy."[7] Ethnographic sculpture reflected and contributed to that mission by solidifying anthropology into three-dimensional "real" space as a method of classification.

ETHNOGRAPHY DEFINED

During the period in which Carpeaux and other sculptors were working, ethnography and anthropology were in their infancy as sciences that employed classificatory methodologies to divide the human species into manageable

groups, races, and types. In the mid-to-late nineteenth century, many ethnographers and anthropologists helped legitimate the idea of colonial expansion by promoting hierarchical thinking and proclaiming "universal fraternity" while conceding that there were "physical differences" between the races that defined intellect and character.[8] The cultural differences between Europeans and non-Europeans became entangled with biological issues to the point where there was "difficulty conceptualizing them except in terms of 'race.'"[9] As a science, ethnography was considered as a legitimate means of measuring racial differences and as a surrogate for the existence and witnessing of actual differentiated bodies in space. Ethnographic sculpture reveals that race is not biologically determined or defined but is "socially constructed, historically malleable, culturally contextual, and produced through learned perceptual practice."[10] The concept of race was highly contested and very political in the mid-nineteenth century as debates about racial origins and theories of racial development were taking place. In its capacity as an ethnographic sculpture, *Why Born Enslaved!* manifests visually and conceptually the ideology of race, described as "a system of ideas which interprets and defines the meaning of racial differences, real or imagined, in terms of some system of cultural values."[11]

Ethnographic sculpture, then, serves as a form of visual documentation that involves much more than visual description alone. As a discourse, ethnography produces meaning that complicates its assumed function as an instrument of scientific knowledge.[12] Through ethnographic sculpture, discourses of knowledge/power are effectively articulated, reinforced, and celebrated by the exertion of political, aesthetic, and physical control over bodies deemed foreign, alien, removed, and distant (exotic). The philosopher and critic Michel Foucault's knowledge/power paradigm underscores the notion that "knowledge and power directly imply one other," the former "activated by the power to turn bodies into *objects of knowledge*."[13] Unlike painting, sculpture has a more direct and intimate relationship to actual bodies in that the sculptor's primary objective is to reproduce three-dimensional bodies in real space rather than to create illusions on a flat surface.[14] As such, sculpture and the act of sculpting become potent instruments for both acquiring and reflecting power/knowledge and (re)creating the ethnographic other as an object to be displayed and experienced in the space of the viewer. In other words, the sculptures presented throughout this essay are not transparent reflections of race or even gender but become, rather, fictive surrogates for

actual bodies. The ethnographic busts of interest here showcase ethnography as an *embodied practice*, an intensely "sensuous way of knowing."[15] Moreover, such ethnographic sculptures engage in racial discourse and the processes of racialization as part of an attempt to define and reference French national and cultural identity sanctioned under the authoritative weight of science. Colonialism is the power structure through which othered bodies get "thingified"—that is, locked into a "crushing objecthood" and filled in with signification that is put to meaningful use by the artist-colonizer.[16] Thus, the ethnographic work is neither innocent nor neutral but a potent political and aesthetic instrument of racial reconstruction and deconstruction in the quest for knowledge and control.

Carpeaux's *Why Born Enslaved!*, in particular, speaks to the intrinsically politicized nature of ethnographic sculpture due to the context in which it and such works were fashioned, namely within the historical parameters of slavery, abolition, and colonialism. Such works are never politically neutral no matter how classicizing or exoticizing they may appear. Their racialized facial features and marked presence as othered bodies says much about Western aesthetics, nineteenth-century science, and racialized discourse, and very little about the personhood or lives of those whom they are intended or claim to represent. Although the facial features of Carpeaux's enslaved woman are particularized, suggesting the use of a living model, her identity—her name and biography—remains unknown, as is the case with so many ethnographic works. She has been made to constitute a racial type, in this case representative of "la superbe Afrique," linked to slavery and abolition as historical fact and moral dilemma.[17]

DRESSING UP

In the nineteenth century, the doyen of ethnographic sculpture was Charles-Henri-Joseph Cordier, who became famous between 1848 and 1870 for his portrait busts of racial types (*types raciaux*) fashioned out of amalgamations of semiprecious materials and combining ethnographic veracity with exoticism, the decorative, and Romantic exuberance.[18] His sculpted portraits of ethnographic types were influential, critically acclaimed, and commercially successful. In written and visual proclamations, the sculptor often boasted that he had single-handedly discovered something new, invigorating, and progressive in his application of ethnography, diverse materials, and color

to sculpture.[19] Cordier's career as an ethnographic sculptor was launched in 1848 when he exhibited his portrait bust *Saïd Abdallah, de la tribu de Mayac, royaume de Darfour* (*Saïd Abdallah of the Mayac Tribe, Kingdom of Darfur*; pl. 29). The sculpture represents Seïd Enkess, a formerly enslaved man who worked as a professional artist's model in Paris.[20] By altering Enkess's last name and giving his piece that title, Cordier demonstrated a practice that would become common in many subsequent ethnographic sculptures: that of transforming the subject into an "imaginary representative of a place in Africa," rather than identifying the piece as a representation of the living model.[21] Such a change happened again in 1850 when, for the annual state-sponsored Salon, Cordier recast *Saïd Abdallah* and exhibited it under the title *Nègre de Timbouctou* (*Negro from Timbuktu*). The change of title transformed the portrait of a specific individual into a generic racial and cultural type, thus generalizing the vast geographical regions of the African continent. This slippage from descriptive individual to generic ethnographic type occurred rather consistently during the Second Empire under Napoléon III and was useful to the political, cultural, and ideological goals of the regime. Several of Cordier's ethnographic sculptures, for example, were commissioned by the French government as part of official missions to Algeria, Egypt, and elsewhere in the Mediterranean, thereby connecting the sculptures even more explicitly to colonialist discourse.[22] Racial and ethnographic types could be fashioned in such ways to appeal to an eclectic array of aesthetic as well as political tastes and, in the process, bolster the artist's reputation and prestige.

As was the case with several artists during the period who applied ethnographic and anthropological methods to their chosen medium, Cordier was no armchair artist-ethnographer. He solicited and received state funding to finance travel to study firsthand the various racial and ethnic types that he sought to depict. Cordier was not the first artist to embark upon such excursions. In 1844, the portrait sculptor Jean-Pierre Dantan (called Dantan-Jeune) visited Algeria and then Egypt in 1848 and sketched from life the native inhabitants he encountered.[23] The result of his stay in Cairo was the execution of two busts of Ethiopian male youths. A version of one of the busts, now in the Musée Carnavalet, is painted umber and bears the inscription "Gala"—a misspelling of the racial epithet "Galla" frequently used in reference to the Oromo people, the ethnic group to which the depicted boy belonged (pl. 28). The work was influenced by the sculptor's interest in theories

of phrenology and physiognomy with an added emphasis on an expressive realism in the capture of the youth's likeness. Phrenology, a theory developed by the German physician Franz Gall in 1796, entails measuring the contours of the skull to predict intellect and character traits. The goal of physiognomy is similar but considers instead the form of facial features and physical attributes like skin tone.[24] Both artists employed aspects of these pseudosciences, along with features taken from ethnography and anthropology, to describe and define the character of not only a particular individual depicted but an entire ethnic/racial group.

Unpainted plaster versions of the busts were gifted, in 1860, to the anthropology division of what is now the National Museum of Natural History (Muséum National d'Histoire Naturelle) in Paris by Antoine d'Abbadie d'Arrast, an explorer/ethnologist/geographer who was with Dantan-Jeune in

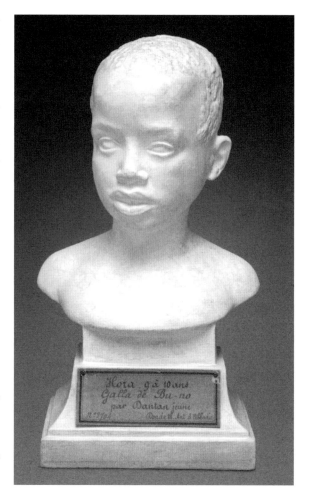

FIG. 23. BUST OF HORA, 1848
Jean-Pierre Dantan, called Dantan-Jeune (French, 1800-1869). Plaster, H. 10¼ in. (26 cm), W. 5⅞ in. (15 cm), D. 4¾ in. (12 cm). Muséum National d'Histoire Naturelle, Paris (MNHN-HA-2704)

Cairo in 1848.[25] In a letter that accompanied the gift, the busts were described as similar in their focus on ethnographic facial features and the attention paid to the shape of their heads. The letter and a handwritten placard affixed to the "Gala" bust reveal that the boy's name was Hora, aged nine or ten (fig. 23). Raised by d'Abbadie in Syria, Hora served as an interpreter with the French army in Crimea and died of typhus in Constantinople (Istanbul) shortly after the Crimean War. The second bust referenced in d'Abbadie's letter depicts Kifla Kingil (called Birru), a young boy between twelve and fourteen years

of age (fig. 24).[26] The busts are signed and inscribed with the date they were modeled. Of note are the figures' torso terminations, which resemble those of ancient sculpted portraits of Roman youths, a classicizing feature that Cordier would exploit in his ethnographic pieces. The works thus bear attributes of "scientific" objects/ethnographic types and art objects.

The busts of Hora and Birru were produced in 1848, the year that the ethnographic genre began to take hold, when slavery had been definitively abolished in all the French territories, and when Cordier chose Seïd Enkess as subject for his *Saïd Abdallah*. With that work, Cordier conscientiously linked his sculptural practice to ethnography and anthropology while explicitly engaging with moral debates over slavery and abolition. He also promoted his own importance as a creative messiah and harbinger of progress: "My genre had the freshness of something new, revolt against slavery, the budding science of anthropology, widening the circle of beauty by showing that it existed everywhere."[27] What made Cordier's ethnographic sculptures distinct and popular was the artist's demonstrated skill at combining ethnographic realism with classical idealization—and, after 1848, his introduction of color. By integrating these features in one work, Cordier succeeded in positioning himself as "the anthropological eyes of France" while giving visual validation to Napoléon III's colonial policy of assimilation and international cultural expansion by incorporating

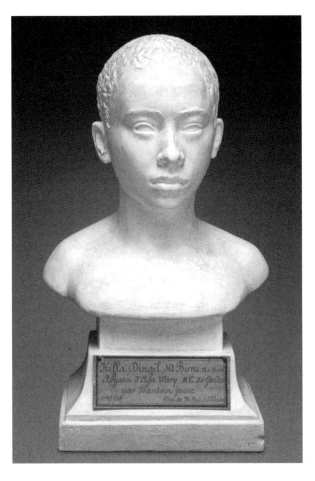

FIG. 24. BUST OF BIRRU, 1848
Jean-Pierre Dantan, called Dantan-Jeune (French, 1800-1869). Plaster, 10⅝ in. (27 cm), W. 6¼ in. (16 cm), D. 4¾ in. (12 cm). Muséum National d'Histoire Naturelle, Paris (MNHN-HA-2705)

the Black figure into a Western paradigm of beauty.[28] Assimilation had its origins in the French Revolution, which held that its ideals of freedom, equality, and brotherhood should apply to all subject individuals regardless of race or color. Predicated on the presumption of French cultural superiority, assimilation applied to foreigners residing in France and also encompassed the expansion of French culture outside of Europe with the aim of unifying the colonial and metropolitan territories. It was the basis of the French "civilizing mission" that served as a rationale for French colonialism—for molding cultural, racial, ethnic, religious, and political others into the image of Frenchmen.

For the Salon of 1850–51, *Saïd Abdallah* was paired with a companion piece titled *Négresse des colonies* (*Negress from the Colonies*; pls. 30, 27). Pairing male and female ethnographic busts was a formula for which Cordier became known in the art world and which inspired subsequent ethnographic sculptors. Both figures exhibit thick and fleshy lips; broad, flat noses; coarse locks of hair; and ethnographically detailed accessories. Both bring together two seemingly disparate yet complementary aspects—painstaking, even exaggerated, realism in their countenances, hair texture, and costume, coupled with suggestions of an idealized classical refinement in the draping of clothing on the body. The form of the woman's torso beneath the drapery is palpable, rendered in such a way as to suggest a relaxed contrapposto stance characteristic of full-figure classicized statuary.

As part of empirical science, ethnography was based on realism, defined as a mode of representation that seeks to depict, in an objective and unfiltered manner, "the reality of a whole world or form of life."[29] The ethnographer's task is to collect, rank, and codify objective data. Even with the advent of ethnographic photographs, which would supplant sculpture as a form of ethnographic representation later in the nineteenth century, the attempt to maintain realism results in a representation that produces not truth but rather a simulation and synthesis of the observer's experience: an imitation of an encounter as well as a falsification and distortion of those who are represented and of their cultures. James Clifford refers to this phenomenon as the "inescapably allegorical" or "mythologizing mode" of ethnography.[30] All of the ethnographic sculptures considered in this essay emphasize the point that "realistic portraits, to the extent that they are 'convincing' . . . , are [in point of fact] extended metaphors, patterns of associations that point to . . .

additional meanings."[31] Cordier's *Saïd Abdallah* and *Négresse des colonies* are prime examples of the "mythologizing mode" of ethnography put into three-dimensional physical form.

Although *Saïd Abdallah*, *Négresse des colonies*, and subsequent ethnographic busts by Cordier embrace realism in visually descriptive terms as portraits of specific individuals, they are in fact idealizations. Cordier himself articulated this unique aspect of his work and the process by which he achieved it in an address to the Anthropological Society of Paris on February 6, 1862:

> I sculpted these busts from life by employing a geometric procedure that guarantees the exactitude of likeness, dimensions, and forms . . . I take my models as much as possible from their respective countries and I proceed . . . in representing a true likeness of the race. First of all, I examine and compare my subjects with a large sampling of individuals from the same race. I study the forms of their heads, the features of their faces, the expression of their physiognomy. I charge myself with seizing the common characteristics of the race that I want to reproduce . . . I then conceive of an ideal or rather a type for each of these characteristics. Then, by grouping all of these partial types, I constitute in my mind an assembled type in which is united all the special beauty of the race that I am examining.[32]

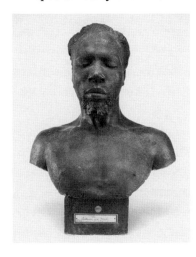

FIG. 25. SEID ENKESS, 1847
Charles-Henri-Joseph Cordier (French, 1827-1905). Painted plaster cast of life mask, H. 23⅝ in. (60 cm), W. 18½ in. (47 cm), D. 10⅝ in. (27 cm). Muséum National d'Histoire Naturelle, Paris (MNHN-HA-1561)

Although he used Seïd Enkess as a model for his debut bust, a comparison between an 1847 life cast of Enkess (fig. 25) and *Saïd Abdallah* shows that Cordier has made slight yet noticeable adjustments in the form of the sitter's eyes, nose, and mouth. He combined the notion of scientific objectivity in the depiction and treatment of facial features, hair, and costume with an aestheticized subjectivity in defining an ultimately elusive and culturally determined universality of racial/ethnic beauty and difference. His approach undermined the standard function of portraiture—of capturing an individual likeness—while underscoring ethnography's "mythologizing mode."[33]

For the Salon of 1857, Gautier gave a new title, *Vénus africaine* (*African Venus*), to Cordier's *Négresse des colonies*, which encouraged the sculptor's integration of ethnographic realism and classicizing idealization. Among other things, the change of title suggested the writer's willingness to collude with the sculptor's avowed humanitarian pursuit and incorporate an enslaved Black presence into the aesthetic and mythological pantheon of Eurocentric classical culture.[34] With *Vénus africaine*, the Greek goddess of love has been grafted onto the image of an ethnographically detailed *Africaine*. Indeed, Gautier was a staunch supporter of Cordier's work and wrote eloquently about what he considered the masterful alliances the sculptor made in his pieces among fine art, science (ethnography), and industry. He lauded Cordier's technical bravura as artistically innovative and his subject matter as morally progressive.[35] In his critique of the Salon of 1869, Gautier took note of Cordier's originality in studying and rendering exotic types, discovering "in his virgin races a beauty that can sustain comparison with classical (antique) beauty."[36]

This balance of a highly scrutinized ethnographic description and the aestheticized language of classicism finds powerful expression in Cordier's *La capresse des colonies* (*Woman from the French Colonies*) of 1861 (pl. 32). Here, a Black female figure with particularized facial features and detailed locks of tufted hair wears a garment composed of striated marble placed diagonally across her torso. She also sports earrings made of enamel and amethyst. Cordier exploits the nuances of color, and in particular skin color, as a visual sign of difference in which the point of comparison is the unseen white male body and its mastery over the racialized body through the aesthetic and technical manipulation of materials.

Like *Woman from the French Colonies*, the majority of Cordier's ethnographic busts produced during the 1850s and 1860s graft onto non-Western races the Western concepts of beauty and nobility, imbuing them with an aura of successful assimilation ("civilization") into a Western aesthetic paradigm. This process was no doubt viewed by Cordier and those who followed in his footsteps not only as an act of ennoblement but as a gesture of abolition itself—that is, as a representational means of demonstrating that racial others could be liberated from their assumed uncivilized status and rendered beautiful, noble, and as civilized as the ancients. This would not be possible, however, without the artist's technical prowess and aesthetic judgment. Indeed, as a "master discourse of colonization," ethnography spawned a renewed interest

in saving or salvaging cultures that were being annihilated through slavery and other forms of colonial domination.[37] Jean-Léon Gérôme's *Bashi-Bazouk* (pl. 31) could be seen in this light as an ostensible effort to provide visual testament to a culture that was elusive and alluring to the European spectator. By posing a Black model in the costume of a bashi-bazouk—an irregular or auxiliary soldier of the Ottoman Empire—the painter did not seek to record this culture but rather to reconstitute it through the prism of European imperialism. Through his ethnographic sculptures, Cordier actively participated in colonial discourse by expressing concern about "disappearing . . . races and a belief that he could preserve them in sculptural form through firsthand observation."[38]

In *Woman from the French Colonies*, an aura of stoic dignity and passive compliance has been bestowed upon a racialized subject, visibly signaling the acceptance of the civilizing process by which Napoléon III desired to identify, pacify, order, and absorb racially and ethnically diverse peoples into the French empire. Moreover, the figure has been (re)constructed and restrained (or constrained) into aesthetic complacency through the incorporation of materials extracted from ancient rock quarries in Algeria and Greece (which had been exploited by the French during the 1840s) that are "imposed" on the artist's sculpted racial types as a supposedly humanitarian gesture of the French civilizing mission, all the while classified and sanctioned under the weight of science (ethnography and anthropology).[39] Here, the ethnographic subject becomes a conduit through which the underlying political motivations of French territorial exploration—infiltration, command, and ultimate assimilation-as-aestheticized-subjugation—are expressed.

STRIPPING DOWN

Contrary and yet complementary to the calm and stoic demeanor of Cordier's "dressed up" *Woman from the French Colonies*, Carpeaux's *Why Born Enslaved!* encapsulates violence and sexualized exploitation of the "stripped down" slave body. The visual display of so much flesh, coupled with the theme of slavery, suggests optical reference to the slave market and auction block, where "men and women were exposed to the calculating gazes of their would-be owners, who checked their teeth, felt their muscles and fondled their genitals to make sure of a good buy."[40] Indeed, this mode of exploitation was "supported by the punitive practices of stripping, beating and otherwise

violating Black bodies in public as signs of white power and ownership."[41] The figure's exposed breasts suggest both the erotic potential of the work and its symbolic nod to lofty ideals associated with liberty and equality as cherished French republican values, exemplified in Eugène Delacroix's painting, *Liberty Leading the People* (1830).[42] Both before and after 1848, it was debates over slavery and abolition, liberty, and equality—with their political, cultural, and representational fallouts—that became critical to France's definition and redefinition of what it meant to be French and who was and was not part of the French nation. Indeed, as the historian Robin Mitchell has pointed out, throughout its history, every French regime "has attempted to redefine for itself what it meant to be French, with constant debates over the meaning of liberty and equality."[43] As an artifact of science and its racialized modes of inquiry, ethnographic sculpture became part and parcel of this discourse.

The reading of Carpeaux's bust as sexualized underscores the work's ambiguity. Carpeaux's enslaved woman is at once defiant and yet subjugated to any and all desires projected upon her. The work accomplishes two seemingly paradoxical goals simultaneously: it speaks the humanitarian language of protest against human bondage as unjust, provoking indignation from its viewers, while at the same time encouraging fantasies of possession and ownership. The enslaved individual is reduced to an emblem of both outrage and titillation. Carpeaux intensifies the ambiguity of his sculpture by posing a moral dilemma to the spectator as either an implied question, "Why born enslaved?" or as a cry of anger or pain, "Why born enslaved!," a query and declaration that have the effect of simultaneously pointing to a liberal concern over slavery and abolition while also absolving the artist and viewer of any complicity in enslavement as an objectifying, colonizing act. The way in which Carpeaux's work accentuates the sensual and the erotic for dramatic effect underscores the enslaved woman's physical subjugation and implied victimization. Her tossed head, facial expression, and wild hair animate the bust and assist in the imagining of a narrativized space and encounter, thus forcing the viewer to take up the position of potential slave owner or that of sympathetic witness to the physical subjugation of the enslaved woman. Both Carpeaux and Cordier ultimately depersonalize their subjects while constructing race and gender as linked categories. They deny the individuality or personhood of the people their works are intended to depict and exploit them as convenient stand-ins for colonial ideologies,

career advancement strategies, moral arguments, or barometers for measuring French cultural and national identity. Cordier accomplishes this by "dressing up" his female subject in classicizing allusions and employing lavish color variations, subduing her assumed sexual, "primitive" impulse, and piecing together ethnographic features in a harmonious fashion. Carpeaux, on the other hand, "strips down" his subject to a minimum of ethnographic signs and activates the surface of the body so that textures (skin, cloth, hair) are rendered palpable and sensualized. Tellingly, both processes—"dressing up" and "stripping down"—operate to subdue, objectify, and commodify the ethnographic other. Both sculptors have exploited the practice of sculpture as colonizing act by exerting physical and technical mastery over enslaved bodies that have been sanctioned and promoted under the legitimizing weight of science (realism) and Eurocentric aesthetics (idealization).

Carpeaux's approach to ethnographic sculpture, like Cordier's, constitutes a colonizing act. Cordier's busts exemplify the extent to which sculpting itself—the piecing together of materials extracted from colonized sources along with ethnographic (scientific) scrutiny rooted in realism and idealization—was a gesture that supported France's civilizing mission through mastery over the racial/ethnographic subject. Likewise, the humanitarian implications of Carpeaux's *Why Born Enslaved!* speak to the French civilizing mission through polarizing visual strategies of sensual attraction and subjugation of the racialized (female) body.

THE POWER OF AMBIGUITY

As sculptors of ethnographic pieces, both Carpeaux and Cordier worked within a highly politicized colonial context and alongside the growing popularity of primitivism, Orientalism, and Africanism. Moreover, their works dovetailed with the promotion of science as a sign of social and cultural progress and also reflected the marked effects of commercial capitalism and materialism. Carpeaux was, as were most sculptors of the Second Empire and Third Republic, deeply invested in the profitability of his works. He often reproduced busts or fragments from his other projects and marketed them as commercial editions.[44] Always on the lookout for subject matter that could draw critical attention and sell, both sculptors bet on slavery, abolition, and ethnography as selling points for their sculptures and as catalysts to further their careers.

Carpeaux, unlike Cordier, did not feel the need to produce a male pendant to his enslaved female figure as a commercial strategy. However, one was later created not by the sculptor himself but by his pupil Jean-François Marie Etcheto.[45] Carpeaux met Etcheto in 1868 while traveling in the Basque region of France and took the young artist into his atelier in 1872, when working on his Fountain of the Observatory (see fig. 1). Five years after Carpeaux's death, during a period when France's colonial expansion efforts in Africa and other territories had intensified, Etcheto produced a male bust in plaster titled *L'esclavage* (*Slavery*) (fig. 26), exhibiting it at the 1881 Salon. *L'esclavage* depicts a male figure of African descent nude from the waist up. Given the figure's distinctive "Negroid" facial features and kinky hair, along with the explicit title and indication of ropes binding the figure's arms behind his back, there is no doubt that Etcheto's bust was conceived as an explicit homage to Carpeaux's. As with that work, an air of ambiguity permeates Etcheto's enslaved male figure. Although the bust noticeably lacks the dynamism and drama of *Why Born Enslaved!*, both works share an interest in delineating ethnographic facial features. Their expressions differ: Carpeaux's piece communicates a degree of defiance as resistance by way of the gaze (*le regard*) noted by Gautier, while Etcheto has rendered his male figure with mouth and eyes closed, his head positioned not so much in a posture of contempt but in seeming acquiescence to his suffering.

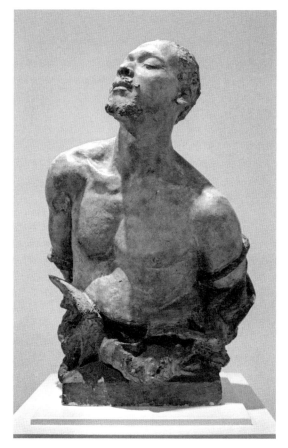

FIG. 26. L'ESCLAVAGE (SLAVERY), 1881
Jean-François Marie Etcheto (Basque, 1853-1889).
Plaster, with socle: H. 33⅝ in. (85.5 cm),
W. 19⅜ in. (49 cm), D. 20⅛ in. (51 cm).
Musée des Beaux-Arts de Pau (881.3.1)

It has been suggested that the closed eyes and position of the head were a deliberate aesthetic choice made by the sculptor to relate and yet differentiate

the bust from that of his master.[46] Both features approximate Carpeaux's interest in stirring moral outrage against human enslavement while provoking in the viewer a combined, ambiguous sentiment of compassion and eroticizing sensuality.

Part of the power and attraction of *Why Born Enslaved!* lies in its capacity to provoke interrogation in the viewer. Viewing it together with Cordier's *Woman from the French Colonies* and Etcheto's *L'esclavage* further underscores the work's multiple potential interpretations, which resist and discourage any restriction or closing down of meaning. The ethnographic works of these sculptors manage to exploit racial politics, classicizing aesthetics, and political capital associated with direct and indirect engagement with the discourses of slavery, abolition, and French colonial expansion as part of a civilizing mission from 1848 onward. Their ethnographic strategies force the viewer to consider these sculptures as enticing spectacles of beauty and sensuality while compelling us to grapple with some disillusioning and vexing questions.

Wendy S. Walters

PRESUMPTIONS ON THE FIGURE, GIVEN THE ABSENCES

In addition to being admired for its artistic accomplishment, Jean-Baptiste Carpeaux's *Why Born Enslaved!* (pl. 1) has been lauded for the way it demonstrates the artist's sympathy for the subject, an enslaved Black woman. It is well known that Carpeaux was in the process of designing the Fountain of the Observatory in Paris (see fig. 1) when he decided to produce a separate bust of the woman who would model for the continent of Africa in the larger work. While the fountain group drew him a large commission, Carpeaux was in financial straits at the time, and he made the bust to support the future fortunes of his studio. The work also resonated with colonial sympathies of the moment, and, because images of enslaved African persons were being translated into metaphors of liberty and freedom, Carpeaux knew there would be considerable opportunity in creating a piece that could be widely reproduced.[1] The attention to detail in the figure's comportment and entreating agony are obvious features of its composition, but the skill with which they have been rendered has prompted presumptions about Carpeaux's investments in abolition and emancipation that may be, perhaps, too generous.

The distress in the figure's face is the most obvious indicator of Carpeaux's awareness of the brutality that enslaved persons were regularly forced to endure. A brief note in *The Metropolitan Museum of Art Bulletin*, which in

1998 announced the acquisition of a terracotta copy of the bust (pl. 2), is generous in its imagining of the artist's intention: "Carpeaux was a liberal romantic whose humanitarian sentiments are manifest in our bust derived from the fountain's figure of Africa. He added a Michelangelesque sideward turn, ropes across the chest that seem barely able to contain the young woman's energy."[2] The "humanitarian sentiments" attributed to Carpeaux in this description speculate on his intention, which is substantiated only if *Why Born Enslaved!* is read as a work of inclusion reflecting a progressive vision of justice. In this interpretation, Carpeaux's accomplishment, beyond his mastery over materials, is the expression of complex feelings in a figure who was not instinctively expected to hold them.

An appreciation of Carpeaux's liberal intentions alongside his vast accomplishments in sculpture has characterized the art-historical understanding of the bust for almost 150 years, commencing with the first published reviews following its premiere, in both bronze and marble, at the 1869 Salon, the annual state-sponsored art exhibition in Paris. In their appreciation for the work, critics were quick to credit Carpeaux for his rich depiction of Black struggle amid suffering, almost as if the nuance of experience, instead of the nuance of representation, was his own accomplishment. The critic and painter André Albrespy remarked that the bronze version of *Why Born Enslaved!* highlighted the artist's gifts and generosity of spirit more than anything else. He noted, "The two busts by M. Carpeaux [*Charles Garnier* and *Why Born Enslaved!*] do him the greatest honor. They are devoid of academic stiffness; life throbs beneath the bronze."[3] With specific reference to *Why Born Enslaved!*, Albrespy also comments on how the color of the bronze reflects the "nature of the model," even though there is no evidence that she was known to him. Underlying his appreciation is the presumption that it was Carpeaux's bold hand that gave the bust a pulse of resistance rather than the subject herself.

Other aspects of the work invite an ambiguous interpretation and complicate our understanding of Carpeaux's humanist ambitions for it, if he in fact had any. The question inscribed on the socle, "Why born enslaved!," serves as the sole indicator of Carpeaux's possible abolitionist leanings, although it is an insufficient indicator of how deeply he held them. The phrase seems to speak directly to the sculpture's audience as an address offered in the second person. The exclamation point frames the question as rhetorical, one that adds the

possibility of narrative and drama to the pathos in the figure's expression. More than provoking debate or dialogue, the inquiry expresses incredulity toward the practice of enslavement.

Today the question would be easily answered by those ready to acknowledge the broad violations of empire—not least among them white supremacy, misogyny, and extraction of natural resources that legitimated the quest for wealth, land, and power. For many the practice of enslavement registers immediately as immoral and a devotion to violence, but some late nineteenth-century critics were bewildered by Carpeaux's query and did not understand why it had been written at all. Consider an early response to the sculpture from the critic Arthur Baignères:

> I would criticize just one thing, namely the pompous and dramatic inscription on the socle: "Why born a slave? [*sic*]" It is to misunderstand all the rules of art to ascribe a thought to a bust, especially a thought that is so complicated. It will be easy to rub away the inscription if it displeases, and [the work] will remain a beautiful art object.[4]

To rub away the text in order to preempt the displeasure of an audience that does not see their fortunes tied to a broadly shared fate is indeed easy compared to undoing the impact of hundreds of years of enslavement. Baignères's anxiety about the text's potential to debase the bust and his insistence that it could remain a "beautiful art object" if the question were removed testify to the power of the inscription in complicating the reception of the work.

It's not known whether Baignères's use of a question mark instead of the exclamation point was intentional or accidental, but it is worth noting that it diminished the emphatic nature of the inquiry. Proclaiming "Why born enslaved!" to an audience that did not consider the practice of sorting people by racial categories to be abhorrent or even unusual carries more urgency with the exclamation point. For some, the question might have been received as an invitation to reconsider one's enthusiasm for inequality. For others, the question brought attention to obvious facts of identity and the racial and national hierarchies that aligned with them. Such was the response of Cl. Suty, a critic who walked through the Salon feeling perplexed about why Carpeaux had asked it at all:

As to how it is that one is born a slave, M. Carpeaux has nothing to teach the good public to which he addresses himself. If we ask M. Carpeaux: "Why born a Muslim or a Buddhist, or a Protestant? Why born a subject of Queen Victoria or Wilhelm of Prussia?", he would doubtless respond that we know the answer just as well as he does. And that is precisely what we say to him.[5]

Insulted by the provocation, Suty insists that the answer to Carpeaux's question is already known. His response relies on essential categories of being that arise from circumstances of birth, as if to be enslaved is as natural a state of being as any other category of personhood, whether granted by faith or nobility.

"Why born enslaved!" is a rhetorical question, addressed to no one in particular, and this slippage masks Carpeaux's intentions in asking it. The phrase is not a statement in favor of abolition, and its indirection accommodates all kinds of responses, including contrivances of morality and justice that can be aligned with power as well as those that are self-serving. One could simply respond, "Why indeed?," as if acknowledging the question was response enough.

The Martiniquais political philosopher and psychiatrist Frantz Fanon recognized the outsize role that belief systems play in the depiction of Black identities, pointing to the entanglement between a person's actual experience and the metaphors that inform how they are described in a social context:

> Sealed into that crushing objecthood, I turned beseechingly to others. Their attention was a liberation, running over my body suddenly abraded into nonbeing, endowing me once more with an agility that I had thought lost, and by taking me out of the world, restoring me to it. But just as I reached the other side, I stumbled, and the movements, the attitudes, the glances of the other fixed me there, in the sense in which a chemical solution is fixed by a dye. I was indignant; I demanded an explanation. Nothing happened. I burst apart. Now the fragments have been put together again by another self.[6]

Fanon notes the experience of being misperceived as deeply damaging and transformative. The "other self" he refers to is a wounded version of one's personhood that emerges in the aftermath of misrepresentation. He argues that this phenomenon is particularly acute for Black people, whose bodies have held monetary value and have been subject to commercial exchange

just like objects of art. At the time *Why Born Enslaved!* premiered, it was not unusual for collections of anthropology, ethnography, and science to gather the remains of enslaved persons for display or dissection. Such practices endure. In 2021, Harvard University reported that its own Peabody Museum of Archaeology and Ethnology, founded in 1866, held the unburied remains of fifteen individuals of African descent who may have been enslaved.[7] The Peabody also has in its collection daguerreotypes of seven enslaved persons, commissioned in 1850 by Louis Agassiz, the Harvard naturalist, zoologist, and phrenologist whose research supported multiple interpretations of Black inferiority. While this collection differs significantly from that of The Met, it is worth considering the gesture of collecting persons as an outcome of a value system that prioritizes ownership as a marker of wealth and achievement. As the possession of Black people was outlawed, it is not surprising that in the years immediately following emancipation public interest in buying representations of Black persons increased, including effigies made more affordable through the ever-expanding means of industrial production. The idea that people's likenesses could be captured and collected without consent is not far from the idea that people could be, and the vast number of objects that were culled as a result of this peculiar fascination remains an issue that all institutions of cultural history must reckon with.

Why Born Enslaved! embraces the paradox of racial mythologies without attempting to resolve them, but it does not advocate for self-liberation by violence or manumission, as the figure's arms are bound by rope (fig. 27). The rope, an essential element of the composition, is an indicator that further abstracts the subject's identity: she represents one of many in bondage. The rope stands in for the institution of slavery and provokes further questions about Carpeaux's vision of this figure in the wake of history while reducing the figure's specificity. Carpeaux consistently included the rope on commercial reproductions of the bust, even as the features of the figure's face grew diminished by the inexactness of the molds. Given that France abolished enslavement (for a second time) in 1848, Britain in 1833, and the United States in 1865, it's clear that the practice had been largely illegalized when Carpeaux completed the first iterations of *Why Born Enslaved!,* though the reverberations of these changes would bring a plethora of new social restrictions designed to limit Black access to power.

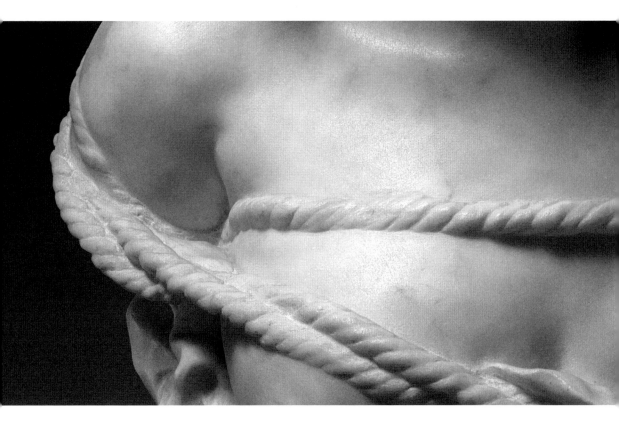

FIG. 27. WHY BORN ENSLAVED! (DETAIL OF PL. 1), MODELED 1868, CARVED 1873
Jean-Baptiste Carpeaux (French, 1827-1875).
Marble, H. 22 ⅜ in. (58.1 cm), W. 16 in. (40.6 cm), D. 12 ½ in. (31.8 cm).
The Metropolitan Museum of Art, New York, Purchase, Lila Acheson Wallace, Wrightsman Fellows,
and Iris and B. Gerald Cantor Foundation Gifts, 2019 (2019.220)

The cultural theorist and literary scholar Fred Moten offers an instructive note to mull on as one considers the choices the viewer may confront in looking at *Why Born Enslaved!*. He writes, "The history of blackness is testament to the fact that objects can and do resist."[8] By highlighting the way Black people are objectified and seen as mere representations of cultural values that are not necessarily their own, Moten reminds us that when we cannot see the possibility of successful resistance in a work it is likely that it was designed to be exactly that way. The ideological implications of insurrection are always relevant to discussions of liberty and freedom, yet it is not unusual to see historical facts about abolitionist struggles elided when emancipation in the colonies is discussed.

Unlike painting, sculpture exists in three dimensions, at once creating space and occupying it. These qualities give it a sense of immediacy that an

audience experiences in the present tense. Sculpture, like other media, also points back to its moment of creation, in addition to all other instances in which it informed or shaped a space through its materials. These accomplishments can be striking when a sculpture also represents the human form in stone, a material that will outlast its audiences. While the animating energy of *Why Born Enslaved!* was not tied to mythology or religion, another grand narrative vied for the sympathies of the audience. The transatlantic slave trade relied on a fiction of racial difference that was immense and consuming, a misperception of such magnitude that it reordered the balance of power and the aesthetic achievements that fol-

lowed in its wake. Thus, it does not seem unusual that sculptors who embraced Romantic expression, like Carpeaux, would be drawn to the dramas created by its sweeping inventions. Long-standing interest in Carpeaux's *Why Born Enslaved!* has much to do with the way it alludes to white supremacy without directly indicting it for the pain it has made visible. For The Met's version of the bust, Carpeaux employed marble, a precious material not often afforded to representations of subjects of African descent. It does seem that Carpeaux intended this figure to sit alongside other classicizing forms and, through the mere fact of its juxtaposition, invite the audience to imagine associations in personal virtue and value, the latter being the most significant.

 Why Born Enslaved! has also been recast or evoked by modern and contemporary artists—in *Negress*, a negative mold taken from the sculpture by Kara Walker, and *After La Négresse, 1872*, by Kehinde Wiley (pls. 3, 4). Promotional

images for Beyoncé's second Adidas × Ivy Park sportswear collection show her standing atop a plinth flanked by classical columns and reproductions of two busts—Carpeaux's and a Nubian queen, starkly rendered in white (fig. 28). In an accompanying video, Beyoncé sways on the plinth and also poses on the ground beside it, a living ideal unconstrained by anyone else's imagination. These contemporary engagements with *Why Born Enslaved!* affirm the many registers in which the work continues to find its audience.

Its appeal may be bolstered by the fact that few such persuasively naturalistic nineteenth-century sculptures of Black women by European artists exist: it is not surprising that this one has such a significant resonance. Another work of note, *Woman from the French Colonies* (pl. 32) by Carpeaux's forebear, the French sculptor Charles-Henri-Joseph Cordier, stands out for the gravitas of the figure's expression, which manifests as prim composure and avoids caricature or exaggeration. But stasis is also essential to Cordier's composition, a full demonstration of the sculptor's control. There has been unsubstantiated speculation, primarily by Cordier's descendants, that the model for both works was the same woman.[9] It is possible that she was Louise Kuling, a free Virginian who was living in Paris at the time and who in 1864 sat for an ethnographic portrait series for the National Museum of Natural History (fig. 29). Although it was typical for models to remain anonymous during Carpeaux's time, the fact that the sitter

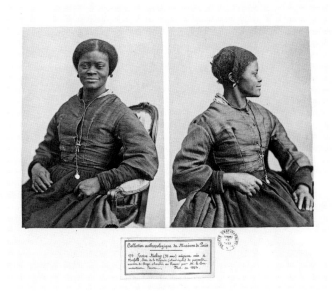

FIG. 29. LOUISE KULING, 1864

Jacques-Philippe Potteau (French, 1807-1876). Albumen prints from wet collodion negatives mounted on an album page from the series Collection Anthropologique du Muséum de Paris, with printed label reading, "179. Louise Kuling (35 years) negress born in Norfolk, State of Virginia (America) to parents from the Congo. Brought to France by M. le Commandant Louvet. Phot. in 1864," sheet: 12¼ × 13⅞ in. (31 × 35.3 cm). Muséum National d'Histoire Naturelle, Paris (SAP 155 [7] / 63)

was thought to be a woman of African descent makes her a distinct subject among all his works. Her story remains a mystery. The gap between what is known and what is imagined about *Why Born Enslaved!*, *Woman from the French Colonies*, and other sculptures from this time is immense and has provoked presumptions informed by the discourse of inclusion. Recognizing the ambiguity of these works is a necessary step in coming to understand what impulses these figures represent, given that they do not depict a specific individual but, rather, a type of person. They are not portraits.

As the art historian Charmaine A. Nelson has noted, the historical event that weighs most heavily on French nineteenth-century visual interpretations of enslavement is the Haitian Revolution of 1791–1804, which included efforts by Napoleon Bonaparte to remand the island's African populace back into enslavement in 1802.[10] The experiences of Black women in the French colony of Saint-Domingue had been especially harrowing. The average life span of a newly enslaved woman after she arrived at the colony was only seven years.[11] Incidents of torture included rape and constant threats of sexual violence as well as branding on their chests and backs.

Accounts of individual experience are rare, but some names of revolutionaries are known.[12] A few of the Black women who served in some revolutionary capacity included Catherine Flon, flagmaker; Suzanne Simone Baptiste Louverture, who suffered through profound torture to safeguard the whereabouts of her husband, Toussaint Louverture; and Sanité Bélair, who took a soldier's role in the revolution, as did her husband. French officers refused to execute her by firing squad, choosing instead to behead her as if to make a final statement about their control over her body and send a warning to all others whose minds aligned with hers.

Although the persons above are recorded in history, few objects commemorate their contributions to the early dismantling of the French empire. To date there are no known sculptures from the eighteenth or nineteenth century that represent their specific likenesses. Exceptions in other media include the English caricaturist Charles Williams's satirical print *Boney's Inquisition. Another Specimen of his Humanity on the Person of Madame Toussaint* [*sic*] (1804), which illustrates Louverture's skin being stretched with pincers and her fingernails being removed with a disturbing comedic candor.[13] Paintings of Bélair by Richard Barbot (fig. 30) and of Louverture by Andrew LaMar

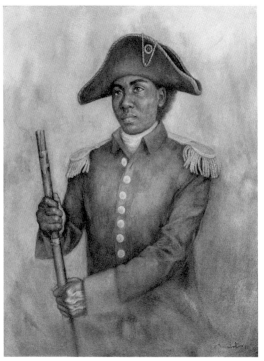

FIG. 30. SANITE BELAIR, 2019
Richard Barbot (Haitian, b. 1961).
Acrylic and oil on canvas, 40 × 30 in.
(101.6 × 76.2 cm). Courtesy the artist

FIG. 31. SUZANNE SIMONE BAPTISTE LOUVERTURE, 2020
Andrew LaMar Hopkins (American, b. 1977).
Acrylic on linen board, 5 × 4 in. (12.7 × 10.2 cm).
Private collection

Hopkins (fig. 31) are notable works in contemporary portraiture that aim to address this lack of representation. But as these images and figures do not exist in sculpture, much less from the nineteenth century, any work that represents a Black woman from that time may appear to stand in for this wide swath of history, whether it was intended to do so or not. Institutions must be cautious not to encourage this specific kind of misinterpretation. For as no known sculpture from this period tells this part of the story, to insist that any representation can occupy that space is to ascribe false meaning to it. In recent years, a portrait of Bélair has been added to the ten-gourdes Haitian banknote (fig. 32). That the above are not examples from the period created a dilemma for this book—how do we represent history accurately given the dearth of objects that can speak to it?

Because of these and other absences in representation, our contextual understanding of *Why Born Enslaved!* is limited to related objects we can

access. Its post-emancipation completion date and the lack of certainty about the sculptor's intentions mean that it is also possible to read *Why Born Enslaved!* as a work that fetishizes violence and submission above its other accomplishments. There is evidence that Carpeaux was a brutal man. An affinity for cruelty is a challenging fact to reckon with in the history of any artist, and in this moment our understanding of the impact of malignity on an individual's access to prestige and status has become harder to ignore. But Carpeaux's capacity for harm was cited in the catalogue accompanying *The Passions of Jean-Baptiste Carpeaux*, a major retrospective held at The Met in 2014, with his own notebooks serving as a kind of confessional:

> He shows himself not only hurting [his wife's] arm, an incident actually reported by Amélie's mother, but imploring her forgiveness, probably during one of her pregnancies, possibly during labor. She is definitely pregnant in a scene from 1871 of him bullying and berating her, probably in London.[14]

In recognition of this disclosure, the critic Barrymore Lawrence Scherer wrote in his review of the exhibition, "This exploration of Carpeaux doesn't ignore the dysfunctional husband and father. A bipolar strain of sadism runs through some of his intimate works—the drawing of bruises he inflicted on his wife, the touching marble portrait of his eldest child as *Wounded Cupid*" (fig. 33).[15] Carpeaux composed the latter work after many days of studying agony in the face of his three-year-old son, Charles, who had dislocated his left shoulder in a train-door accident. There will be those who say that to judge a

FIG. 32. TEN-GOURDES BANKNOTE
Bicentenaire de l'Indépendance d'Haïti/Bisantè Endepandans Dayiti, with detail
of *Sanité Bélair* (2020) by Richard Barbot (Haitian, b. 1961)

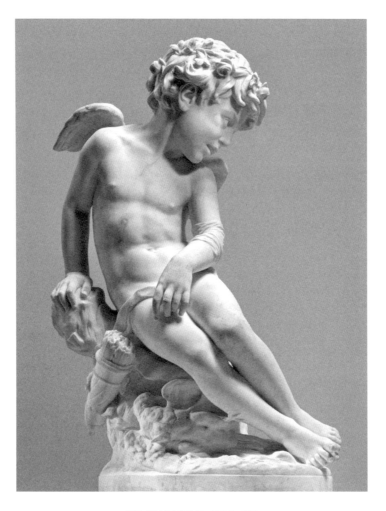

FIG. 33. WOUNDED CUPID, 1874
Jean-Baptiste Carpeaux (French, 1827-1875). Marble,
H. 81 in. (205.7 cm), W. 55 in. (139.7 cm), D. 33 in. (83.8 cm).
Musée des Beaux-Arts, Valenciennes (S.92.77)

nineteenth-century artist by twenty-first-century standards for acceptable behavior is unfair. But changing expectations for how we think about a work and its artist is one of the many tensions that emerge as we face these lacunae in history. To ignore this is to embrace another presumption that serves the past perception of *Why Born Enslaved!* but not the future opportunities for understanding that might be generated by it.

Caitlin Meehye Beach

REPRODUCING AND REFUSING CARPEAUX

Versions of Jean-Baptiste Carpeaux's *Why Born Enslaved!* exist in marble, bronze, terracotta, plaster, and biscuit porcelain. Across these media, they range in scale from lifesize to smaller reductions suitable for a tabletop or mantelpiece. Some bear the titular inscription "Pourquoi naître esclave!"; others do not. This diverse array of works was issued during and after Carpeaux's lifetime by the artist's atelier, or studio, and myriad French firms in the business of manufacturing sculpture and decorative arts, including Susse, E. Colin, Sèvres, and others.[1] And versions still remain in production: copies peddled by various purveyors online range from a bust in resin cast by the official ateliers of the Réunion des Musées Nationaux (fig. 34) to a wax statuette poured by the luxury candle company Cire Trudon.[2] From the time it was first produced to the present moment, *Why Born Enslaved!* has been not a singular object but one defined by a seemingly endless multiplicity.

This essay considers the reproduction of *Why Born Enslaved!* across media, space, and time. Whereas some scholars, most notably Walter Benjamin, have argued that technological reproducibility devalues a work of art, others have long understood replication as a central, even generative facet of Carpeaux's sculptural practice.[3] In 1869—the same year that marble and bronze versions of *Why Born Enslaved!* were displayed at the Paris Salon—the sculptor established his own studio dedicated in large part to the production of replicas.[4] The Atelier Carpeaux was an ambitious commercial enterprise, employing over two dozen men who labored to produce editions of some

of the artist's most popular works, *Why Born Enslaved!* included.[5] But this bust, circulated in the nineteenth century with the intentionally pejorative title *Négresse*, stood apart from the atelier's standard fare of nymphs, fisher boys, and allegorical figures as the only recorded depiction of a woman of African descent.[6] What follows addresses the implications of reproducing *Why Born Enslaved!* from the nineteenth century onward, particularly with regard to questions of race and the commodified body.

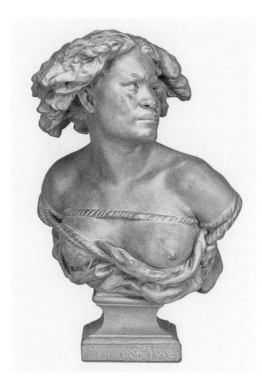

FIG. 34. WHY BORN ENSLAVED!, 21ST-CENTURY CAST
Ateliers d'Art des Musées Nationaux, after
Jean-Baptiste Carpeaux (French, 1827-1875).
Resin copy cast from an unpatinated plaster in the
collection of the Musée des Beaux-Arts Jules Chéret,
Nice, H. 13⅜ in. (35 cm), W. 9 in. (23 cm),
D. 8¼ in. (21 cm)

Although slavery had been outlawed in the French Atlantic for over two decades before Carpeaux first modeled *Why Born Enslaved!*, the proliferation of the bust during and after his lifetime bespeaks the ways representations of enslaved Black subjects were continually commodified and consumed in Western art long after abolition.[7] Yet the very fact of the work's enduring reproducibility has also arguably made space for the contestation of this paradigm in contemporary art. The artists Kehinde Wiley and Kara Walker created sculptures based on *Why Born Enslaved!* in 2006 and 2017, respectively, each of which asks the viewer to consider critically the materialities of making—and refusing—a sculptural body (pls. 3, 4). Wiley's *After La Négresse, 1872* and Walker's *Negress* do not merely respond to Carpeaux's sculpture as a historical representation but critically engage the reproductive processes that brought it into being in the first place. Carpeaux conceived the bust not as a singular object but as a variable one that could be reproduced across media and scales ad infinitum. Because of this inherent multiplicity, the meaning of *Why Born Enslaved!* is not beholden to its historical moment of conception but can rather be reshaped into the present day.

WHY BORN ENSLAVED! ACROSS MEDIA

The conceit for *Why Born Enslaved!* began—but did not end—in Carpeaux's work for the Fountain of the Observatory in the Luxembourg Gardens, Paris. Following a commission from the city architect Gabriel Davioud in 1867, the sculptor produced the fountain's central sculpture, *The Four Parts of the World Supporting the Celestial Sphere*, a monumental bronze group featuring personifications of Asia, Africa, America, and Europe hoisting a celestial orb toward the sky (see fig. 1).[8] *Why Born Enslaved!*, first modeled in 1868, grew from preparatory sketches for the figure of Africa, one of which depicted a Black woman crouching on bent knee (pl. 8). But whereas the women in *The Four Parts of the World* ultimately appeared with outstretched arms and outward poses, with the personification of Africa standing over a set of broken chains, the figure of *Why Born Enslaved!* remains unfree, her twisting torso constrained and truncated by ropes that bind her arms and breasts. This transformation from caryatid to captive is significant, not least because it signified the bust as a work of art in its own right, independent from the future Fountain of the Observatory. The production of the fountain group was of course delimited by the terms of its civic commission, and so Carpeaux's extraction and revision of a single figure allowed him to control and profit from the project in new ways. The changes he made also concretized the idea that the sculpture would be received first and foremost as an enslaved and commodified body, a problem that was further compounded by reproduction across media.

Why Born Enslaved! was first publicly exhibited in 1869, when Carpeaux debuted versions in marble and bronze at the Paris Salon.[9] By 1872, the sculptor had also produced commercial editions of the bust in terracotta and plaster, probably promoted in relation to the display of the first presentation maquettes, or models, for the Fountain of the Observatory at the Salon that year.[10] There is a great deal of variation across this corpus. Terracottas were issued at the full scale of twenty-four inches high and with the inscription "Pourquoi naître esclave" at the base, as seen in the example at The Met (pl. 2). Plasters were produced at full scale (fig. 35) and as half-scale reductions. Surface treatments are also highly variable among the works, with some modifications probably made after the purchase of a bust by different hands and at different times. A half-scale plaster reduction in the collection of the Brooklyn Museum, for example, has been patinated with a coppery wash whose glossiness mimics the

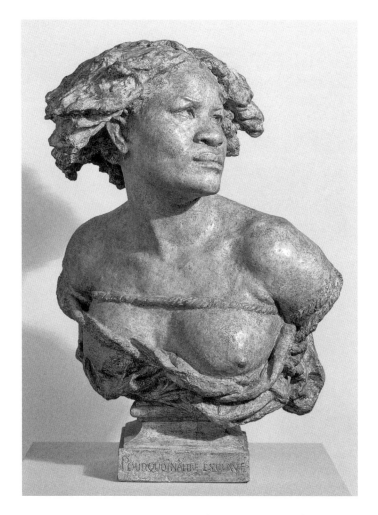

FIG. 35. POURQUOI NAITRE ESCLAVE (WHY BORN ENSLAVED), 1868
Jean-Baptiste Carpeaux (French, 1827-1875). Plaster with patina,
H. 25¼ in. (64 cm), W. 17¾ in. (45 cm), D. 13¾ in. (35 cm).
Petit Palais, Musée des Beaux-Arts de la Ville de Paris (PPS1540)

appearance of bronze (pl. 5), whereas a full-scale plaster at the Musée des Beaux-Arts, Reims, has been fully polychromed through the additional application of paint (fig. 36).[11]

In a general sense, the multiple media of *Why Born Enslaved!* can be traced to Carpeaux's ambition to promote his sculpture across the widest commercial sphere possible, from the imperial household to bourgeois and middle-class homes.[12] Reductions in plaster and terracotta were, of course, more affordable than virtuoso editions in marble and bronze. Whereas the

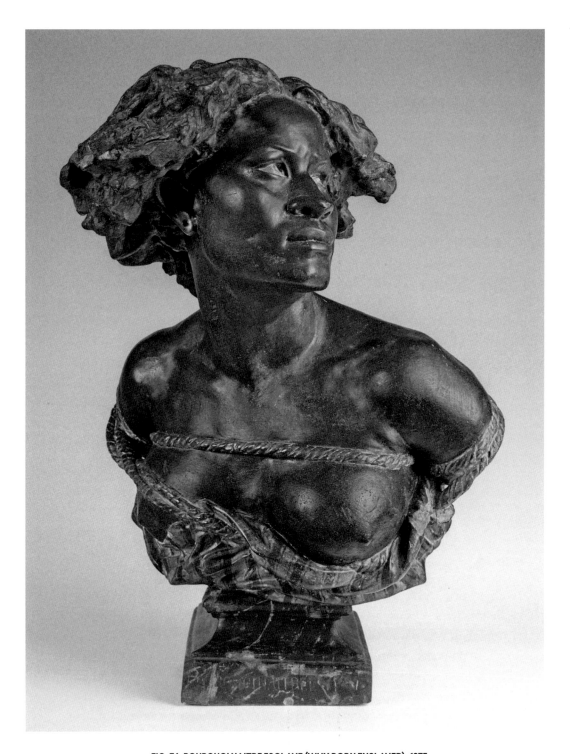

FIG. 36. POURQUOI NAITRE ESCLAVE (WHY BORN ENSLAVED), 1875
Jean-Baptiste Carpeaux (French, 1827-1875). Polychromed plaster,
H. 24 in. (61 cm), W. 18¼ in. (46.5 cm), D. 14⅝ in. (37 cm). Musée des Beaux-Arts, Reims (941.1.1)

latter must be carved or cast in a process that requires expensive materials and specialized technical expertise, the former could be produced at a comparatively cheap price through standardized molds. What is more, the bust's production across different media clearly bespeaks the belief shared by the white artist and many of his patrons and critics that different media and surface treatments should be mobilized to connote racial Blackness in statuary. As many scholars have noted, it was commonplace by the late nineteenth century that the sculptural surface, either by the virtue of the medium itself or its patination, might be regarded as indexical of corporeal skin.[13] Indeed, it was most likely for this very reason that Empress Eugénie had requested that the white marble version initially purchased for her by Napoléon III at the Salon of 1869 be exchanged "for the bronze"; a contemporary critic similarly decried "the dazzling whiteness" of the marble and noted that "bronze was better suited . . . to express such a type."[14] Carpeaux seems to have shared such ideas, for he later expressed a desire to patinate the figures of *The Four Parts of the World* "with the coloring of the races."[15] While this proposal was ultimately rejected by the fountain's commissioners, the reproduction of *Why Born Enslaved!* across media might be understood as a realization of the same aspiration—that the aesthetics of modern sculpture might be called upon to describe racial difference.

COMMODIFIED BODIES

Carpeaux's preoccupations with the racial dimensions of the sculptural surface were far from innocuous celebrations of diversity and multiculturalism. The art historian James Smalls has rightly situated *Why Born Enslaved!* in relation to a colonialist ethnographic tradition popularized at midcentury by white French artists like Charles-Henri-Joseph Cordier, who figured subjects of color as both racial types and eroticized objects for visual consumption.[16] Smalls points out that Carpeaux may have partaken in the humanitarian language of abolitionism in conceiving the bust's inscription but that his representation of a victimized and subjugated figure ultimately stood at odds with any notion of corporeal self-possession or subjective freedom.[17] Although abolition was decreed effective in the French empire in 1848, what the art historian Huey Copeland has described as the "structural logic of slavery" continued to order a visual realm rife with depictions of captive subjects by artists including Cordier, Carpeaux, and many others.[18] The marketing of such

idealized yet lifelike representations in an increasingly commercialized art world was in many ways inextricable from the way that enslavers objectified human lives as salable property.

Elsewhere I have argued that the production and consumption of sculptural bodies under racial capitalism in the nineteenth century perpetuated modes of commodification that were constituted under enslavement and other forms of unfreedom—distinct kinds of coerced labor, whether apprenticed or indentured, instituted across Afro-Asian diasporas after emancipation.[19] In this regard, it is worth noting that Carpeaux conceived of and marketed *Why Born Enslaved!* alongside a bust of a Chinese man, *Le Chinois,* editions of which were issued in 1872 in bronze, terracotta, and plaster, and at full and reduced scales (pl. 26).[20] *Le Chinois* also grew out of the sculptor's preparations for the Fountain of the Observatory and appears to have been the only other continental personification marketed as an independent bust. Its creation can be attributed to Orientalizing interests on the part of predominantly white French publics in the bodies of people defined as "other."[21] Several decades earlier, Cordier had popularized the marketing of decorative pairs, usually exoticized male/female pairs; in one famous instance, Queen Victoria purchased versions of his *Bust of a Woman* (*Négresse des colonies*; after 1857, *Vénus africaine*) and *Saïd Abdallah* for the entrance hall at Osborne House (her family summer home on the Isle of Wight) after seeing them on display at the Great Exhibition (see pls. 29, 30).[22] Carpeaux's specific pairing of a Black woman and an Asian man echoes Cordier's commercial maneuver but moreover evokes a larger history of unfree labor in the Atlantic world before and after emancipation, as European colonial powers forcibly imported East and South Asian workers to the Caribbean to perform plantation labor that before abolition had been stolen from enslaved Africans.[23] The production of both busts as representations of Black and Asian subjects and as reproductive goods themselves superimposes the machinations of racial capitalism on the art world and arguably bespeaks the ways the two exist in perpetual lockstep with one another. Capitalist markets commodify laboring bodies as capital, and the realm of aesthetics reifies this sublimation. Yet the very multiplicity of Carpeaux's sculpture has also paradoxically made space for the possibility of interrupting this seemingly closed circuit.

REMAINS AND REFUSE

In 2007, Kehinde Wiley responded to the commodified body evoked by *Why Born Enslaved!* with the marble bust *After La Négresse, 1872* (pl. 4). The eleven-inch-high statuette reimagines Carpeaux's figure as a young Black man who casts a sidelong glance over his shoulder.[24] Wiley, an American artist best known for his heroic, large-scale portraits, produced this bust as part of a 2006 series that deploys the technique he calls "street casting," in which he collaborates with individuals, often strangers, to pose after figures in famous works of art. Eschewing the nudity and binding ropes of the earlier work, Wiley instead depicts the sitter in a Lakers jersey. In so doing, the artist brings the question of bodily objectification into the contemporary moment, with the basketball jersey in particular evoking the long history of the exploitation and commodification of Black athletes within the sports-industrial complex.[25] With a title evocative of the European academic tradition of artists copying "masterworks," to use a term Wiley has long critiqued in his practice, the sculpture simultaneously reflects and refracts the representational logic of Carpeaux's original work.[26]

Like Carpeaux, Wiley conceived of *After La Négresse* as a work for reproduction. He published the bust in an edition of 250, collaborating with Cerealart, a Philadelphia-based company that "develops, produces, and distributes" work by contemporary artists "who are interested in exploring the possibilities presented by consumer culture."[27] Each bust comes packaged in a glossy black cardboard box printed on one side with a high-contrast photograph of the sculpture, accompanied by its title in elegantly looping script, and on the other a pithy description of the work and Wiley's career (figs. 37, 38). The box seems as much a part of the work of art as the sculpture itself, reminding us that artists' multiples have much more in common with a world of collectible tchotchkes and bibelots than many might initially suspect. In this respect, *After La Négresse* represents a critical engagement not only with *Why Born Enslaved!* but also with Carpeaux's enterprise at large, which the art historian Jacques de Caso has memorably described as "a unique example of undisguised commercialization."[28] In its serial production and presentation, Wiley's bust stands as a forthright statement on the nature of art objects as consumable goods.

Wiley further lays bare the question of consumption in the material composition of the bust, whose cloudy surface approximates but does not

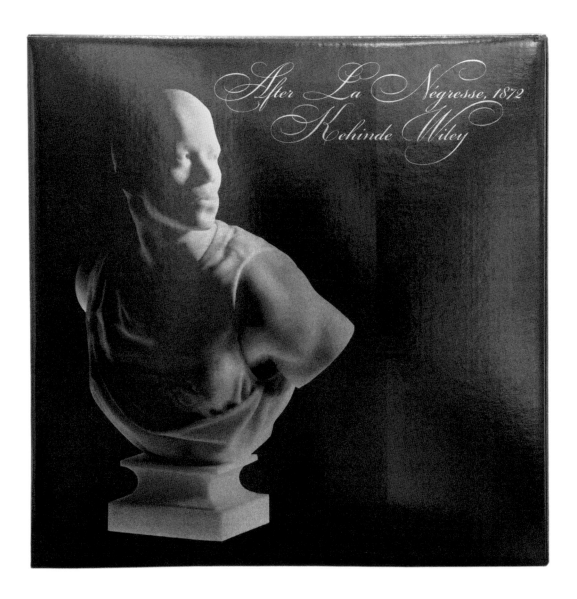

FIG. 37. TOP OF BOX FOR "AFTER LA NEGRESSE, 1872," 2006
Kehinde Wiley (American, b. 1977)

After La Négresse, 1872

Kehinde Wiley

Kehinde Wiley's, After *La Négresse*, 2006, influenced by Jean-Baptiste Carpeaux's "La Négresse, 1872", or as inscribed on the base, "Porquoi! Naître esclave!" ("Why born a slave"), is a limited edition cast marble bust sculpture in a series.

Wiley has employed the classic bust as a new medium in his exploration of the sacred and secular themes of the Renaissance and Baroque. Wiley's portrait references embedded codes of gesture and dress, past and present, while provoking a reconsideration of lingering stereotypes about masculinity, race, and class in our society today.

Wiley's works reference specific paintings in the history of art by several masters, such as Titian and Tiepolo, while drawing from a range of art historical and vernacular styles in his compositions from the French Rococo to the contemporary urban street. Wiley collapses history and style into a uniquely contemporary vision. He describes his approach as "interrogating the notion of the master painter, at once critical and complicit." He makes figurative paintings that quote historical sources and position young black men within that field of power. His heroic figures, sometimes larger than life size, are depicted in poses of power and spiritual awakening. He deliberately mixes images of power and spirituality, using them as a filter in the portrayal of masculinity.

After receiving his MFA from Yale in 2001, Wiley began exhibiting at Deitch Projects in New York, Rhona Hoffman Gallery in Chicago, and Roberts & Tilton in Los Angeles. His most recent exhibitions include *Passing / Posing* at the Brooklyn Museum in New York; Columbus, at the Columbus Museum, OH; *Scenic*, at Rhona Hoffman Gallery, Chicago, IL; and *The World Stage: China*, at the John Michael Kohler Arts Center in Sheboygan, WI.

After La Négresse
Edition: 250 signed and numbered
Material: Cast marble dust and resin
Dimensions: 11" h x 10" w x 9"d / 27.94cm h x 25.4cm w x 22.86cm d
©Kehinde Wiley, 2006
www.kehindewiley.com

CEREALART
149 North 3rd Street
Philadelphia, PA 19106
T.215.627.5060
F.215.627.5061
info@cerealart.com
WWW.CEREALART.COM

FIG. 38. BOTTOM OF BOX FOR "AFTER LA NEGRESSE, 1872," 2006
Kehinde Wiley (American, b. 1977)

FIG. 39. "NEGRESS," IN PROGRESS, 2017
Kara Walker (American, b. 1969). Plaster

reproduce the materiality of white marble. It is cast from a mixture of marble dust and resin, a synthetic compound frequently favored by modern manufacturers in the creation of countertops and home furnishings as well as sculptural replicas—including the replicas of *Why Born Enslaved!* produced in the twenty-first century by the Réunion des Musées Nationaux—because of its relative affordability. The fact that marble dust is fundamentally discard—that which has been chipped, damaged, deformed, buffed away, or otherwise removed—bears particular significance in relation to Wiley's engagement with Carpeaux in *After La Négresse*. Referred to as "wasters" in workshop parlance, the material discarded in the process of making sculpture and ceramics has long been valued by makers, archaeologists, and scholars for the kinds of evidence it yields about processes of experimentation and production.[29] Wasters might lend insight, for example, into how an object was fired or cast, where it was made, or what a manufacturer ultimately deemed unsalvageable. Although Wiley is better known as a painter than a sculptor, this practice of creating a body from discard rhymes with his broader interest in making visible figures who have traditionally been occluded in the canon of Western art. *After La Négresse* does so not only in the realm of

representation but also in its negotiation and interruption of the very processes of sculptural reproduction, making new bodies from what otherwise might be overlooked.

Wiley is not the only artist to engage with *Why Born Enslaved!* through sculptural remains. In 2017, the American artist Kara Walker cast a copy in plaster of one of the many existing reduced multiples of Carpeaux's bust but ultimately jettisoned the positive copy in favor of the plaster mold in which it was cast (pl. 3).[30] The work, *Negress*, is thus the ghostly inverse of the bust, recognizable through the soft contours of the figure's face imprinted into the deepest deposit of the cavity. In a photograph taken after the casting process, replica and mold lie next to one another surrounded by the rubble of studio detritus (fig. 39). The fragments are strange bedfellows, lying in a haphazard intimacy not unlike that depicted in the famous study of severed heads executed by Théodore Géricault in about 1818 (fig. 40). Géricault made the painting in preparation for his depiction of a shipwreck off the Senegalese coast in *The Raft of the Medusa*, which likewise figures the catastrophic events that unfolded in the wake of French colonialism in terms of corporeal fragments.[31]

Walker chose to display *Negress* on the ground. The work was first debuted in 2017 at the DESTE Foundation for Contemporary Art on the Greek island of Hydra as part of the artist's installation of *Figa*, the severed front paw of her colossal sugar-and-polystyrene sphinx *A Subtlety, or the Marvelous Sugar Baby*, originally exhibited at the former Domino Sugar Refinery in Williamsburg, Brooklyn, in 2014 (fig. 41; see fig. 14).[32] Walker installed *Negress* in a corner at ground level, nestled into a heap of plaster dust and illuminated by a single flickering candle. Positioned off to one side of the monumental *Figa*, the installation called to mind the philosopher Georges Bataille's notion of the *informe*, or the gravitational pull toward formlessness and abjection, and the art critic and historian Rosalind Krauss's reading of the *informe* as both structure and technique, or "a way . . . to group a

FIG. 40. SEVERED HEADS, CA. 1818
Théodore Géricault (French, 1791–1824).
Oil on canvas, 19⅝ × 24 in. (50 × 61 cm).
Nationalmuseum, Stockholm (NM 2113)

FIG. 41. "FIGA" (2014), INSTALLATION AT DESTE FOUNDATION PROJECT SPACE, 2017
Kara Walker (American, b. 1969). Sugar on polystyrene,
H. 55 in. (139.7 cm), W. 11 ft. 4 in. (345.4 cm), D. 88 in. (223.5 cm),
installed at *Kara Walker: Figa*, DESTE Foundation Project Space, Slaughterhouse,
Hydra, Greece

variety of strategies for knocking form off its pedestal."[33] These ideas are especially resonant in light of the ways that representations of enslavement so frequently reproduce the abject position of the slave, as the historian and literary scholar Saidiya Hartman has written.[34] With *Negress,* Walker refuses the bodily presence of the enslaved both in her jettisoning of the bust in favor of its mold and in its display. Abjection, instead, figures as both refuse and refusal as the hollowed-out form of Carpeaux's *Why Born Enslaved!* is knocked off its pedestal and made to lie on the ground.

CODA: MULTIPLICITY AND THE *DROIT D'AUTEUR*

In accordance with French copyright law, which grants free use of an author's works fifty years after their death, Carpeaux's body of work entered into the public domain in 1925.[35] Previously, the artist's family had limited reproduction rights to just a handful of contracted producers (primarily Susse and the Sèvres Manufactory); the expiration of an exclusive copyright allowed for unrestricted access to his oeuvre.[36] On the one hand, this shift exacerbated

the problem of commodification discussed earlier in this essay as editions of *Why Born Enslaved!* proliferated to an unprecedented degree. On the other, it signaled the potential for a new kind of engagement with—and reproduction of—Carpeaux's works. With the circumscriptions of the *droit d'auteur* no longer in effect, anyone was free to use his creations in the manner they wished. Walker's *Negress*, in particular, directly indexes this phenomenon. The plaster mold is the ghostly inverse of a reproduction of a reproduction, a fitting irony considering that Carpeaux believed his molds to be as much objects of value and artistry as the sculptures themselves.[37]

It is often all too easy to conceive of contemporary artists' responses to historical works of art as a kind of solvent to the devastating hierarchies of race, gender, and power that so frequently structured their production. Yet *After La Négresse* and *Negress* are, arguably, not mere art historical ripostes to the many multiples of *Why Born Enslaved!*. Rather, Wiley and Walker pull apart the phantasmagoria of mechanical reproduction that makes this very multiplicity possible, demanding that we apprehend the material processes that work over time to render sculptural bodies visible and invisible, present and absent, singular and multiple.

Chronology

Rachel Hunter Himes

1603

The publication of the first illustrated edition of Cesare Ripa's *Iconologia*, a handbook of allegorical figures, establishes the iconography of the four parts of the world—Europe, Africa, Asia, and America—as female personifications accompanied by attributes symbolizing the respective continents' native resources and the perceived character of their inhabitants, and emphasizing the difference between Europeans and other peoples they deemed less "civilized."

1659

France establishes a colonial settlement on the island of Saint-Louis in the mouth of the Senegal River. Saint-Louis will become an important site for the sale and transportation of enslaved Africans to the group of Caribbean islands known as the French Antilles.

1664

Finance Minister Jean-Baptiste Colbert charters the French West India Company (Compagnie Française des Indes Occidentales), the first of seven successive companies to receive exclusive trading rights and a state-sanctioned monopoly on the sale of enslaved Africans in the French colonies. Despite the government's attempts to regulate the trade in goods and enslaved persons, the monopoly companies are unable to meet the demands of colonial planters, and private enterprise grows rapidly.

1670

France's colonial empire in the Antilles consists of French Guiana, Martinique, Guadeloupe, Grenada, Réunion, and Saint-Domingue. (Ile de France, or Mauritius, would be claimed from the Dutch in 1715.) Following the execution, expulsion, and withdrawal of the indigenous Kalinago (Carib) and Taíno peoples from the colonies, a plantation system is established that relies upon the labor of enslaved Black men and women to produce lucrative agricultural commodities, including coffee, tobacco, cotton, indigo, and, most significantly, sugar.

1684

An early and influential ethnographic text, *A New Division of the Earth by the Different Species or "Races" of Man That Inhabit It* (*Nouvelle Division de la Terre*) is published. Written by François Bernier, it distinguishes four distinct "races" by physical traits, including skin color.

1685

Colbert's Code Noir insists slavery in the French colonies is "necessary and authorized," identifying enslaved persons as property and establishing systems of control over free and enslaved persons of color by codifying the inheritance of enslavement through the mother, regulating marriage and sexual relations between the free and the enslaved, standardizing punishment on the plantation, and forbidding enslaved persons from owning property and making contracts.

1716

In response to pressure from wealthy colonists, the Regent of France, Philippe II, duc d'Orléans, issues an edict permitting the transport of enslaved persons to France, contradicting a long-standing policy that granted freedom to the enslaved upon arrival in that country. It is the first in a series of decrees that attempt to regulate the presence of enslaved and free people of color (*gens de couleur*) in the metropole.

1781

Jean Antoine Houdon completes the model for a fountain group featuring lifesize figures of a nude bather in white marble (fig. 7) and an attendant in contrasting black lead. Initially proposed as a royal commission, the sculpture is instead acquired by Louis Philippe Joseph

d'Orléans, duc de Chartres, for his gardens at Monceau, where it stands for several years as the only known representation of a lifesize Black figure on a fountain in France (fig. 8). After the duc d'Orléans is executed by the revolutionary government, the fountain is vandalized. It is later confiscated by the Commission Temporaire des Arts, and the figure of the attendant is lost or destroyed.

1787

The Society for Effecting the Abolition of the Slave Trade is founded in London by a group of twelve prominent campaigners. The pottery firm directed by businessman and abolitionist Josiah Wedgwood issues a ceramic medallion featuring a kneeling and shackled Black man with the inscription "Am I not a man and a brother?" that is quickly adopted as the seal of the Society (pl. 10).

1788

Parisian abolitionists establish the Société des Amis des Noirs (Society of the Friends of the Blacks), which advocates for an immediate end to the slave trade and a gradual end to slavery, and adopts the Wedgwood image as its official seal. It is countered by the Massiac Club, which defends the interests of colonial planters in the National Assembly.

1789

The Declaration of the Rights of Man pronounces that all men are born and remain free and equal in rights, establishing the principles that will underpin the French Revolution. While the document makes no mention of slavery, abolitionists argue for emancipation and an end to the slave trade on its grounds. News of the declaration circulates among the enslaved in Saint-Domingue, who will soon take up these values in their own revolution. The Sèvres Manufactory produces a biscuit porcelain medallion after the Wedgwood

antislavery medallion that bears the inscription "Ne suis-je pas un homme? Un frère?" (Am I not a man? A brother?) (fig. 9). The manufactory's director, Charles Claude de Flahaut, comte d'Angiviller, halts production soon after firing begins for fear that the medallion's circulation will incite rebellion among the enslaved in the French colonies.

1791

After months of covert organizing, enslaved individuals in the northern province of Saint-Domingue launch the largest slave insurrection in the history of the Americas, systematically seizing and destroying plantations, burning the principal cities of Le Cap and Port-au-Prince, and demanding their own freedom and an end to slavery.

1792

In response to the uprising, the National Assembly grants civil and political rights to free men of color in the colonies against the objections of colonial planters. In September, the First French Republic is declared, and the monarchy is abolished.

1793

In August, Civil Commissioner Léger Félicité Sonthonax, sent from Paris by the revolutionary government, unilaterally abolishes slavery in the northern province of Saint-Domingue in an attempt to put an end to the rebellion. Two months later, Sonthonax and his fellow commissioner Etienne de Polverel end slavery in the remainder of the colony.

1794

In the first French abolition of slavery, the National Convention ratifies emancipation in Saint-Domingue and extends it to all French colonies, granting the rights of citizenship to the formerly enslaved. Wages and free time are mandated for the newly emancipated, who

are nevertheless prohibited from seeking employment beyond the plantation. Houdon repurposes the model from his 1781 fountain to create a bust of a Black woman with an inscription commemorating emancipation (pls. 19, 20). Louis Simon Boizot designs two prints featuring a Black man and woman in profile with the inscriptions "Moi égale à toi" (Me equal to you) and "Moi libre aussi" (Me also free) (pls. 17, 18). The same figures, adorned with a Phrygian cap and level symbolizing freedom and equality, appear in a biscuit porcelain group that Boizot designs for Sèvres (pl. 16). These works recall his revolutionary porcelain group *La fraternité ou la mort* (*Fraternity or Death*, 1793; Musées d'Art et d'Histoire de La Rochelle, MNM.1983.4.1). A set of playing cards featuring revolutionary figures instead of kings and queens is issued. Among the figures depicted is an armed Black man seated on a sack of coffee, broken shackles at his feet, representing "Courage" and "Egalité de Couleurs" (pl. 14).

1801

The formerly enslaved revolutionary leader Toussaint Louverture issues a constitution that proclaims him governor-general of Saint-Domingue, permanently abolishes slavery, and eliminates social and civil distinctions based on race and color, yet also codifies mandatory plantation labor.

1802

Following the coup d'état of 18 Brumaire, Napoleon Bonaparte, the new First Consul for Life, reinstates the slave trade and reestablishes slavery in St. Lucia, Ile de France (Mauritius), Réunion, Martinique, and Guadeloupe. In the same year, General Charles Leclerc lands at Saint-Domingue with an expeditionary force of 20,000 in a bid to reassert French control over the colony.

1804

Governor-General Jean Jacques Dessalines proclaims the independence of the former French colony of Saint-Domingue, calling the new nation "Haiti" after the Taíno name for the island.

1807

The British transatlantic slave trade is abolished by Parliament. In the United States, Congress passes a law prohibiting the import of enslaved persons into the country, although both illegal trade and the domestic market persist.

1815

Napoleon abolishes the French slave trade during the Hundred Days, his temporary return to power following abdication and exile. Although traders continue to violate these prohibitions, France will curtail the slave trade twice more: in 1817, when it is limited to the French colonies, and in 1818, when it is banned outright. After Napoleon's defeat at Waterloo, the Treaty of Paris restores French Guiana, Martinique, Réunion, Guadeloupe, and territory in Senegal to French control and stipulates that France should take immediate measures to end the slave trade. The National Museum of Natural History in Paris acquires the skeleton and body cast of Sarah Baartman, the Khoekhoe woman exhibited in London and Paris for her so-called primitive physiognomy. The cast will later be displayed in the same gallery as Charles-Henri-Joseph Cordier's ethnographic busts.

1821

A new wave of French abolitionism is marked by the establishment of an anti–slave trade committee in the newly formed Society for Christian Morals (Société de la Morale Chrétienne).

1825

Charles X recognizes Haitian independence in exchange for an indemnity payment of 150 million gold francs as compensation for lost revenue and properties in land and enslaved persons.

1830

The French invade Ottoman Algeria and capture Algiers, establishing colonial rule.

1833

Parliament abolishes slavery in all British territories.

1834

The French Abolition Society (Société Française pour l'Abolition de l'Esclavage) is founded and begins to campaign for an immediate end to slavery in the French Antilles.

1838

After Haiti borrows extensively from French, German, and US banks to make indemnity payments to France totaling 30 million francs, Louis Philippe I reduces the remaining debt on its indemnity to 90 million francs (approximately US $21 billion). Haiti will not finish paying the interest incurred from these loans until 1947.

1839

The Ethnological Society of Paris, the first such organization of its kind, is founded by the physician and physiologist William Frédéric Edwards. The society seeks to establish a relationship between physical traits—particularly head shape and facial features—and racial types.

1848

Under the newly established Second Republic, slavery is ended for the second time in the French colonies, and the slave trade is abolished. Civil rights, citizenship, and universal male suffrage are extended to the formerly enslaved.

Yet coercive labor regimes bind newly freed people to plantations, where they work under systems of sharecropping, contract labor, and indenture alongside laborers imported from India, China, and Central Africa. Cordier makes his Salon debut with the bust of a formerly enslaved Sudanese artists' model, which is received as a celebration of the end of slavery (pl. 29). Exhibited under the name *Saïd Abdallah* and later at the 1850–51 Salon as *Nègre de Timbouctou* (*Negro from Timbuktu*), the bust marks Cordier's transformation of the individual Seïd Enkess into a fictive ethnographic type, a process he would repeat with other sitters. Jean-Pierre Dantan (called Dantan-Jeune) travels to Egypt where he models the busts *Hora* (pl. 28, fig. 23) and *Birru* (fig. 24) after two Ethiopian children. These are later donated by ethnologist Antoine d'Abbadie d'Arrast to the National Museum of Natural History in Paris.

1851

Cordier shows *Saïd Abdallah* at the Great Exhibition in London, where it is purchased by Queen Victoria, who also commissions a bronze cast of its pendant, known after 1857 as *Vénus africaine* (*African Venus*; pl. 30). The same pair is commissioned by the French state for display in the anthropological gallery at the National Museum of Natural History in Paris. In December, French president Louis Napoléon Bonaparte stages a coup and declares himself Emperor Napoléon III. Under the Second Empire (1852–70) the rights of citizenship are rescinded in the Antillean colonies while labor requirements become more stringent, imposing heavy penalties for failure to work on the plantations.

1852

Within ten months of its initial publication, eleven translations—including one in French—and three theatrical adaptations of

Harriet Beecher Stowe's novel *Uncle Tom's Cabin* appear, reflecting the immense popular appeal of this critique of American slavery following abolition in the French colonies, which was itself a source of great national pride for France.

1853

Arthur de Gobineau publishes the widely read *Essay on the Inequality of the Human Races* (*Essai sur l'inégalité des races humaines*), which argues for a hierarchy of races, correlating race with intellectual capacity and civilizational achievement.

1856

Cordier undertakes a state-funded trip to Algeria to "study the various types of indigenous people from the standpoint of art" and purchase marble from Algerian quarries. During the first of seven trips to Egypt, Jean-Léon Gérôme is joined by Frédéric-Auguste Bartholdi in Cairo.

1860

Cordier joins the Anthropological Society of Paris (La Société d'Anthropologie de Paris, founded in 1859), where he will later lecture on his ethnographic art, and debuts his Anthropological and Ethnographic Gallery, a collection of forty-nine busts, at the Palais de l'Industrie in Paris. Following the exhibition's success, he is awarded the Legion of Honor by Napoléon III.

1861

To protect its economic interests in the region, France invades Mexico, overthrowing the Second Mexican Republic (1846–63) and establishing the short-lived Second Mexican Empire (1864–67), ruled by Austrian Archduke Ferdinand Maximilian. The Civil War breaks out in the United States over the question of slavery. While France remains officially neutral, voices among the elite, including Napoléon III, express support for the

secession of the Confederacy, seeking to retain economic ties with the cotton-producing South, which they view as a potential bulwark against US expansion into Latin America. At the Paris Salon, the state purchases Cordier's *Woman from the French Colonies* (pl. 32) on behalf of Napoléon III.

1863

Abraham Lincoln delivers the Emancipation Proclamation, declaring the freedom of all enslaved persons in the Southern secessionist states. Inspired by this event, John Quincy Adams Ward completes the model for *The Freedman* and exhibits the sculpture at the National Academy of Design in New York the following year (pl. 22). The term "ethnographic sculpture" (*la sculpture éthnographique*) first appears in Julien Girard de Rialle's description of several full-length non-European figures on display at the Paris Salon, including the *Allegory of Africa* (pl. 25) from Bartholdi's fountain commemorating Admiral Armand Joseph Bruat, the colonial military leader and former governor-general of the Antilles. Girard de Rialle favorably contrasts the perceived scientific realism of these sculptures with academic idealism.

1865

The ratification of the Thirteenth Amendment abolishes slavery in the United States, and the Civil War comes to an end. Edmonia Lewis departs for Europe, visiting London, Paris, and Florence on her way to Rome.

1867

The Universal Exhibition is held in Paris and attended by Jean-Baptiste Carpeaux and Edmonia Lewis. On view are Ward's *Freedman* and Cordier's *Love One Another* (fig. 4), in which a Black and a white child embrace. That summer, Carpeaux receives a state-sponsored commission for a sculpture group to top a

fountain on the Paris meridian line along the Avenue de l'Observatoire in the Luxembourg Gardens. He submits preliminary designs for a group representing the four parts of the world supporting the celestial sphere (pl. 9). Edmonia Lewis completes *Forever Free* in Rome (pl. 21).

1868

While working on the commission for the Fountain of the Observatory, Carpeaux models *Le Chinois* (pl. 26) and *Why Born Enslaved!* after unidentified models who pose in his studio.

1869

Why Born Enslaved! is exhibited at the Salon under the title *Négresse*. A marble edition (fig. 3) is purchased by the emperor for the Saint-Cloud apartments of his wife, Empress Eugénie, who later exchanges the bust for a bronze version (now destroyed). Carpeaux establishes an atelier at which commercial editions of *Why Born Enslaved!* are produced for sale. Lewis's *Forever Free* arrives in Boston and is dedicated to the abolitionist minister, the Reverend Leonard A. Grimes. In his Paris studio, Gérôme completes his portrait of a Black man exhibited as *Bashi-Bazouk* (pl. 31).

1870

Blamed for France's decisive defeat in the Franco-Prussian War, Napoléon III is deposed by the National Assembly, ending the Second Empire. Under the Third Republic, universal male suffrage and the rights of citizenship are restored in the colonies. While colonial citizens are no longer subject to special work legislation, sugar production continues, now facilitated by the labor of immigrants from India and China.

1872

Carpeaux's full-scale clay model for *The Four Parts of the World* is approved by the Commission des Beaux-Arts. A plaster cast is exhibited at the Paris Salon (fig. 21), where it

receives mostly negative reviews from critics. Atelier Carpeaux launches a bronze edition of *Le Chinois* and makes the bust available as a half-size reduction in plaster, terracotta, and bronze.

1873

A second marble version of *Why Born Enslaved!* is completed (pl. 1). In Algeria, the Warnier Law opens up Muslim-owned land for purchase, facilitating the transfer of more than a million acres of arable land to French settlers.

1874

The Fountain of the Observatory is installed in the Luxembourg Gardens (fig. 1). After its installation, Carpeaux writes to Gabriel Davioud, the city architect responsible for the commission, to request that the four figures be patinated "with the coloring of the races," but his suggestion is declined.

Notes

PREFACE

1. Jean-Baptiste Carpeaux, *Ugolino and His Sons*, 1865–67, MMA 67.520.
2. Christina Sharpe, *In the Wake: On Blackness and Being* (Durham, N.C., and London: Duke University Press, 2016), p. 117.
3. Sarah E. Lawrence and Elyse Nelson, with photographs by Paul Lachenauer, "*Why Born Enslaved!*," MetCollects, episode 11 (2019), online feature, including Wendy S. Walters, "A Poet's Response," video, 3:25 minutes, https://www.metmuseum .org/art/online-features/metcollects /why-born-enslaved.

INTRODUCTION

1. Anne Middleton Wagner, *Jean-Baptiste Carpeaux: Sculptor of the Second Empire* (New Haven: Yale University Press, 1986), p. 183.
2. Problems inherent to the sculptural representation of abolitionist ideas are examined in Caitlin Meehye Beach's book *Sculpture at the Ends of Slavery* (Berkeley: University of California Press, forthcoming).
3. The literature on this topic is vast and growing; for additional resources, see Further Reading. David Bindman and Henry Louis Gates Jr., eds., *The Image of the Black in Western Art*, new ed., 5 vols. (Cambridge, Mass.: Belknap Press of Harvard University Press, in collaboration with the W. E. B. Du Bois Institute for African and African American Research and the Menil Collection, 2010–14); Charmaine A. Nelson, *The Color of Stone: Sculpting the Black Female Subject in Nineteenth-Century America* (Minneapolis and London: University of Minnesota Press, 2007); Charmaine A. Nelson, *Representing the Black Female Subject in Western Art*, Routledge Studies on African and Black Diaspora 2 (New York and London: Routledge, 2010); Anne Lafont, *L'art et la race: L'Africain (tout) contre l'oeil des Lumières* (Dijon: Les Presses du Réel, 2019); and James Smalls, "Exquisite Empty Shells: Sculpted Slave Portraits and the French Ethnographic Turn," in *Slave Portraiture in the Atlantic World*, ed. Agnes Lugo-Ortiz and Angela Rosenthal (New York and Cambridge: Cambridge University Press, 2013), pp. 283–312.
4. See Esther Chadwick and Meredith Gamer, *Figures of Empire: Slavery and Portraiture in Eighteenth-Century Atlantic Britain*, exh. brochure (New Haven: Yale Center for British Art, 2014), https://britishart.yale.edu /exhibitions-programs/figures-empire -slavery-and-portraiture-eighteenth-century -atlantic-britain; Adrienne L. Childs and Susan H. Libby, *The Black Figure in the European Imaginary*, with an introduction by David Bindman, exh. cat. (Winter Park, Fla.: The Cornell Fine Arts Museum, Rollins College, 2017); Denise Murrell, *Posing Modernity: The Black Model from Manet and Matisse to Today*, exh. cat., Wallach Art Gallery, Columbia University, New York, and Musée d'Orsay, Paris (New Haven: Yale University Press in association with The Miriam and Ira D. Wallach Art Gallery, Columbia University in the City of New York, 2018); and *Le modèle noir de Géricault à Matisse*, exh. cat., Musée d'Orsay, Paris, and Mémorial ACTe, Pointe-à-Pitre, Guadeloupe (Paris: Flammarion, 2019).
5. We wish to extend our sincere thanks to Rachel Hunter Himes for undertaking painstaking research in an effort to learn more about the identity of Carpeaux's model and the life of Louise Kuling.
6. See "Négresse, étude," in *XIX⁰ siècle*, dealer cat. (Paris: Talabardon & Gautier, 2003), lot 25, unpag.
7. MMA 67.250 and MMA 1974.297, respectively.
8. Laure de Margerie, "Fountain of the Observatory," in James David Draper and Edouard Papet et al., *The Passions of Jean-Baptiste Carpeaux*, exh. cat. (New York:

The Metropolitan Museum of Art, 2014), pp. 156–67.

9. See Paul Vitry, *L'art de notre temps: Carpeaux* (Paris: Librairie Centrale des Beaux-Arts, 1912), p. 90. We are exceptionally grateful to Laure de Margerie and Julie Cahen-Ulloa for their expertise and assistance with the provenance research on this bust.

10. At the time of publication, a version of *Why Born Enslaved!* that sold in the Carpeaux sale on May 30, 1913, lot 42, as the *plâtre originale* (original plaster) was with Stuart Lochhead Sculpture, London. A separate plaster *épreuve* (proof) is in the collection of the Musée des Beaux-Arts de Valenciennes, France (Val. 1927-53). Neither plaster bears an inscription. On the Valenciennes bust, see Vitry, *L'art de notre temps*, p. 90; and André Hardy and Anny Braunwald, *Catalogue des peintures et sculptures de Jean-Baptiste Carpeaux à Valenciennes* (Valenciennes: Musée des Beaux-Arts, 1978), p. 146 (no. 168, pl. 45). *Laocoön and His Sons* is in the collection of the Vatican Museums, Vatican City, Italy (MV.1059.0.0).

11. As discussed in Susan H. Libby, "The Color of Frenchness: Racial Identity and Visuality in French Anti-Slavery Imagery, 1788–94," in *Blacks and Blackness in European Art of the Long Nineteenth Century*, ed. Adrienne L. Childs and Susan H. Libby (Farnham, Surrey, and Burlington, Vt.: Ashgate, 2014), p. 21. For further discussion of the use of these words in the naming of artworks, see Anne Higonnet, "Renommer l'oeuvre," in *Le modèle noir*, pp. 27–31.

12. Hugh Honour, "The Seductions of Slavery," in *From the American Revolution to World War I, Part 2: Black Models and White Myths*, vol. 4 of *The Image of the Black in Western Art*, ed. Bindman and Gates (2012), p. 172.

13. Higonnet disputes this point; see "Renommer l'oeuvre," pp. 27–31.

14. Lawrence C. Jennings, *French Anti-Slavery: The Movement for the Abolition of Slavery in France, 1802–1848* (Cambridge and New York: Cambridge University Press, 2000).

15. Carpeaux's parents and brothers lived in California for most of his career. His father died in America, and his mother returned to France in 1863. See Nadège Horner, "Chronology," in Draper and Papet et al., *The Passions of Jean-Baptiste Carpeaux*, p. 3; and Wagner, *Jean-Baptiste Carpeaux*, p. 274.

THE VANQUISHED UNCHAINED: ABOLITION AND EMANCIPATION IN SCULPTURE OF THE ATLANTIC WORLD

1. George L. Hersey, *The Lost Meaning of Classical Architecture: Speculations on Ornament from Vitruvius to Venturi* (Cambridge, Mass., and London: MIT Press, 1988), pp. 69–75.

2. Elizabeth McGrath, "Caryatids, Page Boys and African Fetters: Themes of Slavery in European Art," in *The Slave in European Art: From Renaissance Trophy to Abolitionist Emblem*, ed. Elizabeth McGrath and Jean Michel Massing, Warburg Colloquia 20 (London: Warburg Institute; Turin: Nino Aragno Editore, 2012), pp. 9–14.

3. Mark Rosen, "Pietro Tacca's 'Quattro Mori' and the Conditions of Slavery in Early Seicento Tuscany," *Art Bulletin* 97, no.1 (March 2015), p. 36.

4. Anthea Brook, "From Borgo Pinti to Doccia: The Afterlife of Pietro Tacca's Moors for Livorno," in McGrath and Massing, *The Slave in European Art*, pp. 165–91.

5. Rita Balleri, "Copying, Reworking and Inventing the Sculpture Models at the Ginori Factory in the Eighteenth and Nineteenth Centuries," *French Porcelain Society Journal* 6 (2016), pp. 178–79.

6. Adrienne L. Childs, "Sugar Boxes and Blackamoors: Ornamental Blackness in Early Meissen Porcelain," in *The Cultural Aesthetics of Eighteenth-Century Porcelain*, ed. Alden Cavanaugh and Michael E. Yonan (Farnham, Surrey, and Burlington, Vt.: Ashgate, 2010), pp. 159–77.

7. Robin Blackburn, *The Making of New World Slavery: From the Baroque to the Modern, 1492–1800* (London and New York: Verso, 1997), p. 34.

8. Adrienne L. Childs, "A Blackamoor's Progress: The Ornamental Black Body in European Furniture," in *ReSignifications: European Blackamoors, Africana Readings*, ed. Awam Ampka and Ellyn Mary Toscano, exh. cat., Museo Stefano Bardini, Villa La Pietra, and Fondazione Biagiotti Progetto Arte, Florence (Rome: Postcart, 2017), pp. 117–26.

9. Tim Barringer, Gillian Forrester, and Barbaro Martinez-Ruiz, eds., *Art and Emancipation in Jamaica: Isaac Mendes Belisario and His Worlds*, exh. cat. (New Haven and London: Yale Center for British Art in Association with Yale University Press, 2007), p. 3.

10. Cheryl Finley, *Committed to Memory: The Art of the Slave Ship Icon* (Princeton and Oxford: Princeton University Press, 2018), p. 52.

11. James Walvin, *Slavery in Small Things: Slavery and Modern Cultural Habits* (Malden, Mass., and Oxford: Wiley-Blackwell, 2017), p. 222.

12. Childs, "A Blackamoor's Progress," p. 123.

13. Some discussions of the Wedgwood medallion include David Bindman, "Am I Not a Man and a Brother? British Art and Slavery in the Eighteenth Century," *RES: Anthropology and Aesthetics*, no. 26 (Autumn 1994), pp. 68–82; Finley, *Committed to Memory*, pp. 49–55; and Marcus Wood, *Blind Memory: Visual Representations of Slavery in England and America, 1780–1865* (New York: Routledge, 2000), pp. 21–23.

14. Lawrence C. Jennings, *French Anti-Slavery: The Movement for the Abolition of Slavery in France, 1802–1848* (Cambridge and New York: Cambridge University Press, 2000), pp. 3–4.

15. H. H. Arnason, *The Sculptures of Houdon* (London: Phaidon, 1975), p. 68. See also Anne L. Poulet, *Jean-Antoine Houdon: Sculptor of the Enlightenment*, exh. cat., National Gallery of Art, Washington, D.C.; J. Paul Getty Museum, Los Angeles; Musée et Domaine National du Château de Versailles (Washington, D.C.: National Gallery of Art in association with University of Chicago Press, Chicago and London, 2003).

16. See Tanya Paul, "Houdon's *Bather* in a Drawing by Pierre Antoine Mongin," *Metropolitan Museum Journal* 48, no. 1 (2013), pp. 161–67.

17. James Smalls, "Exquisite Empty Shells: Sculpted Slave Portraits and the French Ethnographic Turn," in *Slave Portraiture in the Atlantic World*, ed. Agnes Lugo-Ortiz and Angela Rosenthal (New York and Cambridge: Cambridge University Press, 2013), pp. 289–90.

18. Susan H. Libby, "The Color of Frenchness: Racial Identity and Visuality in French Anti-Slavery Imagery, 1788–94," in *Blacks and Blackness in European Art of the Long Nineteenth Century*, ed. Adrienne L. Childs and Susan H. Libby (Farnham, Surrey, and Burlington, Vt.: Ashgate, 2014), p. 19.

19. Saidiya V. Hartman, *Scenes of Subjection: Terror, Slavery, and Self-Making in Nineteenth-Century America*, Race and American Culture (New York and Oxford: Oxford University Press, 1997), p. 116.

20. Kirk Savage, *Standing Soldiers, Kneeling Slaves: Race, War, and Monument in Nineteenth-Century America* (Princeton and Oxford: Princeton University Press, 2018), pp. 52–53. See also Thayer Tolles, "*The Freedman*, 1863," in *American Sculpture in The Metropolitan Museum of Art, Volume 1. A Catalogue of Works by Artists Born before 1865*, ed. Thayer Tolles (New York: The Metropolitan Museum of Art, 1999), pp. 140–42.

21. Savage, *Standing Soldiers*, p. 54.

22. Freeman Henry Morris Murray, *Emancipation and the Freed in American Sculpture: A Study in Interpretation* (Washington, D.C.: Freeman Henry Morris Murray, 1916), p. 16.

23. Steven F. Ostrow, "Pietro Tacca and his Quattro Mori: The Beauty and Identity of the Slaves," *Artibus et Historiae* 36, no. 71 (2015), p. 171.

24. Savage, *Standing Soldiers*, p. 54.

25. Ibid, p. 55.

26. While Edmonia Lewis was a mixed-race woman, in this essay I refer to her as Black or African American in consideration of how nineteenth-century understandings of race treated any mixture with "Negro" blood as determinative of Blackness. For more on Edmonia Lewis, see Harry Henderson and Albert Henderson, *The Indomitable Spirit of Edmonia Lewis: A Narrative Biography* (Milford, Conn.: Esquiline Hill Press, 2012); Susanna Gold, "The Death of Cleopatra/The Birth of Freedom: Edmonia Lewis at the New World's Fair," *Biography* 35, no. 2 (Spring 2012), pp. 318–41; and Naurice Frank Woods Jr., *Race and Racism in Nineteenth-Century Art: The Ascendency of Robert Duncanson, Edward Bannister, and Edmonia Lewis* (Jackson: University Press of Mississippi, 2021).

27. For more on Edmonia Lewis and *Forever Free*, see Kirsten Pai Buick, *Child of the Fire: Mary Edmonia Lewis and the Problem of Art History's Black and Indian Subject* (Durham, N.C., and London: Duke University Press, 2010); and Charmaine A. Nelson, *The Color of Stone: Sculpting the Black Female Subject in Nineteenth-Century America* (Minneapolis and London: University of Minnesota Press, 2007).

28. Buick, *Child of the Fire*, p. 56.

29. Nelson, *The Color of Stone*, p. 70. Nelson makes the point that marble mediates the sexual and racial transgressive potential of the sculpted Black female. I believe it applies to Lewis's male in this case.

30. See Buick, *Child of the Fire*, pp. 52–54; Lisa E. Farrington, *Creating Their Own Image: The History of African-American Women Artists* (New York and Oxford: Oxford University Press, 2005), pp. 53–64; and Nelson, *The Color of Stone*, pp. 159–78.

31. Buick, *Child of the Fire*, pp. 55–59.

32. Nelson, *The Color of Stone*, p. 130.

33. Saidiya Hartman, "Venus in Two Acts," *Small Axe* 12, no. 2 (June 2008), p. 3.

34. Buick, *Child of the Fire*, p. 204. I would like to acknowledge Thayer Tolles for suggesting we look into the possibility that the Ward sculpture was exhibited at the 1867 Universal Exhibition in Paris and for providing helpful sources.

35. *Official Catalogue of the Products of the United States of America Exhibited at Paris, 1867* (Paris: A. Chaix et Cie, 1867), p. 55.

36. Ibid, pp. 49–53. Versions of Johnson's and White's paintings are in the collection of the New-York Historical Society, S-225 and S-200, respectively.

WHITE FRAGILITY: ABOLITIONIST PORCELAIN IN REVOLUTIONARY FRANCE

My thanks to Caitlin Meehye Beach, Adrienne L. Childs, Elyse Nelson, Tamara Préaud, Wendy S. Walters, and the members of the racialized porcelain study group for their help. Once attributed to Louis Simon Boizot, the unsigned medallion was probably modeled by someone working under the director of the sculpture workshop. I thank Tamara Préaud for providing this distinction.

1. See Anne Lafont, *L'art et la race: L'Africain (tout) contre l'oeil des Lumières* (Dijon: Les Presses du Réel, 2019), pp. 279–80. Lafont mistakenly describes the Sèvres medallion as the same "image" as the Wedgwood medallion.

2. On the Wedgwood antislavery medallion, see J. R. Oldfield, *Popular Politics and British Anti-Slavery: The Mobilisation of Public Opinion against the Slave Trade, 1787–1807* (London and New York: Routledge, 1998), especially pp. 155–84; Sam Margolin, "'And Freedom to the Slave': Antislavery Ceramics, 1787–1865," *Ceramics in America* (2002), http://www.chipstone.org/article.php/39/Ceramics-in-America-2002/"And-Freedom-to-the-Slave":-Antislavery-Ceramics,-1787–1865; and Mary Guyatt, "The Wedgwood Slave Medallion: Values in Eighteenth-Century Design," *Journal of Design History* 13, no. 2 (2000), pp. 93–105.

3. Tamara Préaud and Guilhem Scherf, *La manufacture des Lumières: La sculpture à Sèvres de Louis XV à la Révolution*, exh. cat., Cité de la Céramique, Sèvres (Dijon: Editions

Faton, 2015), p. 284. Préaud and Scherf list the Sèvres medallion at the Musée National Adrien Dubouché, Limoges, as the only known surviving example. However, the medallion shown here is from the Princeton University Art Museum; the reverse has a gold interlaced L mark and pierced hole, and the gilding is slightly different from the example in Limoges.

4. Jean Etienne Montucla to Antoine Régnier, April 8, 1789, H 4, Liasse 3, Archives, Manufacture Nationale de Sèvres, quoted in Thérèse Picquenard, "Biographie et étude de l'oeuvre de Louis-Simon Boizot," in *Louis-Simon Boizot (1743–1809): Sculpteur du roi et directeur de l'atelier de sculpture à la Manufacture de Sèvres*, exh. cat., Musée Lambinet, Versailles (Paris: Somogy Editions d'Art, 2001), p. 233.

5. Julius S. Scott, *The Common Wind: Afro-American Currents in the Age of the Haitian Revolution* (New York: Verso, 2018), p. 76.

6. For an important discussion of the political uses of biscuit sculpture, see Emily Richardson, "Unlikely Citizens? The Manufacturers of Sèvres Porcelain and the French Revolution" (PhD diss., University College London, 2007), especially pp. 167–82. For discussion of the medallion, see Picquenard, "Biographie et étude," p. 233, and Préaud and Scherf, *La manufacture des Lumières*, p. 284.

7. For a timeline of events, see Marcel Dorigny, ed., *The Abolitions of Slavery: From L. F. Sonthonax to Victor Schoelcher, 1793, 1794, 1848* (New York and Oxford: Berghahn Books in association with UNESCO, 2003), pp. 359–63.

8. C. L. R. James, *The Black Jacobins: Toussaint L'Ouverture and the San Domingo Revolution* (New York: Vintage Books, 1989), p. 47.

9. On James and postcolonial alliances, see Lisa Lowe, *The Intimacies of Four Continents* (Durham, N.C., and London: Duke University Press, 2015), especially chapter 3.

10. See, for example, Laurent Dubois, *Avengers of the New World: The Story of the Haitian Revolution* (Cambridge, Mass., and London: Belknap Press of Harvard University Press, 2004); Marlene Daut, *Tropics of Haiti: Race and the Literary History of the Haitian Revolution in the Atlantic World, 1789–1865* (Liverpool: Liverpool University Press, 2015); and Chelsea Stieber, *Haiti's Paper War: Post-Independence Writing, Civil War, and the Making of the Republic, 1804–1954*, America and the Long 19th Century (New York: New York University Press, 2020).

11. Madeleine Dobie, *Trading Places: Colonization and Slavery in Eighteenth-Century French Culture* (Ithaca, N.Y., and London: Cornell University Press, 2010), pp. 2–3.

12. Marcel Dorigny, "Mirabeau and the Société des Amis des Noirs," in Dorigny, *Abolitions of Slavery*, p. 125.

13. James, *Black Jacobins*, p. 116.

14. The complex racial politics of the colonies meant that French citizenship was initially granted to the free *gens de couleur* and Black people but not to the enslaved. The claims to universal freedom were belied by the fact that the Law of 16 Pluviôse only applied to French colonial territories that had not fallen to British or Spanish forces; slavery persisted in Martinique and Tobago. See, for example, Miranda Frances Spieler, "The Legal Structure of Colonial Rule during the French Revolution," *William and Mary Quarterly* 66, no. 2 (April 2009), pp. 365–408.

15. Préaud and Scherf, *La manufacture des Lumières*, p. 274.

16. Picquenard, "Biographie et étude," p. 48.

17. Jules Renouvier, *Histoire de l'art pendant la Révolution, 1789–1804: Suivi d'une étude sur J.-B. Greuze* (Paris: Renouard, 1863; Geneva: Slatkine Reprints, 1996), p. 49.

18. Although many Sèvres biscuits during the revolutionary period have been attributed to Boizot, scholars have indicated that a number of models were probably made by sculptors working under his supervision, including Josse François Joseph Le Riche, Henri Victor Roguier, and Jean Charles Nicolas Brachard l'Aîné. See Anne Billon,

"Louis-Simon Boizot et la statuaire à la Manufacture de Sèvres," in *Louis-Simon Boizot*, pp. 178–93. For examples of revolutionary-period sculpture produced under his direction, see Préaud and Scherf, *La manufacture des Lumières*, pp. 274–93.

19. Préaud and Scherf, *La manufacture des Lumières*, p. 274.

20. Tamara Préaud, "L'atelier de sculpture: Histoire, organization et production," in Préaud and Scherf, *La manufacture des Lumières,* p. 21.

21. The repertoire of sculptural subjects in biscuit increased throughout the 1760s and 1770s, with busts later introduced by Jean Jacques Bachelier. While Meissen and Nymphenburg produced Black ornamental figures in enameled porcelain, they were never produced in biscuit at Sèvres, although a rare early glazed group of the four continents in The Met collection portrays Africa as a partially nude allegorical figure, paired with a standing Asia (MMA 2012.507).

22. On examples of enameled figures of "blackamoors" in Nymphenburg porcelain, see Adrienne L. Childs, "Sugar Boxes and Blackamoors: Ornamental Blackness in Early Meissen Porcelain," in *The Cultural Aesthetics of Eighteenth-Century Porcelain*, ed. Alden Cavanaugh and Michael E. Yonan (Farnham, Surrey, and Burlington, Vt.: Ashgate, 2010), pp. 159–77.

23. On the regulation of "frivolous" goods, see Rebecca Spang, "The Frivolous French: 'Liberty of Pleasure' and the End of Luxury," in *Taking Liberties: Problems of a New Order from the French Revolution to Napoleon*, ed. Howard G. Brown and Judith A. Miller (Manchester and New York: Manchester University Press, 2002), pp. 110–25.

24. Préaud and Scherf, *La manufacture des Lumières*, p. 277.

25. Ibid., p. 271.

26. James, *Black Jacobins*, pp. 137–42.

27. Préaud and Scherf, *La manufacture des Lumières*, p. 277.

28. Madelyn Gutwirth, *The Twilight of the Goddesses: Women and Representation in the French Revolutionary Era* (New Brunswick, N.J.: Rutgers University Press, 1992), pp. 363–64. On the politics of the breast and issues of race and gender in *Portrait d'une négresse*, see James Smalls, "Slavery Is a Woman: 'Race,' Gender, and Visuality in Marie Benoist's *Portrait d'une négresse* (1800)," *Nineteenth-Century Art Worldwide* 3, no. 1 (Spring 2004), http://www.19thc-artworldwide.org/spring04/286-slavery-is-a-woman-race-gender-and-visuality-in-marie-benoists-portrait-dune-negresse-1800.

29. See Susan H. Libby, "The Color of Frenchness: Racial Identity and Visuality in French Anti-Slavery Imagery, 1788–94," in *Blacks and Blackness in European Art of the Long Nineteenth Century*, ed. Adrienne L. Childs and Susan H. Libby (Farnham, Surrey, and Burlington, Vt.: Ashgate, 2014), p. 36.

30. Florence Gauthier, "The Role of the Saint-Domingue Deputation in the Abolition of Slavery," in Dorigny, *Abolitions of Slavery*, p. 170.

31. I thank Tamara Préaud for this information.

32. This phrase is taken from Saidiya V. Hartman, *Scenes of Subjection: Terror, Slavery, and Self-Making in Nineteenth-Century America*, Race and American Culture (New York and Oxford: Oxford University Press, 1997).

33. Palace of Versailles, INV.DESS 736.

34. Lafont, *L'art et la race*, pp. 286–87.

35. On the ties of violence to vodou in Haiti, see Joan Dayan, *Haiti, History, and the Gods* (Berkeley: University of California Press, 1995). On revolutionary violence, see Walter Benjamin, "Critique of Violence," in *Walter Benjamin: Selected Writings, Volume 1: 1913–1926*, ed. Marcus Bullock and Michael W. Jennings (Cambridge, Mass., and London: Belknap Press of Harvard University Press, 1996), pp. 236–52.

SCULPTING ABOUT SLAVERY IN THE SECOND EMPIRE

I thank Wendy S. Walters, Laure de Margerie, Caitlin Meehye Beach, Elizabeth Benjamin, and Eleanor Hughes for their expertise and suggestions, which contributed significantly to the development of this essay.

1. Caitlin Meehye Beach has written about the imbalances of power that arise in the sculptural production of enslaved figures in her essay, "John Bell's *American Slave* in the Context of Production and Patronage," *Nineteenth-Century Art Worldwide* 15, no. 2 (Summer 2016), http://www.19thc-artworldwide.org/summer16/beach-on-john-bell-american-slave-context-of-production-and-patronage.

2. Hugh Honour, "The Seductions of Slavery," in *From the American Revolution to World War I, Part 2: Black Models and White Myths*, vol. 4 of *The Image of the Black in Western Art*, ed. David Bindman and Henry Louis Gates Jr. (Cambridge, Mass.: Belknap Press of Harvard University Press in collaboration with the W. E. B. Du Bois Institute for African and African American Research and the Menil Collection, 2012), p. 172; James Smalls, "Exquisite Empty Shells: Sculpted Slave Portraits and the French Ethnographic Turn," in *Slave Portraiture in the Atlantic World*, ed. Agnes Lugo-Ortiz and Angela Rosenthal (New York and Cambridge: Cambridge University Press, 2013), pp. 303–7; and Denise Murrell, *Posing Modernity: The Black Model from Manet and Matisse to Today*, exh. cat., Wallach Art Gallery, Columbia University, New York, and Musée d'Orsay, Paris (New Haven: Yale University Press in association with The Miriam and Ira D. Wallach Art Gallery, Columbia University in the City of New York, 2018), p. 43.

3. Charles-Henri-Joseph Cordier, "Mémoires et notes écrites par Charles Cordier, statuaire, chevalier de la Légion d'honneur, né Cambrai le 1ᵉʳ novembre 1827, décédé à Alger le 19 avril 1905," unpublished manuscript, private collection. In his early career, Carpeaux was supported by a liberal network in Valenciennes, and this connection is often cited as evidence of the sculptor's political leanings. But Anne Wagner points out that Carpeaux's politics were defined by his work; see Anne Middleton Wagner, *Jean-Baptiste Carpeaux: Sculptor of the Second Empire* (New Haven: Yale University Press, 1986), pp. 70, 185.

4. The sculpture does not appear in the civil list and was probably acquired using Napoléon III's private purse ("cassette de l'empereur"). See Catherine Granger, *L'empereur et les arts: La liste civile de Napoléon III* (Paris: Ecole Nationale des Chartes, 2005), pp. 67, 447. Many thanks to Laure de Margerie for this reference.

5. Granger, *L'empereur et les arts*, p. 219; Philadelphia Museum of Art, Detroit Institute of Arts, and Grand Palais, Paris, *The Second Empire, 1852–1870: Art in France under Napoleon III*, exh. cat. (Philadelphia: Philadelphia Museum of Art, 1978), p. 12; Patricia Mainardi, *Art and Politics of the Second Empire: The Universal Exhibitions of 1855 and 1867* (New Haven: Yale University Press, 1987), pp. 33–35; and Alison McQueen, *Empress Eugénie and the Arts: Politics and Visual Culture in the Nineteenth Century* (Farnham, Surrey, and Burlington, Vt.: Ashgate, 2011), pp. 149–226.

6. Philippe de Chennevières to Emilien de Nieuwerkerke, "La liste des ouvrages remarqués par leurs majestés au Salon de 1869" (The list of works remarked on by Her Majesty at the 1869 Salon), June 12, 1869, Z/21n 1869, Archives du Louvre, Paris; and comte de Brissac to Emilien de Nieuwerkerke, June 30, 1869, S12, 1869–1882, Archives du Louvres, Paris. Both transcribed by Anne Pingeot and cited by Laure de Margerie in an email message to author, March 4, 2021.

7. Théophile Gautier, "Salon de 1869," *Journal officiel*, May 19, 1869, unpag.

8. On the exclusion of the Black figure from Western notions of the ideal human form, see Charmaine A. Nelson, *Representing the Black Female Subject in Western Art*,

Routledge Studies on African and Black Diaspora 2 (New York and London: Routledge, 2010), pp. 105–21, 139–69.

9. See Beach, "John Bell's *American Slave.*"

10. Laure de Margerie, "Fountain of the Observatory," in James David Draper and Edouard Papet et al., *The Passions of Jean-Baptiste Carpeaux*, exh. cat. (New York: The Metropolitan Museum of Art, 2014), p. 163.

11. McQueen, *Empress Eugénie and the Arts*, pp. 149–51.

12. Albert Boime, *Art in the Age of Civil Struggle, 1848–1871*, Social History of Modern Art 4 (Chicago: University of Chicago Press, 2007), p. 698.

13. See McQueen, *Empress Eugénie and the Arts*, pp. 210–11. During the Second Empire, Eugénie used the official areas of her apartments at the Tuileries Palace in Paris as the spaces in which she most frequently performed her public persona for foreign heads of state and diplomats. Her apartments at Saint-Cloud, west of Paris, functioned, like those at Fontainebleau, as private and semipublic spaces in which power was exhibited and reified through cultural objects. It is not known how the bust was displayed within the apartments at Saint-Cloud. The bronze left in her possession was destroyed when the palace burned down during the Franco-Prussian War.

14. Smalls, "Exquisite Empty Shells," p. 304.

15. Honour, "Seductions of Slavery," p. 172. On the post-emancipation display of a representation of an enslaved woman in Victorian England, see Mia L. Bagneris, "Miscegenation in Marble: John Bell's *Octoroon*," *Art Bulletin* 102, no. 2 (2020), pp. 64–90.

16. On the African origins of Andromeda, see Elizabeth McGrath, "The Black Andromeda," *Journal of the Warburg and Courtauld Institutes* 55 (1992), pp. 1–18.

17. Smalls, "Exquisite Empty Shells," p. 305.

18. Saidiya V. Hartman, *Scenes of Subjection: Terror, Slavery, and Self-Making in Nineteenth-Century America,* Race and American Culture (New York and Oxford: Oxford University Press, 1997), p. 22.

19. Laure de Margerie, "The Dance," in Draper and Papet et al., *The Passions of Jean-Baptiste Carpeaux*, p. 153.

20. Wagner, *Jean-Baptiste Carpeaux*, p. 187. See also Boime, *Art in an Age of Civil Struggle*, pp. 605–6.

21. Wagner, *Jean-Baptiste Carpeaux*, p. 187; and McQueen, *Empress Eugénie and the Arts*, pp. 54–57.

22. Edouard Papet, "The Imperial Couple," in Draper and Papet et al., *The Passions of Jean-Baptiste Carpeaux*, p. 213.

23. On the commission and Carpeaux's process in arriving at his subject, see Margerie, "Fountain of the Observatory," pp. 156–61. The colonialist underpinnings of the site and iconography of *The Four Parts of the World* as it relates to the Second Empire are examined in Hoyon Mephokee, "At the Center of the Globe: Empire and Empiricism in Jean-Baptiste Carpeaux's *Fontaine des Quatres-Parties-du-Monde*," *Athanor* 38 (forthcoming).

24. See Freyda Spira, "Allegories of the Four Continents," *Heilbrunn Timeline of Art History* (New York: The Metropolitan Museum of Art, 2000–), https://www.metmuseum.org/toah/hd/alfc/hd_alfc.htm (March 2021). Cesare Ripa included the personification of the continents in the second edition of his *Iconologia* (Rome, 1603).

25. On the Fulda manufactory's porcelain group, see Jeffrey Munger, *European Porcelain in the Metropolitan Museum of Art* (New York: The Metropolitan Museum of Art, 2018), pp. 132–34.

26. See Alison Luchs, "Allegory of Africa," in Ruth Butler and Suzanne Glover Lindsay et al., *European Sculpture of the Nineteenth Century*, The Collections of the National Gallery of Art Systematic Catalogue (Washington, D.C.: National Gallery of Art, 2001), p. 4. The fountain was destroyed during German occupation in 1940 and later recreated. The original heads of the continents are preserved in the Bartholdi Museum in Colmar, France.

27. Quoted in Margerie, "Fountain of the Observatory," p. 167.

28. Nelson, *Representing the Black Female Subject in Western Art*, pp. 170–78.

29. Until the late seventeenth century, "race" referred to ancestral lineage, not ethnicity. The earliest study to categorize humans by skin color was published in 1684: [François Bernier], "Nouvelle division de la terre, par les différentes espèces ou races d'hommes qui l'habitent," *Le journal des sçavans*, April 23, 1684, pp. 133–40.

30. "Race is the child of racism, not the father.... Difference in hue and hair is old. But the belief in the pre-eminence of hue and hair, the notion that these factors can correctly organize a society and that they signify deeper attributes, which are indelible—this is the new idea at the heart of these new people who have been brought up hopelessly, tragically, deceitfully, to believe that they are white." Ta-Nehisi Coates, *Between the World and Me* (New York: Spiegel & Grau, 2015), p. 7.

31. Susan H. Libby, "The Color of Frenchness: Racial Identity and Visuality in French Anti-Slavery Imagery, 1788–94," in *Blacks and Blackness in European Art of the Long Nineteenth Century*, ed. Adrienne L. Childs and Susan H. Libby (Farnham, Surrey, and Burlington, Vt.: Ashgate, 2014), pp. 22, 40n5.

32. The literature on the 1867 Universal Exhibition is vast. For general information, see Volker Barth, "Paris 1867," in *Encyclopedia of World's Fairs and Expositions*, ed. John F. Findling and Kimberly D. Pelle (Jefferson, N.C.: McFarland, 2008), pp. 37–44. On the colonialist underpinnings of the Universal Exhibition, see Volker Barth, "Displaying Normalisation: The Paris Universal Exhibition of 1867," *Journal of Historical Sociology* 20, no. 4 (December 2007), pp. 462–85. A selection of studies of French colonial displays includes Isabelle Flour, "Orientalism and the Reality Effect: Angkor at the Universal Expositions, 1867–1937," *Getty Research Journal* 6 (2014), pp. 63–82; Timothy Mitchell, *Colonising Egypt* (Cambridge: Cambridge University Press, 1988); and Zeynep Çelik, *Displaying the Orient: Architecture of Islam at Nineteenth-Century World's Fairs*, Comparative Studies on Muslim Societies (Berkeley: University of California Press, 1992).

33. George Augustus Sala, "The Paris Universal Exhibition," *Illustrated London News*, April 13, 1867.

34. George Augustus Sala, "The Paris Universal Exhibition," *Illustrated London News*, February 21, 1867.

35. *Arab Woman* (1862) is now in the collection of the Château de Fontainebleau, France (F1721C).

DRESSING UP/STRIPPING DOWN: ETHNOGRAPHIC SCULPTURE AS COLONIZING ACT

I want to thank Elyse Nelson, Wendy S. Walters, Eleanor Hughes, and Elizabeth Benjamin for their insightful editorial suggestions and content recommendations during the writing of this essay.

1. Théophile Gautier, "Salon de 1869," *Journal officiel*, May 19, 1869, unpag. Quoted in Laure de Margerie, "Fountain of the Observatory," in James David Draper and Edouard Papet et al., *The Passions of Jean-Baptiste Carpeaux*, exh. cat. (New York: The Metropolitan Museum of Art, 2014), p. 163.

2. Cited in Antoinette Le Normand-Romain et al., *La sculpture ethnographique: De la Vénus hottentote à la Tehura de Gauguin*, Dossiers du Musée d'Orsay 53, exh. cat., Musée d'Orsay, Paris (Paris: Réunion des Musées Nationaux, 1994), p. 42.

3. See Julien Girard de Rialle, *A travers le Salon de 1863* (Paris: E. Dentu, 1863), pp. 138–39. Cited in Le Normand-Romain, *La sculpture ethnographique*, p. 42.

4. Elise Dubuc, "La sculpture ethnographique ou l'esthétisme des théories/Ethnographic Sculpture or the Aestheticism of Theories," *Espace* 60 (Summer 2002), p. 11.

5. Martin Staum, "Nature and Nurture in French Ethnography and Anthropology, 1859–1914," *Journal of the History of Ideas* 65, no. 3 (July 2004), p. 488.

6. In the context of this essay, I draw from a postcolonial definition of colonialism as "the forceful occupation of another people's land in order to extract material benefit" and "to establish and maintain power." Deborah Wyrick, *Fanon for Beginners* (London: Writers and Readers, 1998), p. 62.

7. Lisa Moses Leff, "Jews, Liberals and the Civilizing Mission in Nineteenth-Century France," *Historical Reflections/Réflexions Historiques* 32, no. 1 (Spring 2006), p. 105. See also Patrick Petitjean, "Science and the 'Civilizing Mission': France and the Colonial Enterprise," in *Science Across the European Empires, 1800–1950*, ed. Benedikt Stuchtey, Studies of the German Historical Institute, London (Oxford and New York: Oxford University Press, 2005), pp. 107–28; and Lewis Pyenson, *Civilizing Mission: Exact Sciences and French Overseas Expansion, 1830–1940* (Baltimore and London: Johns Hopkins University Press, 1993).

8. Staum, "Nature and Nurture," pp. 475–76.

9. Ibid., p. 476.

10. Linda Martín Alcoff, "Towards a Phenomenology of Racial Embodiment," *Radical Philosophy* 95 (May/June 1999), p. 17.

11. Manning Nash, "Race and the Ideology of Race," *Current Anthropology* 3, no. 3 (June 1962), p. 285. On ethnographic sculpture and the ideology of race, see Gloria Wallace, "Charles Cordier: Ethnographic Sculpture and the Ideology of Race," *Chrysalis: A Critical Student Journal of Transformative Art History* 1, no. 5 (Spring 2017), pp. 132–39.

12. For sustained elaboration on the discursive complexities of ethnography, see James Clifford and George E. Marcus, eds., *Writing Culture: The Poetics and Politics of Ethnography* (Berkeley: University of California Press, 1986).

13. See Michel Foucault, *Discipline and Punish: The Birth of a Prison*, trans. Alan Sheridan (New York: Vintage Books, 1977), pp. 27–28; Charmaine A. Nelson, *The Color of Stone: Sculpting the Black Female Subject in Nineteenth-Century America* (Minneapolis and London: University of Minnesota Press, 2007), p. xxxiv. Italics in the original.

14. See Kirk Savage, *Standing Soldiers, Kneeling Slaves: Race, War, and Monument in Nineteenth-Century America* (Princeton and Oxford: Princeton University Press, 1997), p. 8. Also quoted in Nelson, *The Color of Stone*, p. xxx.

15. Dwight Conquergood, "Rethinking Ethnography: Towards a Critical Cultural Politics," *Communication Monographs* 58 (June 1991), p. 180.

16. See Aimé Césaire, *Discourse on Colonialism*, trans. Joan Pinkham (New York: Monthly Review, 2000), p. 21; and Frantz Fanon, *Black Skin, White Masks*, trans. Charles Lam Markmann (New York: Grove, 1967), p. 109.

17. Gayatri Chakravorty Spivak, "Imperialism and Sexual Difference," *Oxford Literary Review* 8, no. 1/2 (1986), pp. 228–29.

18. Many of the ideas presented in this section are taken from my essay, "Exquisite Empty Shells: Sculpted Slave Portraits and the French Ethnographic Turn," in *Slave Portraiture in the Atlantic World*, ed. Agnes Lugo-Ortiz and Angela Rosenthal (Cambridge and New York: Cambridge University Press, 2013), pp. 283–312.

19. Charles-Henri-Joseph Cordier, "Mémoires et notes écrites par Charles Cordier, statuaire, chevalier de la Légion d'honneur, né Cambrai le 1er novembre 1827, décédé à Alger le 19 avril 1905," unpublished manuscript, private collection.

20. Laure de Margerie, "Chronology," in Laure de Margerie and Edouard Papet, *Facing the Other: Charles Cordier (1827–1905), Ethnographic Sculptor*, exh. cat., Musée d'Orsay, Paris; Musée National des Beaux-Arts du Québec; Dahesh Museum of Art, New York (New York: Harry N. Abrams, 2004), p. 129.

21. Robley Holmes, "Re-Casting Difference: Charles Cordier's Ethnographic Sculptures" (master's thesis, University of North Carolina at Chapel Hill, 2011), p. 3.

22. Ibid., p. 5.

23. On the portraits and caricatures of Dantan-Jeune, see Philippe Sorel, *Dantan-Jeune: Caricatures et portraits de la société romantique: Collections du Musée Carnavalet*,

exh. cat., Maison de Balzac, Paris (Paris: Paris-Musées, 1989); and Peter Fusco and H. W. Janson, eds., *The Romantics to Rodin: French Nineteenth-Century Sculpture from North American Collections*, exh. cat., Los Angeles County Museum of Art and others (New York: George Braziller, 1980).

24. See Anne Roquebert, "La sculpture ethnographique au XIXᵉ siècle, objet de mission ou oeuvre de musées?," in Le Normand-Romain, *La sculpture ethnographique*, pp. 5–32. On the importance of phrenology and physiognomy in ethnographic sculpture, see Dubuc, "La sculpture ethnographique." For an expanded and detailed discussion of the aesthetic, historical, and ideological operations and implications of physiognomy and phrenology in Romantic sculpture of the mid-nineteenth century in France, see Florence Quideau, "Origins of Modernism in French Romantic Sculpture: David D'Angers, Dantan-Jeune, Daumier and Préault" (PhD diss., Rutgers, the State University of New Jersey, 2011).

25. Arnauld d'Abbadie, *Douze ans de séjour dans la Haute-Éthiopie (Abyssinie)*, vol. 1 (Paris: Librairie de L. Hachette et Cie, 1868).

26. Antoine d'Abbadie to [Armand de Quatrefages?], October 28, 1860, Muséum National d'Histoire Naturelle, Paris.

27. Cordier, "Mémoires," p. 10.

28. Holmes, "Re-Casting Difference," p. 36; Timothy Mitchell, "Orientalism and the Exhibitionary Order," in *The Art of Art History: A Critical Anthology*, ed. Donald Preziosi, new ed., Oxford History of Art (Oxford: Oxford University Press, 2009), p. 413.

29. George E. Marcus and Dick Cushman, "Ethnographies as Texts," *Annual Review of Anthropology* 11 (1982), p. 29. On ethnographic photography, see Léopold Ernest Mayer and Pierre-Louis Pierson, *La photographie considérée comme art et comme industrie, histoire de sa découverte, ses progrès, ses applications, son avenir* (Paris: L. Hachette et Cie, 1862), unpag., cited in Le Normand-Romain, *La sculpture ethnographique*, p. 24; and Christine Barthe, "Models and Norms: The Relationship Between Ethnographic Photographs and Sculptures," in Margerie and Papet, *Facing the Other*, pp. 93–113.

30. Clifford and Marcus, *Writing Culture*, pp. 99, 111.

31. Ibid., p. 100.

32. Charles Cordier, "Types ethniques représentés par la sculpture," *Bulletin de la Société d'Anthropologie de Paris* 3 (1862), pp. 65–66.

33. On Cordier's oxymoronic approach to slave portraiture, see Smalls, "Exquisite Empty Shells."

34. For a sustained and critical discussion of *Vénus africaine* in the context of the intersection of race, aesthetics, and sexual significance, see Charmaine A. Nelson, "Vénus Africaine: Race, Beauty and Africanness," in *Black Victorians: Black People in British Art 1800–1900*, ed. Jan Marsh, exh. cat., Birmingham City Museum and Art Gallery, and Manchester City Art Gallery, U.K. (Aldershot, Hampshire, and Burlington, Vt.: Lund Humphries, 2005), pp. 46–56.

35. Théophile Gautier, "Le Salon de 1857," *L'artiste*, n.s., 2, no. 12 (November 22, 1857), p. 183.

36. Théophile Gautier, "Salon de 1869."

37. Clifford and Marcus, *Writing Culture*, p. 24.

38. See Holmes, "Re-Casting Difference," p. 7.

39. Cordier's interest in incorporating color into his sculptures had been whetted by the eighteenth-century discoveries of antiquities at Herculaneum and Pompeii, and also of onyx and marble quarries in Algeria that had been abandoned since antiquity and reopened in 1842. See Edouard Papet, "The Polychromy Techniques of Charles Cordier," in Margerie and Papet, *Facing the Other*, p. 83. See also Andreas Blühm, ed., *The Colour of Sculpture, 1840–1910*, exh. cat., Van Gogh Museum, Amsterdam, and Henry Moore Institute, Leeds (Zwolle: Waanders, 1996).

40. Griselda Pollock, *Differencing the Canon: Feminist Desire and the Writing of Art's*

Histories, Re Visions: Critical Studies in the History and Theory of Art (London and New York: Routledge, 1999), p. 299.

41. Coco Fusco, *The Bodies That Were Not Ours and Other Writings* (London and New York: Routledge in collaboration with Institute of International Visual Arts, 2001), p. 6.

42. For the multiple potential symbolisms associated with the exposed female breast, see Marilyn Yalom, *A History of the Breast* (New York: Alfred A. Knopf, 1997); Marcia Pointon, *Naked Authority: The Body in Western Painting, 1830–1908*, Cambridge Studies in New Art History and Criticism (Cambridge: Cambridge University Press, 1990), pp. 59–82; and Maurice Agulhon, *Marianne into Battle: Republican Imagery and Symbolism in France, 1789–1880* (Cambridge and New York: Cambridge University Press, 1981).

43. Robin Mitchell, *Vénus Noire: Black Women and Colonial Fantasies in Nineteenth-Century France*, Race in the Atlantic World, 1700–1900 (Athens: University of Georgia Press, 2020), p. 9.

44. Anne Middleton Wagner, *Jean-Baptiste Carpeaux: Sculptor of the Second Empire* (New Haven: Yale University Press, 1986), p. 180.

45. A. Foltzer, *Etcheto, sculpteur basque* (Bayonne, France: Imprimerie du Courrier, 1930).

46. Two bronze castings of Etcheto's *L'esclavage* were produced posthumously in 1897 at the Gruet atelier in Paris, one of which was erected in the Parc Beaumont in Pau in 1902. The art historian Anouk Bertaux claims that Etcheto was an abolitionist. However, there is no evidence to support this claim save for the bust itself. See Anouk Bertaux, "L'esclavage de Jean-François Etcheto (1880) ou l'ambiguïté de la représentation de l'homme noir asservi," *Florilèges* (December 21, 2017), https:// florilegeswebjournal.com/2017/12/21 /lesclavage-de-jean-francois-etcheto-1880 -ou-lambiguite-de-la-representation-de -lhomme-noir-asservi/.

PRESUMPTIONS ON THE FIGURE, GIVEN THE ABSENCES

I wish to express my deep gratitude to Sarah E. Lawrence and Elyse Nelson for inviting me to participate in this conversation. I am also grateful to Cécile Bishop, Adrienne L. Childs, James Smalls, Caitlin Meehye Beach, Iris Moon, Lisa Farrington, and Karen Lemmey for their expertise and openness in discussions about these objects.

1. On Carpeaux's exploitation of his art as marketable commodity, see Anne Middleton Wagner, *Jean-Baptiste Carpeaux: Sculptor of the Second Empire* (New Haven: Yale University Press, 1986), p. 180.

2. James David Draper, in Perrin Stein et al., "Europe 1700–1900," *The Metropolitan Museum of Art Bulletin*, n.s., 56, no. 2 (Autumn 1998), p. 47.

3. André Albrespy, "Beaux-Arts: Le Salon de 1869," *Revue chrétienne*, ann. 16 (July 5, 1869), pp. 442–43. Translation by John Goodman.

4. Arthur Baignères, "Peintres et sculpteurs à l'exposition de 1869," *Revue contemporaine*, ann. 18, ser. 2, 69 (May 15, 1869), p. 279. Translation by John Goodman.

5. Cl. Suty, "Promenade au Salon," *L'union médicale: Journal des intérêts scientifiques et pratiques, moraux et professionels du corps médical*, ser. 3, 8, no. 91 (August 3, 1869), p. 173. Translation by John Goodman.

6. Frantz Fanon, *Black Skin, White Masks*, trans. Charles Lam Markmann, new ed., Get Political (1952; London: Pluto Press, 2008), p. 82.

7. Jasper G. Goodman and Kelsey J. Griffin, "Possible Remains of Enslaved People Found in Harvard Museum Collections," *Harvard Crimson*, January 29, 2021, https://www .thecrimson.com/article/2021/1/29 /committee-to-examine-human-remains -in-harvard-museums/.

8. Fred Moten, *In the Break: The Aesthetics of the Black Radical Tradition* (Minneapolis and London: University of Minnesota Press, 2003), p. 1.

9. Laure de Margerie, "'The Most Beautiful Negro Is Not The One Who Looks Most Like Us,' Cordier, 1862," in Laure de Margerie and Edouard Papet, *Facing the Other: Charles Cordier (1827–1905), Ethnographic Sculptor*, exh. cat., Musée d'Orsay, Paris; Musée National des Beaux-Arts du Québec; Dahesh Museum of Art, New York (New York: Harry N. Abrams, 2004), p. 13.

10. Charmaine A. Nelson, *The Color of Stone: Sculpting the Black Female Subject in Nineteenth-Century America* (Minneapolis and London: University of Minnesota Press, 2007).

11. Patrick Bellegarde-Smith, *Haiti: The Breached Citadel*, rev. ed. (Toronto: Canadian Scholars Press, 2004), p. 58.

12. "With few exceptions, the female slaves themselves left no letters or other accounts of their history. Many of their names have thus gone unrecorded, but tales of their courage in the face of extreme adversity remain." Jayne Boisvert, "Colonial Hell and Female Slave Resistance in Saint-Domingue," *Journal of Haitian Studies* 7, no. 1 (Spring 2001), p. 62.

13. Published October 25, 1804, by S. W. Fores, 50 Piccadilly, London. Versions of this print are in the collections of the Firestone Library, Princeton University; the Lewis Walpole Library, Yale University; and the British Museum, London.

14. James David Draper and Edouard Papet, "Family," in Draper and Papet et al., *The Passions of Jean-Baptiste Carpeaux*, exh. cat. (New York: The Metropolitan Museum of Art, 2014), p. 257.

15. Barrymore Lawrence Scherer, "Jean-Baptiste Carpeaux: Romance in the Stone," *The Wall Street Journal*, April 1, 2014. https://www.wsj.com/articles/SB1000142405270230 3725404579461422373450770. See also Draper and Papet et al., *The Passions of Jean-Baptiste Carpeaux*, pp. xi, 252–63.

REPRODUCING AND REFUSING CARPEAUX

I thank Elyse Nelson, Wendy S. Walters, Iris Moon, and Adrienne L. Childs for their help and suggestions in developing this essay.

1. Michel Poletti and Alain Richarme, *Jean-Baptiste Carpeaux, sculpteur: Catalogue raisonné de l'oeuvre édité* (Paris: Les Editions de l'Amateur, 2003), pp. 141–42.

2. "Reproduction de sculpture: Négresse captive, Carpeaux," Ateliers d'Art des Musées Nationaux, accessed March 22, 2021, https://www.ateliersartmuseesnationaux.fr/fr/sculptures/RF005715; and "Pourquoi naître esclave?," Cire Trudon, accessed March 22, 2021, https://trudon.com/eu_en/lesclave.html.

3. Walter Benjamin, "The Work of Art in the Age of Its Technological Reproducibility: Second Version," in *The Work of Art in the Age of Its Technological Reproducibility and Other Writings on Media*, ed. Michael W. Jennings, Brigid Doherty, and Thomas Y. Levin (Cambridge, Mass.: Belknap Press of Harvard University Press, 2008), pp. 19–55. For two now-classic accounts of Carpeaux's relation to reproduction, see Jacques de Caso, "Serial Sculpture in Nineteenth-Century France," in *Metamorphoses in Nineteenth-Century Sculpture*, ed. Jeanne L. Wasserman, exh. cat., Fogg Art Museum, Harvard University (Cambridge, Mass.: Harvard University Press, 1975), pp. 1–27; and Anne Middleton Wagner, *Jean-Baptiste Carpeaux: Sculptor of the Second Empire* (New Haven: Yale University Press, 1986), pp. 175–208.

4. Nadège Horner, "Chronology," in James David Draper and Edouard Papet et al., *The Passions of Jean-Baptiste Carpeaux*, exh. cat. (New York: The Metropolitan Museum of Art, 2014), p. 13.

5. De Caso, "Serial Sculpture," pp. 6–7.

6. On the titling of *Why Born Enslaved!*, see Anne Higonnet, "Renommer l'oeuvre," in *Le modèle noir de Géricault à Matisse*, exh. cat., Musée d'Orsay, Paris, and Mémorial ACTe, Pointe-à-Pitre, Guadeloupe (Paris: Flammarion, 2019), pp. 27–31; see also Huey Copeland, "In the Wake of the Negress," in

Modern Women: Women Artists at the Museum of Modern Art, ed. Cornelia Butler and Alexandra Schwartz (New York: Museum of Modern Art, 2010), pp. 480–97.

7. See Oruno D. Lara, *Abolition de l'esclavage: 1848–1852* (Paris: L'Harmattan, 2016); and Lawrence C. Jennings, *French Anti-Slavery: The Movement for the Abolition of Slavery in France, 1802–1848* (Cambridge and New York: Cambridge University Press, 2000).

8. Laure de Margerie, "Fountain of the Observatory," in Draper and Papet et al., *The Passions of Jean-Baptiste Carpeaux*, pp. 156–58.

9. The Salon livret notes the display of the bust in marble: *Explication des ouvrages de peinture, sculpture, architecture, gravure et lithographie, des artistes vivants, exposés au Palais des Champs-Elysées le 1er mai 1869* (Paris: C. de Morgues, 1869), p. 459. Additional records state the presence of a second "buste de Négresse bronze," although it is unclear whether both appeared on display at the same time or one after the other, and whether their display was contingent upon the vagaries of the Empress's purchase and return. Philippe de Chennevières to Emilien de Nieuwerkerke, "La liste des ouvrages remarqués par leurs majestés au Salon de 1869" (The list of works remarked on by Her Majesty at the 1869 Salon), June 12, 1869, Z/21n 1869, Archives du Louvre, Paris, transcribed by Anne Pingeot and cited by Laure de Margerie in an email message to Elyse Nelson, March 4, 2021.

10. *Explication des ouvrages de peinture, sculpture, architecture, gravure et lithographie, des artistes vivants, exposés au Palais des Champs-Elysées le 1er mai 1872* (Paris: Imprimerie Nationale, 1872), p. 242.

11. Nadège Horner, "Un répertoire de la sculpture polychrome dans les collections publiques en France, 1848–1916," *La Revue des Musées de Reims* 2 (2019), p. 30.

12. As Anne Middleton Wagner has noted, Carpeaux pursued a "ceaseless multiplication" of his work in the late 1860s and early 1870s especially due to the fact that he fell into a state of financial ruin. Wagner, *Jean-Baptiste Carpeaux*, p. 203.

13. Of the vast literature on sculpture and race, especially relevant examples include Mia L. Bagneris, "Miscegenation in Marble: John Bell's *Octoroon*," *Art Bulletin* 102, no. 2 (2020), pp. 64–90; Linda Kim, *Race Experts: Sculpture, Anthropology, and the American Public in Malvina Hoffman's "Races of Mankind"* (Lincoln: University of Nebraska Press, 2018); James Smalls, "Exquisite Empty Shells: Sculpted Slave Portraits and the French Ethnographic Turn," in *Slave Portraiture in the Atlantic World*, ed. Agnes Lugo-Ortiz and Angela Rosenthal (New York and Cambridge: Cambridge University Press, 2013), pp. 283–312; and Charmaine A. Nelson, *The Color of Stone: Sculpting the Black Female Subject in Nineteenth-Century America* (Minneapolis and London: University of Minnesota Press, 2007).

14. A courtier noted, "Faire envoyer au Palais de Saint-Cloud la Négresse de Carpeaux. Ce n'est pas le buste en marbre blanc que l'Impératrice a demandé à M. Carpeaux, c'est celui en bronze. Faire reprendre le marbre, l'échanger avec le bronze (fait le 1er juillet)." ("Send Carpeaux's *Négresse* to the Palais Saint-Cloud. It is not the bust in white marble that the Empress asked of M. Carpeaux, it is the one in bronze. Remove the marble and exchange it with the bronze [done on July 1].") Comte de Brissac to Emilien de Nieuwerkerke, June 30, 1869, S12, 1869–1882, Archives du Louvre, Paris, transcribed by Anne Pingeot and cited by Laure de Margerie in an email message to Elyse Nelson, February 28, 2021; see also Marius Chaumelin, *L'art contemporain* (Paris: Librairie Renouard, 1873), cited in Paul Vitry, *L'art de notre temps: Carpeaux* (1912; Paris: Librairie Centrale des Beaux-Arts, 2016), p. 90.

15. De Margerie, "Fountain of the Observatory," p. 163.

16. Smalls, "Exquisite Empty Shells," pp. 283–312.

17. Ibid., pp. 304–305.

18. Huey Copeland, *Bound to Appear: Art, Slavery, and the Site of Blackness in Multiracial America* (Chicago and London: University of Chicago Press, 2013), p. 14. See also Huey Copeland and Krista Thompson, "Perpetual Returns: New World Slavery and the Matter of the Visual," *Representations* 113, no. 1 (Winter 2011), pp. 1–15; and Stephen M. Best, *The Fugitive's Properties: Law and the Poetics of Possession* (Chicago and London: University of Chicago Press, 2004).

19. Caitlin Meehye Beach, *Sculpture at the Ends of Slavery* (Berkeley: University of California Press, forthcoming); see also Beach, "John Bell's *American Slave* in the Context of Production and Patronage," *Nineteenth-Century Art Worldwide* 15, no. 2 (Summer 2016), https://www.19thc -artworldwide.org/summer16/beach-on -john-bell-american-slave-context-of -production-and-patronage.

20. De Margerie, "Fountain of the Observatory," in Draper and Papet et al., *The Passions of Jean-Baptiste Carpeaux*, p. 163.

21. Carpeaux initially made the bust of the young Chinese man while producing studies from a male model, which he then trans- formed into a woman for the fountain. As most sources note, the change was due to the fact that Carpeaux was reportedly unable to find an Asian female model. This anecdote is especially interesting in light of discourses around the simultaneous invisibility and hypervisibility of East Asian women in Western cultural imaginaries, or what Anne Anlin Cheng reads as the contingency of Asiatic femininity as "ornamentalism." See "Bust of a Chinese Man (Le Chinois)," in John Davis and Jaroslaw Leshko, *Smith College of Museum of Art: European and American Painting and Sculpture, 1760– 1960* (New York: Hudson Hills Press, 2000), p. 30; and Anne Anlin Cheng, *Ornamentalism* (New York: Oxford University Press, 2019).

22. Jonathan Marsden, ed., *Victoria & Albert: Art & Love*, exh. cat., The Queen's Gallery, Buckingham Palace, London (London: Royal Collection Trust, 2010), p. 460; and Laure de

Margerie and Edouard Papet, *Facing the Other: Charles Cordier (1827–1905), Ethnographic Sculptor*, exh. cat., Musée d'Orsay, Paris; Musée National des Beaux- Arts du Québec; Dahesh Museum of Art, New York (New York: Harry N. Abrams, 2004), pp. 14, 74.

23. See Tao Leigh Goffe, "Sugarwork: The Gastropoetics of Afro-Asia after the Plantation," *Asian Diasporic Visual Cultures and the Americas* 5, nos. 1–2 (Spring 2019), pp. 31–56; Lisa Lowe, *The Intimacies of Four Continents* (Durham, N.C., and London: Duke University Press, 2015); and Moon-Ho Jung, *Coolies and Cane: Race, Labor, and Sugar in the Age of Emancipation* (Baltimore: Johns Hopkins University Press, 2006).

24. Krista Thompson, "A Sidelong Glance: The Practice of African Diaspora Art History in the United States," *Art Journal* 70, no. 3 (Fall 2011), pp. 6–31, especially pp. 26–27. Thompson evokes the "sidelong glance" as a strategy deployed by contemporary artists of the African diaspora to refract, reorient, and occlude Western proclivities toward ocular representation and transparency.

25. See William C. Rhoden, *Forty Million Dollar Slaves: The Rise, Fall, and Redemption of the Black Athlete* (New York: Three Rivers Press, 2006).

26. On street casting and Wiley's critique of the Old Masters more broadly, see Eugenie Tsai, "Introduction," and Connie Choi, "Kehinde Wiley: The Artist and Interpretation," in *Kehinde Wiley: A New Republic*, ed. Eugenie Tsai, exh. cat. (New York: Brooklyn Museum in association with Delmonico Books and Prestel, 2015), pp. 14–15, 20–33.

27. Larry Mangel, *Cerealart: Feed Your Head* (Philadelphia: Cerealart, 2004). See also "Cerealart," https://cerealart.com (accessed March 30, 2021).

28. De Caso, "Serial Sculpture in Nineteenth- Century France," p. 6; cited also in Wagner, *Jean-Baptiste Carpeaux*, p. 180.

29. See Amanda Dunsmore, ed., *This Blessed Plot, This Earth: English Pottery Studies in Honour of Jonathan Dunsmore* (London:

Paul Holberton, 2011). I thank Iris Moon for first making the suggestion of connecting Wiley's work to the idea of "wasters" and for sharing her insights on the topic.

30. On Walker's reappropriation of the racist epithet "negress," see Gwendolyn DuBois Shaw, *Seeing the Unspeakable: The Art of Kara Walker* (Durham, N.C., and London: Duke University Press, 2004); Ian Berry et al., eds., *Kara Walker: Narratives of a Negress,* exh. cat., Tang Museum, Skidmore College, Saratoga Springs, N.Y., and Williams College Museum of Art, Williamstown, Mass. (Cambridge, Mass., and London: MIT Press in association with the Tang Teaching Museum and Art Gallery at Skidmore College and Williams College Museum of Art, 2003); and Rebecca Peabody, *Consuming Stories: Kara Walker and the Imagining of American Race* (Oakland: University of California Press, 2016).

31. Géricault's final painting of 1818–19 is now in the collection of the Musée du Louvre, Paris (INV 4884). See Darcy Grimaldo Grigsby, "Cannibalism," in *Extremities: Painting Empire in Post-Revolutionary France* (New Haven: Yale University Press, 2002), pp. 165–235; and Jonathan Crary, "Géricault, The Panorama, and Sites of Reality in the Early Nineteenth Century," *Grey Room* 9 (Autumn 2002), pp. 5–25.

32. Karen Marta, ed. *Kara Walker, Figa* (Athens: DESTE Foundation for Contemporary Art, 2018), unpag. In a striking parallel to the old Domino Sugar Refinery, the DESTE Foundation for Contemporary Art is located in the space of the former Hydra Slaughterhouse.

33. Hal Foster et al., "The Politics of the Signifier II: A Conversation on the "Informe" and the Abject," *October* 67 (Winter 1994), p. 4; see also Yve-Alain Bois and Rosalind Krauss, *Formless: A User's Guide*, exh. cat., Centre Georges Pompidou, Paris (New York: Zone Books, 1997).

34. Saidiya Hartman, *Lose Your Mother: A Journey Along the Atlantic Slave Trade Route* (New York: Farrar, Straus and Giroux, 2008), 167; see also Hartman, *Scenes of Subjection: Terror, Slavery, and Self-Making in Nineteenth-Century America*, Race and American Culture (New York and Oxford: Oxford University Press, 1997).

35. Anne Latournerie, "Petite histoire des batailles du droit d'auteur," *Multitudes* 5, no. 2 (2001), pp. 37–62. Nineteenth-century French copyright law was based on the *droit d'auteur*, which granted authors exclusive rights over their creative work for the duration of their lifetime. In 1866, these rights were extended to fifty years after the author's death.

36. Horner, "Chronology," in Draper and Papet et al., *The Passions of Jean-Baptiste Carpeaux*, p. 21.

37. As Jacques de Caso has noted, "The mold was an object of speculation and value no less than the sculpture itself." De Caso, "Serial Sculpture in Nineteenth-Century France," p. 2.

Further Reading

Bagneris, Mia L. "Miscegenation in Marble: John Bell's *Octoroon*." *Art Bulletin* 102, no. 2 (2020), pp. 64–90.

Barringer, Tim, Gillian Forrester, and Barbaro Martinez-Ruiz, eds. *Art and Emancipation in Jamaica: Isaac Mendes Belisario and His Worlds*. Exh. cat. New Haven and London: Yale Center for British Art in association with Yale University Press, 2007.

Baucom, Ian. *Specters of the Atlantic: Finance Capital, Slavery, and the Philosophy of History*. Durham, N.C., and London: Duke University Press, 2005.

Beach, Caitlin. "John Bell's *American Slave* in the Context of Production and Patronage." *Nineteenth-Century Art Worldwide* 15, no. 2 (Summer 2016), https://www.19thc -artworldwide.org/summer16/beach-on -john-bell-american-slave-context-of -production-and-patronage.

Bindman, David. "Am I Not a Man and a Brother? British Art and Slavery in the Eighteenth Century." *RES: Anthropology and Aesthetics*, no. 26 (Autumn 1994), pp. 68–82.

———. *Ape to Apollo: Aesthetics and the Idea of Race in the 18th Century*. London: Reaktion, 2002.

Bindman, David, and Henry Louis Gates Jr., eds. *The Image of the Black in Western Art*. New ed. 5 vols. Cambridge, Mass.: Belknap Press of Harvard University Press in collaboration with the W. E. B. Du Bois Institute for African and African American Research and the Menil Collection, 2010–14.

Boime, Albert. *Art in an Age of Civil Struggle, 1848–1871*. A Social History of Modern Art 4. Chicago and London: University of Chicago Press, 2007.

———. *The Art of Exclusion: Representing Blacks in the Nineteenth Century*. Washington, D.C.: Smithsonian Institution Press, 1990.

Buick, Kirsten Pai. *Child of the Fire: Mary Edmonia Lewis and the Problem of Art History's Black and Indian Subject*. Durham, N.C., and London: Duke University Press, 2010.

Césaire, Aimé. *Discourse on Colonialism: A Poetics of Anticolonialism*. 1972. Translated by Joan Pinkham, with an introduction by Robin D. G. Kelley. New York: Monthly Review, 2000.

Chadwick, Esther, and Meredith Gamer. *Figures of Empire: Slavery and Portraiture in Eighteenth-Century Atlantic Britain*. Exh. brochure. New Haven: Yale Center for British Art, 2014. https://britishart.yale.edu /exhibitions-programs/figures-empire -slavery-and-portraiture-eighteenth -century-atlantic-britain.

Cheng, Anne Anlin. *Ornamentalism*. New York: Oxford University Press, 2019.

Chesneau, Ernest. *Le statuaire J.-B. Carpeaux: Sa vie et son oeuvre*. Paris: A. Quantin, 1880.

Childs, Adrienne L. "The Black Exotic: Tradition and Ethnography in Nineteenth-Century Orientalist Art." PhD diss., University of Maryland, College Park, 2005.

Childs, Adrienne L., and Susan H. Libby, with an introduction by David Bindman. *The Black Figure in the European Imaginary*. Exh. cat. Winter Park, Fla.: The Cornell Fine Arts Museum, Rollins College; London: D. Giles, 2017.

Childs, Adrienne L., and Susan H. Libby, eds. *Blacks and Blackness in European Art of the Long Nineteenth Century*. Farnham, Surrey, and Burlington, Vt.: Ashgate, 2014.

Clarkson, Thomas. *The History of the Rise, Progress, and Accomplishment of the Abolition of the African Slave-Trade by the British Parliament*. 2 vols. London: Longman, Hurst, Rees, and Orme, 1808.

Clément-Carpeaux, Louise. *La vérité sur l'oeuvre et la vie de J.-B. Carpeaux (1827–1875)*. 2 vols. Paris: Dousset et Bigerelle, 1934–35.

Clifford, James, and George E. Marcus, eds. *Writing Culture: The Poetics and Politics of Ethnography*. Berkeley: University of California Press, 1986.

Curran, Andrew S. *The Anatomy of Blackness: Science and Slavery in an Age of*

Enlightenment. Baltimore: Johns Hopkins University Press, 2011.

Dobie, Madeleine. *Trading Places: Colonization and Slavery in Eighteenth-Century French Culture*. Ithaca, N.Y., and London: Cornell University Press, 2010.

Dorigny, Marcel, ed. *The Abolitions of Slavery: From L. F. Sonthonax to Victor Schoelcher, 1793, 1794, 1848*. New York and Oxford: Berghahn Books in association with UNESCO, 2003.

Draper, James David, Edouard Papet, Elena Carrara, Nadège Horner, Laure de Margerie, Jean-Claude Poinsignon, and Philip Ward-Jackson. *The Passions of Jean-Baptiste Carpeaux*. Exh. cat. New York: The Metropolitan Museum of Art, 2014.

Dubois, Laurent. *A Colony of Citizens: Revolution and Slave Emancipation in the French Caribbean, 1787–1804*. Chapel Hill and London: University of North Carolina Press for the Omohundro Institute of Early American History and Culture, Williamsburg, Va., 2004.

Everill, Bronwen. *Not Made by Slaves: Ethical Capitalism in the Age of Abolition*. Cambridge, Mass.: Harvard University Press, 2020.

Fanon, Frantz. *Black Skin, White Masks*. 1952. Translated by Richard Philcox. New York: Grove, 2008.

———. *The Wretched of the Earth*. 1961. Translated by Richard Philcox, with commentary by Jean-Paul Sartre and Homi K. Bhabha. New York: Grove, 2004.

Farrington, Lisa E. *Creating Their Own Image: The History of African-American Women Artists*. New York and Oxford: Oxford University Press, 2005.

Gikandi, Simon. *Slavery and the Culture of Taste*. Princeton and Oxford: Princeton University Press, 2011.

Glissant, Edouard. *Caribbean Discourse: Selected Essays*. Translated and with an introduction by J. Michael Dash. Charlottesville: University Press of Virginia, 1989.

Grigsby, Darcy Grimaldo. *Extremities: Painting Empire in Post-Revolutionary France*. New Haven: Yale University Press, 2002.

———. "Still Thinking about Olympia's Maid." *Art Bulletin* 97, no. 4 (December 2015), pp. 430–51.

Hartman, Saidiya V. *Scenes of Subjection: Terror, Slavery, and Self-Making in Nineteenth-Century America*. Race and American Culture. New York and Oxford: Oxford University Press, 1997.

———. "Venus in Two Acts." *Small Axe* 12, no. 2 (June 2008), pp. 1–14.

Hyde, James H. *The Four Continents: From the Collection of James Hazen Hyde*. New York: Cooper Union Museum, 1961.

Jennings, Lawrence C. *French Anti-Slavery: The Movement for the Abolition of Slavery in France, 1802–1848*. Cambridge and New York: Cambridge University Press, 2000.

Johnson, Jessica Marie. *Wicked Flesh: Black Women, Intimacy, and Freedom in the Atlantic World*. Philadelphia: University of Pennsylvania Press, 2020.

Lafont, Anne. *L'art et la race: L'Africain (tout) contre l'oeil des Lumières*. Dijon: Les Presses du Réel, 2019.

Lewis, Robin Coste. *Voyage of the Sable Venus and Other Poems*. New York: Knopf Doubleday, 2019.

Lowe, Lisa. *The Intimacies of Four Continents*. Durham, N.C., and London: Duke University Press, 2015.

Lugo-Ortiz, Agnes, and Angela Rosenthal, eds. *Slave Portraiture in the Atlantic World*. New York and Cambridge: Cambridge University Press, 2013.

Margerie, Laure de, and Edouard Papet. *Facing the Other: Charles Cordier (1827–1905), Ethnographic Sculptor*. Exh. cat. Musée d'Orsay, Paris; Musée National des Beaux-Arts du Québec; Dahesh Museum of Art, New York; 2004–5. New York: Harry N. Abrams, 2004.

Margolin, Sam. "'And Freedom to the Slave': Antislavery Ceramics, 1787–1865." *Ceramics in America* (2002), pp. 80–109.

McGrath, Elizabeth, and Jean Michel Massing, eds. *The Slave in European Art: From Renaissance Trophy to Abolitionist Emblem*. Warburg Institute Colloquia 20. London: Warburg Institute; Turin: Nino Aragno Editore, 2012.

Miller, Christopher L. *The French Atlantic Triangle: Literature and Culture of the Slave Trade*. Durham, N.C., and London: Duke University Press, 2008.

Mitchell, Robin. *Vénus Noire: Black Women and Colonial Fantasies in Nineteenth-Century France*. Race in the Atlantic World, 1700–1900. Athens: University of Georgia Press, 2020.

Murrell, Denise. *Posing Modernity: The Black Model from Manet and Matisse to Today*. Exh. cat. Wallach Art Gallery, Columbia University, New York, and Musée d'Orsay, Paris; 2018–19. New Haven: Yale University Press in association with The Miriam and Ira D. Wallach Art Gallery, Columbia University in the City of New York, 2018.

Nelson, Charmaine A. *Representing the Black Female Subject in Western Art*. Routledge Studies on African and Black Diaspora 2. New York and London: Routledge, 2010.

———. *The Color of Stone: Sculpting the Black Female Subject in Nineteenth-Century America*. Minneapolis and London: University of Minnesota Press, 2007.

———. "Vénus Africaine: Race, Beauty and African-ness." In *Black Victorians: Black People in British Art 1800–1900*, edited by Jan Marsh, pp. 46–56. Exh. cat. Birmingham City Museum and Art Gallery, and Manchester City Art Gallery, U.K.; 2005–6. Aldershot, Hampshire, and Burlington, Vt.: Lund Humphries, 2005.

Peabody, Sue. *"There Are No Slaves in France": The Political Culture of Race and Slavery in the Ancien Régime*. New York and Oxford: Oxford University Press, 1996.

Poletti, Michel, and Alain Richarme. *Jean-Baptiste Carpeaux, sculpteur: Catalogue raisonné de l'oeuvre édité*. Paris: Editions de l'Amateur, 2003.

Said, Edward. *Orientalism*. New York: Pantheon Books, 1978.

Sala-Molins, Louis. *Dark Side of the Light: Slavery and the French Enlightenment*. Translated and with an introduction by John Conteh-Morgan. Minneapolis: University of Minnesota Press, 2006.

Savage, Kirk. "Molding Emancipation: John Quincy Adams Ward's *The Freedman* and the Meaning of the Civil War." *Art Institute of Chicago Museum Studies* 27, no. 1 (2001), pp. 26–39.

———. *Standing Soldiers, Kneeling Slaves: Race, War, and Monument in Nineteenth-Century America*. Princeton and Oxford: Princeton University Press, 1997.

Scarry, Elaine. *The Body in Pain: The Making and Unmaking of the World*. New York and Oxford: Oxford University Press, 1985.

Smalls, James. "Exquisite Empty Shells: Sculpted Slave Portraits and the French Ethnographic Turn." In Lugo-Ortiz and Rosenthal, *Slave Portraiture in the Atlantic World*, pp. 283–312.

Spicer, Joaneath, ed. *Revealing the African Presence in Renaissance Europe*. Exh. cat. Walters Art Museum, Baltimore, and Princeton University Art Museum; 2012–13. Baltimore: Walters Art Museum, 2012.

Sund, Judy. *Exotic: A Fetish for the Foreign*. London: Phaidon, 2019.

Thomas, Sarah. *Witnessing Slavery: Art and Travel in the Age of Abolition*. London: Paul Mellon Centre for Studies in British Art in association with Yale University Press, 2019.

Tolles, Thayer. "*The Freedman*, 1863." In *American Sculpture in The Metropolitan Museum of Art, Volume 1. A Catalogue of Works by Artists Born before 1865*, edited by Thayer Tolles, pp. 140–42. New York: The Metropolitan Museum of Art, 1999.

Vitry, Paul. *L'art de notre temps: Carpeaux*. 1912. Paris: Librairie Centrale des Beaux-Arts, 2016.

Wagner, Anne Middleton. *Jean-Baptiste Carpeaux: Sculptor of the Second Empire*. New Haven: Yale University Press, 1986.

Wheeler, Roxann. *The Complexion of Race: Categories of Difference in Eighteenth-Century British Culture*. New Cultural Studies. Philadelphia: University of Pennsylvania Press, 2000.

Willis, Deborah, ed., with Carla Williams. *Black Venus 2010: They Called Her "Hottentot."* Philadelphia: Temple University Press, 2010.

Young, Robert. *Colonial Desire: Hybridity in Theory, Culture, and Race*. London and New York: Routledge, 1995.

Works in the Exhibition

PLS. 1A–D
Jean-Baptiste Carpeaux (French, 1827–1875)
Why Born Enslaved! (*Négresse*), modeled 1868,
carved 1873
Marble
H. 22⅞ in. (58.1 cm), W. 16 in. (40.6 cm),
D. 12½ in. (31.8 cm)
The Metropolitan Museum of Art, New York,
Purchase, Lila Acheson Wallace, Wrightsman
Fellows, and Iris and B. Gerald Cantor
Foundation Gifts, 2019 (2019.220)
Inscription: POURQUOI · NAITRE · ESCLAVE!

PL. 2
Jean-Baptiste Carpeaux (French, 1827–1875)
Why Born Enslaved! (*Négresse*), modeled 1868,
cast 1872
Terracotta
H. 21¼ in. (54 cm), W. 17½ in. (44.5 cm),
D. 13¾ in. (34.9 cm)
The Metropolitan Museum of Art, New York,
Gift of James S. Deely, in memory of Patricia
Johnson Deely, 1997 (1997.491)
Inscription: POURQUOi! NAÎTRE ESCLAVE!

PL. 3
Kara Walker (American, born 1969)
Negress, 2017
Plaster
H. 15¾ in. (40 cm), W. 13¾ in. (35 cm),
D. 6 in. (15 cm)
Courtesy the artist and Sikkema Jenkins & Co.,
New York

PL. 4
Kehinde Wiley (American, born 1977)
After La Négresse, 1872, 2006
Cast marble dust and resin, edition 170/250
H. 11 in. (27.9 cm), W. 10 in. (25.4 cm),
D. 9 in. (22.9 cm)
Courtesy the artist and Sean Kelly Gallery,
New York

PL. 5
Jean-Baptiste Carpeaux (French, 1827–1875)
Why Born Enslaved! (*Négresse*), modeled 1868
Plaster and paint
H. 13¾ in. (34.9 cm), W. 9¼ in. (23.5 cm),
D. 7 in. (17.8 cm)
Brooklyn Museum, New York, Gift of Benno
Bordiga, by exchange and Mary Smith Dorward
Fund (1993.83a-b)
Inscription: POURQUOI NÂITRE ESCLAVE

PL. 6
Jean-Baptiste Carpeaux (French, 1827–1875)
Study of a Woman for "Why Born Enslaved!,"
1868
Unbaked clay
H. 5¾ in. (14.5 cm), W. 6¼ in. (16 cm), D. 5⅞ in.
(15 cm); with base: H. 10⅞ in. (27.7 cm)
Private collection, courtesy Galerie Talabardon
et Gautier, Paris

PL. 7
Jean-Baptiste Carpeaux (French, 1827–1875)
Sketch Relating to "Why Born Enslaved!"
(recto), 1868
Black crayon on blue grid paper
9⅛ × 8¼ in. (23.1 × 20.9 cm)
Museum of Fine Arts, Budapest (1935-2667)

PL. 8
Jean-Baptiste Carpeaux (French, 1827–1875)
Study of a Woman Kneeling, ca. 1867–68
Terracotta
H. 10⅞ in. (27.5 cm), W. 5¾ in. (14.6 cm),
D. 7½ in. (18.9 cm)
Musée d'Orsay, Paris, acquis en 1908 (RF1466)

PL. 9
Jean-Baptiste Carpeaux (French, 1827–1875)
*Study for the Four Parts of the World
Supporting the Celestial Sphere*, 1867–68
Plaster
H. 10⅞ in. (27.5 cm), W. 5⅞ in. (14.8 cm),
D. 6⅛ in. (15.7 cm)
Musée d'Orsay, Paris, acquis en 1889 (RF 820)

PL. 10
Antislavery Medallion, ca. 1787
Manufactured by Josiah Wedgwood (British,
1730–1795), after a design by William Hackwood
(British, ca. 1753–1836)
Jasperware
$^{13}/_{16}$ × $^{11}/_{16}$ in. (3 × 2.7 cm)
The Metropolitan Museum of Art, New York,
Gift of Frederick Rathbone, 1908 (08.242)
Inscription: AM I NOT A MAN AND A BROTHER?

PL. 11
Abolitionist Jug, ca. 1820
Unknown manufacturer (British, probably
Staffordshire or Sunderland)
Pearlware (glazed earthenware) with transfer-
printed and luster decoration
H. 4½ in. (11.4 cm), W. 5½ in. (14 cm),
D. 3 in. (7.6 cm)
The Metropolitan Museum of Art, New York,
Purchase, Brett and Sara Burns Gift, in honor of
Austin B. Chinn, 2020 (2020.106)
Inscription: (front) AM NOT I A MAN AND A
BROTHER; (back) THE NEGRO'S / COMPLAINT
Fleecy locks and black complexion.
Cannot forfeit natures claim:
Skins may differ but affection,
Dwells in white and black the same.
Slaves of gold whose sordid dealings;
Tarnish all your boasted powers.
Prove that you have human feelings,
Ere you boldly question ours;

PL. 12
Double-Sided Antislavery Seal Set into a Fob,
ca. 1830s
After Josiah Wedgwood (British, 1730–1795)
Engraved gems; gilded metal setting
Overall: 1⅛ × 1½ in. (3 × 3.9 cm); seal: ⅝ × ¾ in.
(1.6 × 1.8 cm)
Collection of Rex Stark
Inscription (mirrored; on both sides): AM I NOT
A WOMAN AND A SISTER / AM I NOT A MAN
AND A BROTHER

PL. 13
Cologne Bottle with Encrusted Antislavery Image,
ca. 1830
Attributed to Falcon Glassworks of Apsley
Pellatt & Co. (British, 1791–1890)

Blown and cut glass
H. 6 in. (15.2 cm), W. 4 in. (10.2 cm),
D. 2¾ in. (7 cm)
Minneapolis Institute of Art, Gift of the
Decorative Arts Council (2001.40a, b)

PL. 14
Revolutionary Playing Card, 1793–94
Designed by Jean Démosthène Dugourc
(French, 1749–1825), published by Michel
Hennin (French, 1777–1863)
Woodcut engraving
3⅛ × 2⅛ in. (8 × 5.5 cm)
Bibliothèque Nationale de France, Paris,
Département des Estampes et de la
Photographie (Hennin, 11841)
Inscription: COURAGE; ÉGALITÉ DE COULEUR

PL. 15
Unknown French artist
Sketch of an Allegory of the Abolition of Slavery,
ca. 1848
Terracotta
H. 13⅝ in. (34.6 cm), W. 6⁵/₁₆ in. (16 cm),
D. 6¹⁵/₁₆ in. (17.6 cm)
The Metropolitan Museum of Art, New York,
Purchase, Friends of European Sculpture and
Decorative Arts Gifts, 2021 (2021.43)

PL. 16
Louis Simon Boizot (French, 1743–1809)
Porcelain Group of a Free Man and Woman
(*Les noirs libres*), 1794
Hard-paste biscuit porcelain
H. 8⅝ in. (22 cm), W. 6⅛ in. (15.5 cm),
D. 5⅜ in. (13.7 cm)
Musées d'Art et d'Histoire de La Rochelle
(83-4-2)
Inscription: MOI ÉGALE À TOI. MOI LIBRE AUSSI.

PL. 17
Louis Darcis (French, 1760–1801), after
Louis Simon Boizot (French, 1743–1809)
Print of a Free Man (*Moi libre aussi*), 1794
Engraving
Bibliothèque Nationale de France, Paris,
Département des Estampes et de la
Photographie (RESERVE QB-370 [44]-FT 4)
Inscription: Moi Libre aussi.

PL. 18

Louis Darcis (French, 1760–1801), after
Louis Simon Boizot (French, 1743–1809)
Print of a Free Woman (*Moi libre aussi*), 1794
Engraving
Bibliothèque Nationale de France, Paris,
Département des Estampes et de la
Photographie (RESERVE QB-370 [44]-FT 4)
Inscription: Moi Libre aussi.

PL. 19

Jean Antoine Houdon (French, 1741–1828)
Head of a Woman (*Buste de négresse*), ca. 1781
Plaster and paint
H. 12¼ in. (31 cm), D. 9⅞ in. (25 cm)
Musée Municipale Ancienne Abbaye
Saint-Léger, Soissons (93.7.2766)

PL. 20

Jean Antoine Houdon (French, 1741–1828)
Bust of a Woman (*Buste de négresse*), 1794
or later
Terracotta and paint
H. 8⅛ in. (20.5 cm), W. 4⅞ in. (12.4 cm),
D. 2¾ in. (7 cm)
The Metropolitan Museum of Art, New York,
Bequest of Mrs. Charles Wrightsman, 2019
(2019.283.37)
Inscription:
RENDUE A LA LIBERTE / ET A L'EGALITE /
PAR LA CONVENTION NATIONALE / LE 16
PLUVIOSE / 2ME DE LA REPUBLIQUE FRANCAISE /
UNE ET INDIVISIBLE

PL. 21

Edmonia Lewis (American, 1844–1907)
Forever Free, 1867
Marble
H. 41¾ in. (106 cm), W. 21½ in. (54.6 cm),
D. 12⅜ in. (31.4 cm)
Howard University Gallery of Art,
Washington, D.C. (67.9.S)
Inscription: FOREVER FREE.

PL. 22

John Quincy Adams Ward (American,
1830–1910)
The Freedman, modeled 1863, cast 1891
Bronze

H. 19½ in. (49.5 cm), W. 14¾ in. (37.5 cm),
D. 9¾ in. (24.8 cm)
The Metropolitan Museum of Art, New York,
Gift of Charles Anthony Lamb and Barea Lamb
Seeley, in memory of their grandfather, Charles
Rollinson Lamb, 1979 (1979.394)

PLS. 23A–D

Johann Justin Preissler (German, 1698–1771),
after Edme Bouchardon (French, 1698–1762)
Allegories of the Four Parts of the World,
1730–32
Engraving
The Metropolitan Museum of Art, New York,
Harris Brisbane Dick Fund, 1953

A. *Allegory of Europe*
10⅝ × 12¹⁄₁₆ in. (27 × 30.7 cm)
(53.600.2407)

B. *Allegory of Africa*
11⅛ × 12¹⁵⁄₁₆ in. (28.2 × 32.8 cm)
(53.600.2408)

C. *Allegory of America*
11⅛ × 12¹⁵⁄₁₆ in. (28.2 × 32.8 cm)
(53.600.2409)

D. *Allegory of Asia*
11⅛ × 12¹⁵⁄₁₆ in. (28.2 × 32.8 cm)
(53.600.2410)

PLS. 24A–D

Allegories of the Four Parts of the World,
1781–88
Fulda Manufactory (German, 1764–89),
after a design by Johann Andreas Herrlein
(German, 1720–1796)
Hard-paste porcelain
The Metropolitan Museum of Art, New York,
Gift of Estate of James Hazen Hyde, 1959

A. *Allegory of Europe*
H. 9⅛ in. (23.2 cm), W. 5¾ in. (14.6 cm),
D. 4⁷⁄₁₆ in. (11.3 cm)
(59.208.4)

B. *Allegory of America*
H. 9⁷⁄₁₆ in. (24 cm), W. 5 in. (12.7 cm),
D. 4¼ in. (10.8 cm)
(59.208.5)

C. *Allegory of Africa*
H. 9¹³⁄₁₆ in. (24.9 cm), W. 4⅞ in. (12.4 cm),
D. 4⁹⁄₁₆ in. (11.6 cm)
(59.208.6)

D. *Allegory of Asia*
H. 8⁹⁄₁₆ in. (21.7 cm), W. 5 in. (12.7 cm),
D. 3¾ in. (9.5 cm)
(59.208.7)

PL. 25
Frédéric-Auguste Bartholdi (French,
1834–1904)
Allegory of Africa, modeled ca. 1863–64
Reduced cast of a figure for a fountain com-
memorating Admiral Armand Joseph Bruat
Bronze
H. 12½ in. (31.8 cm), W. 19¹⁵⁄₁₆ in. (50.6 cm),
D. 6⅝ in. (16.8 cm)
National Gallery of Art, Washington, D.C.,
Gift of the 50th Anniversary Gift Committee
(1991.84.1)

PL. 26
Jean-Baptiste Carpeaux (French, 1827–1875)
Bust of a Man (*Le Chinois*), modeled 1868,
cast 1872
Bronze
H. 27½ in. (69.9 cm), W. 20⅛ in. (51.1 cm),
D. 13⅝ in. (34.6 cm)
Detroit Institute of Arts, Gift of Florence Ballin
(2000.158)

PL. 27
Charles-Henri-Joseph Cordier (French,
1827–1905)
Head of a Woman (*Vénus africaine*), modeled
1851, cast 1851 or after
Plaster and paint
H. 5¼ in. (13.5 cm), W. 4⅜ in. (11 cm),
D. 3 in. (7.5 cm)
Musée d'Orsay, Paris, don de Marcel Cordier,
petit-fils de l'artiste, 1933 (RF 4621)

PL. 28
Jean-Pierre Dantan, called Dantan-Jeune
(French, 1800–1869)
Bust of Hora, 1848
Plaster and paint
H. 10⅜ in. (26.3 cm)

Musée Carnavalet–Histoire de Paris (S 1156)
Inscription: Gala

PL. 29
Charles-Henri-Joseph Cordier (French,
1827–1905)
Bust of Seïd Enkess (*Saïd Abdallah, de la tribu
de Mayac, royaume de Darfour*; after 1850,
Nègre de Timbouctou), 1848
Bronze
With socle: H. 32½ in. (82.6 cm), W. 18 in.
(45.7 cm), D. 14 in. (35.6 cm); without socle:
H. 28⅛ in. (71.3 cm)
Art Institute of Chicago, Ada Turnbull Hertle
Endowment (1963.839)

PL. 30
Charles-Henri-Joseph Cordier (French,
1827–1905)
Bust of a Woman (*Négresse des colonies*; after
1857, *Vénus africaine*), 1851
Bronze
With socle: H. 30½ in. (78.5 cm), W. 16 in.
(40.6 cm), D. 11½ in. (29.2 cm); without socle:
H. 27¼ in. (69.2 cm)
Art Institute of Chicago, Ada Turnbull Hertle
Endowment (1963.840)

PL. 31
Jean-Léon Gérôme (French, 1824–1904)
Bashi-Bazouk, 1868–69
Oil on canvas
31¾ × 26 in. (80.6 × 66 cm)
The Metropolitan Museum of Art, New York,
Gift of Mrs. Charles Wrightsman, 2008
(2008.547.1)

PL. 32
Charles-Henri-Joseph Cordier (French,
1827–1905)
Woman from the French Colonies (*La capresse
des colonies*), 1861
Algerian onyx-marble, bronze, enamel,
amethyst; white marble socle
With socle: H. 37¾ in. (95.9 cm), W. 23¼ in.
(59.1 cm), D. 12¼ in. (31.1 cm); without socle:
H. 30¾ in. (78.1 cm)
The Metropolitan Museum of Art, New York,
European Sculpture and Decorative Arts Fund,
2006 (2006.112a–c)

Acknowledgments

This exhibition and catalogue are a milestone for The Met as the first project dedicated to examining the relationship between European sculpture and the histories of colonialism, slavery, and empire. Centering this exploration around a single work, *Why Born Enslaved!*, gave the project focus and breadth, and we are extremely grateful to the institutions, galleries, artists, and private collectors who partnered with us in this endeavor. Their collaboration and generosity signal a growing commitment to participating in the conversation around urgent issues of representation and the histories and legacies of slavery and colonialism in the world of European decorative arts. We look forward to future opportunities to continue this important work.

Many individuals have worked tirelessly behind the scenes to assist the loan process for the exhibition. In North America: James Rondeau, Gloria Groom, Emerson Bowyer, and Anna Simonovic (Art Institute of Chicago); Anne Pasternak, Catherine Futter, Lisa Small, and Elizabeth Largi (Brooklyn Museum); Justin Witte (Cleve Carney Museum of Art); Salvador Salort-Pons, Alan Darr, Jill Shaw, and Michelle Smith (Detroit Institute of Arts); Lisa Farrington and Abby Eron (Howard University Gallery of Art); Katherine Crawford Luber, Michelle Klein, Ghenete Zelleke, and Tanya Morrison (Minneapolis Institute of Art); Kaywin Feldman, C. D. Dickerson III, Alison Luchs, and Lisa MacDougall (National Gallery of Art); Kehinde Wiley, Ian Dickman, Rosey Selig-Addiss, Gabriella Wilks, and Rei Halverson (Studio of Kehinde Wiley); Janine Cirincione, Arin Madera, Robert Spring, and Emma Karasz (Sean Kelly Gallery); Kara Walker; Scott Briscoe and Matthew Droege (Sikkema Jenkins & Co.); and Rex Stark. In Europe: Laurence Engel, Corinne Le Bitouzé, and Brigitte Robin-Loiseau (Bibliothèque Nationale de France); Valérie Guillaume, Juliette Tanré-Szewczyk, and Valérie Fours (Musée Carnavalet–Histoire de Paris); Laurence des Cars, Christophe Leribault, Edouard Papet, Ophélie Ferlier-Bouat, and Isolde Pludermacher (Musée d'Orsay); Mélanie Moreau, Barbara Favreau, Violetta Giraldos, and Dominique Guego (Musées d'Art et d'Histoire de La Rochelle); Alain Crémont, Christophe Brouard, and Manon Jambut (Musées de Soissons); László Baán, Kinga Bódi, and Judit Geskó (Museum of Fine Arts, Budapest); and Bertrand Gautier and Marie-Elise Dupuis (Galerie Talabardon et Gautier).

This project benefited from the guidance and encouragement of numerous individuals. Sarah E. Lawrence, Iris and B. Gerald Cantor Curator in Charge of the Department of European Sculpture and Decorative Arts, was the exhibition's earliest proponent—indeed, it was Sarah who acquired *Why Born Enslaved!* and foresaw an urgent need for rethinking the conversation around it. The exhibition would not have been possible without her leadership and vision. Enormous thanks are due to Daniel H. Weiss, President and Chief Executive Officer, for his abiding support and role in securing assistance from the Wallace Foundation, and to Max Hollein, Marina Kellen French Director, for his endorsement of this exhibition. Our frame of engagement was enhanced in consultation with Lavita McMath Turner, Chief Diversity Officer, and Andrea Bayer, Deputy Director for Collections and Administration. Quincy Houghton, Deputy Director for Exhibitions, was a steadfast steward of the project, providing invaluable perspective and counsel. We are grateful for the many contributions of Heidi Holder, Frederick P. and Sandra P. Rose Chair of Education, whose experience in community engagement and public outreach proved invaluable in our process of thinking through the opportunities for reconsidering this work. Associate Curator Denise Murrell's generous feedback and experienced perspective on the challenges of mounting an exhibition of this nature were essential, and for her support in advocating for funding from the Ford Foundation we are most grateful. Rachel Hunter

Himes, intern in the Department of European Sculpture and Decorative Arts, was a key partner, contributing interpretive material to the book and exhibition, and assisting with many other organizational aspects of the project. Former interns Julie Cahen-Ulloa and Nora Alvarez Ahdab contributed significantly as well through in-depth research.

An exhibition dedicated to confronting the representation of the Black figure in the wake of colonial slavery does not get mounted at this time of racial reckoning without a number of challenging conversations, and we are especially grateful to the colleagues who were willing to participate in them. An early convening of experts from both sides of the Atlantic in March 2021 brought robust discussion about the history of *Why Born Enslaved!* and the ways we might re-center the themes of the exhibition around underexplored issues related to Western imperialism, representation, and power. To those who participated and are not listed elsewhere, we extend our thanks: David Bindman, Cécile Bishop, Meredith Gamer, Karen Lemmey, Susan H. Libby, Nathaniel Silver, Judy Sund, and Deborah Willis. Lisa Farrington's name bears repeating for her generous engagement and for helping us to better understand the work of Edmonia Lewis. Special thanks are due to Laure de Margerie for extending her time and expertise toward researching the provenance and early exhibition history of *Why Born Enslaved!*, as well as to Meredith Martin, Luke Syson, Ellenor Alcorn, Tim Barringer, James A. Doyle, and Emerson Bowyer for their recommendations and support. Tobias Meyer and Allen R. Adler and Frances F. L. Beatty went to great lengths to help secure several exhibition loans, and we are indebted to them for their efforts.

In the Department of European Sculpture and Decorative Arts, Kristen Hudson, Wolf Burchard, Denny Stone, Juan Stacey, Sam Winks, Jasmine Kuylenstierna Wrede, Jennifer Begazo, Lisa Krainik, and Ana Matisse Donefer-Hickie provided sustained assistance of many kinds. Denise Allen gave invaluably to the exhibition by offering her keen insights at various stages of development, while Iris Moon enriched the project through her contribution to this publication. For other support from within The Met, we thank Sylvia Yount, Lawrence A. Fleischman Curator in Charge, Thayer Tolles, Marica F. Vilcek Curator of American Paintings and Sculpture, and Adrienne Spinozzi in the American Wing; Nadine M. Orenstein, Drue Heinz Curator in Charge, Perrin Stein, Allison Rudnick, and David del Gaizo in the Department of Drawings and Prints; Stephan Wolohojian, John Pope-Hennessy Curator in Charge, Asher E. Miller, David Pullins, and Adam Eaker in the Department of European Paintings; Sheena Wagstaff, Leonard A. Lauder Chair, Ian Alteveer, Aaron I. Fleischman Curator, Kelly Baum, Cynthia Hazen Polsky and Leon Polsky Curator of Contemporary Art, and Brinda Kumar in the Department of Modern and Contemporary Art; and Andrea Achi and Julia Perratore in the Department of Medieval Art and The Cloisters. Dita Amory, Curator in Charge of the Robert Lehman Collection, deserves special recognition for her outstanding support of the exhibition from its conception. This book and the convening simply would not have happened without her advocacy.

So many other talented colleagues helped bring this project to fruition, and we are grateful to every one of them. Gillian Fruh in the Exhibitions Office acted with her usual virtuosity as project manager. Aislinn Hyde and Mary F. Allen, working with Meryl Cohen in the Registrar's Office, coordinated the safe movement of precious works of art to and from the Museum and within the galleries. Daniel Kershaw, Zoe Alexandra Florence, Mortimer Lebigre, Alexandre Viault, Sarah Pulvirenti, Luke Chase, Maanik Singh Chauhan, Sarah M. Parke, and Amy Nelson, under Alicia Cheng's outstanding direction in the Design Department, created an intelligent and imaginative design for the exhibition, lighting, and graphics that was fastidiously brought to realization by many colleagues in Buildings, under Tom Scally, Taylor Miller, and Gordon Hairston, and our logistical liaisons, technicians, mount-makers, and shops. The exhibition's complex themes were made accessible to a wide audience through a beautifully crafted audio

guide, supported by Bloomberg Philanthropies, and produced by Melissa Smith with Nina Diamond, Will Fenstermaker, Skyla Choi, and Rachel Smith in the Digital Department, while Douglas Hegley, Chief Digital Officer, lent his crucial insights on how the exhibition might best engage with audiences through the digital platform. Marianna Siciliano in the Education Department contributed heroically to the planning of a scholarly symposium, while Inka Drögemüller, Deputy Director for Digital, Education, Publications, Imaging, Libraries, and Live Arts, and Tricia Robson in the Executive Office, Darcy-Tell Morales in Education, and Lela Jenkins in Digital offered further support. Sharon H. Cott, Amy Desmond Lamberti, and Nicole Sussmane in the Counsel's Office, and Marci King in Exhibitions generously assisted in the preparation of loan letters and legal documentation. In External Affairs, Kenneth Weine, Gretchen Scott, Ann M. Bailis, Jennifer Isakowitz, and Claire Lanier contributed their expertise to refining the exhibition's message. In Institutional Advancement we thank Clyde B. Jones III, Jason Herrick, Daphne Butler Birdsey, Elizabeth A. Burke, Jennifer M. Brown, Kimberly McCarthy, Hillary S. Bliss, and Evie Chabot for the crucial role they played in fundraising, and Kate Dobie, Kimberly Chey, and Maeve Dare for envisioning events supporting the project.

In preparation for the exhibition considerable conservation work was undertaken on objects in The Met collection and beyond by Jack Soultanian Jr., and Wendy Walker. To them we are much obliged, as well as to Lisa Pilosi, Sherman Fairchild Conservator in Charge, Kendra Roth, and Linda Borsch in Objects Conservation. We owe a particular debt of gratitude to Jack, who went above and beyond the call of duty as conservator by undertaking difficult international travel during the course of the pandemic and making a generous introduction to one of the project's vital supporters, Robert E. Holmes, mentioned below.

Our profound gratitude is owed to The Met's Publications and Editorial Department, led by Mark Polizzotti, with Michael Sittenfeld and Peter Antony, without whom this book and the exhibition's interpretive material would not exist. Elizabeth Benjamin deserves abundant credit for editing the exhibition's in-gallery text and helping shape the book's content, providing superlative editorial support along the way. She was assisted in her efforts by bibliographer and editor Eleanor Hughes, who was equally suited to the monumental task, and by Jennifer Bantz, who helped coordinate exhibition interpretation. We are indebted to them for their professionalism, acumen, and extraordinary attention to detail. Christopher Zichello oversaw the book's design, production, and printing with great skill; Shannon Cannizzaro sourced numerous images; and photographers Paul H. Lachenauer, Bruce J. Schwarz, and Richard Lee contributed stunning photography for the book. Rodrigo Corral, Alex Merto, and Dasha Buduchina are the creative minds behind the book's design; Tina Henderson provided the typesetting and layout; Polly Watson and Richard Koss ably proofread the text; and John Goodman provided translations. The catalogue is enriched by the brilliant contributions of three authors not already mentioned, Caitlin Meehye Beach, Adrienne L. Childs, and James Smalls.

Finally, we offer our heartfelt thanks to the Iris & B. Gerald Cantor Foundation and Allen R. Adler and Frances F. L. Beatty for their remarkable gifts in support of the exhibition. We are indebted to the Robert Lehman Foundation, the Wallace Foundation, and Mr. and Mrs. Richard L. Chilton, Jr., whose generosity enabled the project's commitment to collaboration and collegial scholarly exchange. We express our gratitude as well to The Met's Fund for Diverse Art Histories, Mary J. Wallach, Robert E. Holmes, the Ford Foundation, and the Henry Moore Foundation for support of this publication. It is difficult to imagine a more inspiring group of patrons and philanthropic organizations to help bring this project into being.

Elyse Nelson and Wendy S. Walters

Contributors

CAITLIN MEEHYE BEACH
Assistant Professor of Art History, and Affiliated
Faculty, African and African American Studies,
Fordham University

ADRIENNE L. CHILDS
Independent art historian and curator; Adjunct
Curator, The Phillips Collection, Washington,
D.C.; and associate of the W. E. B. Du Bois Research
Institute at the Hutchins Center for African and
African American Research, Harvard University

RACHEL HUNTER HIMES
PhD student, Department of Art History and
Archaeology, Columbia University

SARAH E. LAWRENCE
Iris and B. Gerald Cantor Curator in Charge,
Department of European Sculpture and Decorative
Arts, The Metropolitan Museum of Art

IRIS MOON
Assistant Curator, Department of European
Sculpture and Decorative Arts, The Metropolitan
Museum of Art

ELYSE NELSON
Assistant Curator, Department of European
Sculpture and Decorative Arts, The Metropolitan
Museum of Art

JAMES SMALLS
Professor and Chair, Department of Visual Arts,
and Affiliate Professor of Gender, Women's and
Sexuality Studies; Africana Studies; and Language,
Literacy, and Culture, University of Maryland,
Baltimore County

WENDY S. WALTERS
Concentration Head in Nonfiction and Associate
Professor, Writing Program, School of the Arts,
Columbia University

Lenders to the Exhibition

Art Institute of Chicago
Bibliothèque Nationale de France, Paris
Brooklyn Museum, New York
Detroit Institute of Arts
Howard University Gallery of Art, Washington, D.C.
The Metropolitan Museum of Art, New York
Minneapolis Institute of Art
Musée Carnavalet–Histoire de Paris
Musée d'Orsay, Paris
Musées d'Art et d'Histoire de La Rochelle
Musée Municipale Ancienne Abbaye Saint-Léger, Soissons
Museum of Fine Arts, Budapest
National Gallery of Art, Washington, D.C.
Private collection, courtesy Galerie Talabardon et Gautier, Paris
Rex Stark
Kara Walker and Sikkema Jenkins & Co., New York
Kehinde Wiley and Sean Kelly Gallery, New York

Index

Italic page numbers refer to figures.

race: equality, 11, 35, 37, 44, 68, 72, 104, *pl. 14*; hierarchies, 57, 63, 82; in classicizing sculpture, 32–33, 70, 73; physical types, 16, 57, 58, 63, 102, 104, 105; sculptural surfaces representing skin colors, 31, 57, 93; social construction, 57, 63, 82. *See also* ethnography

Réunion des Musées Nationaux, 88, *89*, 98

Ripa, Cesare (Italian, 1555–1622), 54–56

Robespierre, Maximilien (French, 1758–1794), 41, 43

Rousseau, Jean Jacques (French, 1712–1778), 44

Saint-Domingue: women, 84–85; delegation in Paris, 44; slave revolt, 28, 35, 37, 38, 84, 103; sugar plantations, 38, 41. *See also* Haiti

Salon. *See* Paris Salon

Schoelcher, Victor (French, 1804–1893), 45

Second Empire, 49, 65, 105, 107, *See also* Napoléon III; Universal Exhibition

Sèvres Manufactory: Antislavery Medallion, 35–37, *36*, 39, 103; biscuit sculptures, 39–43, 44–47, 112n18; Carpeaux reproductions, 88, 100. *See also* Boizot, Louis Simon

slavery, 19–20, 25–26, 37, 38, 41, 57, 102. *See also* abolition; emancipation; enslaved people

slave trade, 19, 27–28, 80, 82, 102, 104; James Phillips, *Description of a Slave Ship*, 26

Société des Amis des Noirs (Society of the Friends of the Blacks), 38–39, 103

Society for Effecting the Abolition of the Slave Trade, 26, 36, 38, 103

Susse, 88, 100

Suty, Cl. (French, act. 19th century), 78–79

Tacca, Pietro (Italian, 1577–1640), *I Quattro Mori (The Four Moors)*, *23*, 25, 27, 30, 31

United States: abolitionism, 105–6; abolition of slavery, 20–21; Civil War, 20–21, 30, 31, 51, 106; Thirteenth Amendment, 31–33, 106. *See also* Emancipation Proclamation

Universal Exhibition (1867), 21, 33, 58–59, 106

Victoria, Queen (British, 1819–1901), 94, 105

Walker, Kara (American, b. 1969): *Figa*, 99, *100*; *Negress*, 82, 88, *98*, 99–100, 101, *pl. 3*; *A Subtlety, or the Marvelous Sugar Baby*, 45, *45*, 99

Ward, John Quincy Adams (American, 1830–1910), *The Freedman*, 21, 30–31, 32, 33, 106, *pl. 22*

Wedgwood, Josiah (British, 1730–1795), Antislavery Medallion, 20, 26–28, 30–31, 35–36, 46, 103, *pl. 10*

White, Edwin (American, 1817–1877), *Thoughts of the Future (Thoughts of Liberia, Emancipation)*, 33

Why Born Enslaved!: ambiguity and contradictions, 34, 52, 72, 73, 75, 77, 84; contemporary evocations, 82–83, *82*, 95, *96*, *97*, *98*, 98–100, 101, *pls. 3, 4*; context, 22, 49–54, 59, 62, 85–87; critical reception, 49, 61, 77, 78–79; eroticism, 34, 52, 72; as ethnographic sculpture, 63, 64, 72–73, 75, 93; exhibited at Paris Salon (1869), 19, 49, 61, 77, 78–79, 90, 107; inscription, *18*, 20, 34, 50, 72, 77–79, 88, *89*, 90, *91*, *92*, 93, 109n10, *pls. 1A, 1D, 2, 5*; sources, 20–21, 52–53, 58, 90; intentions, 20, 76–79, 80, 86; interpretations, 14, 52, 71–72, 75, 77–78, 86–87; model, 17–18, 34, 64, 76, 83–84, 107; purchased by Napoléon III for Empress Eugénie, 19, 49, 93, 107, 114n4, 115n13; rope, 10–11, 19, 34, 48, 50, 52, 59, 77, 80, *81*, 90; studies related to, 17, 34, 52, *pls. 6, 7, 8*

Why Born Enslaved! versions: in Adidas ad, *82*, 83; bronze, 49, 61, 77, 88, 90–91, 93, 107, 115n13, 121n9, 121n14; marble, 82, 88, 90, 93; marble (Copenhagen), *18*, 19, 20, 49; marble (The Metropolitan Museum of Art), *2*, 9–11, 19, 20, *81*, *82*, 107, *pl. 1*; media, 88, 90–93; plaster, 19, 90–93, *91*, 109n10; plaster (Brooklyn), 90, *pl. 5*; polychromed plaster (Reims), 91, *92*; reproductions, 88–89, 90–93, 100–101, 107; resin casts, 88, *89*, 98; terracotta (The Metropolitan Museum of Art), 77, 90, 91–93, *pl. 2*

Wiley, Kehinde (American, b. 1977), *After La Négresse, 1872*, 82, 88, 95, *96*, *97*, 98–99, 101, *pl. 4*

Williams, Charles (British, act. 1797–1850), *Boney's Inquisition*, 84

women: artists, 31–33, 34; bodies, 52, 58, 71–72; breastfeeding, 44; captives, 52; East Asian, 122n21; in Haiti, 84–85; servants, 29

Photograph Credits